GALLERY OF GREAT PAINTERS

Degas

Joana Torres Ramos

© 2005 Gorg Blanc
© 2006 Rebo International b.v., Lisse, The Netherlands

EDITORIAL MANAGEMENT:	Jordi Vigué
TEXT:	Joana Torres Ramos
PHOTOGRAPHS:	Arxiu Gorg Blanc
COMPUTER PROCESSING:	Estudio Gráfico Gorg Blanc
GRAPHIC DESIGN AND LAYOUT:	Claudia Martínez Alonso
ENGLISH TRANSLATION:	Wendy Allatson for First Edition Translations Ltd, Cambridge, UK
EDITING:	Lin Thomas for First Edition Translations Ltd
TYPESETTING:	Amos Typographical Studio, Prague, The Czech Republic
PROOFREADING:	Sarah Dunham

ISBN 90 366 1896 7

GALLERY OF GREAT PAINTERS

Degas

Joana Torres Ramos

REBO
PUBLISHERS

Life and work

Edgar Degas lost his mother at the age of thirteen. It has never been clearly established just how much he was affected by the event, since he never spoke of it, but it is thought that this was one of the reasons why he never liked the Left Bank district of Paris. Although he himself attributed this dislike to the fact that it was chaotic and disordered, it was here that his mother died, in a house occupied by the family for several months, on the Left Bank of the River Seine. After her death the young Degas sought refuge in drawing, an interest that his father encouraged to alleviate his son's grief.

Degas was born into a wealthy, cosmopolitan family. His paternal grandfather, René-Hilaire de Gas, had fled Paris at the outbreak of the French Revolution and settled in Naples, founding a bank and marrying his daughters to members of the Italian aristocracy. His maternal grandfather was of Creole origin and had settled in New Orleans where he owned a cotton business. When his wife died, he moved to Paris with his children so that they would receive a better education. There, his daughter Célestine met Auguste de Gas, whose father had sent him to manage the Paris branch of the family bank.

Degas's parents were very different in character. While Célestine was captivated by Parisian society and the life led by her in-laws in Naples, Auguste preferred artistic and cultural pursuits. Degas therefore grew up in an environment where there was no shortage of musical soirées, visits to exhibitions and museums, and encounters with artists and collectors. Throughout his life, he maintained this duality by compartmentalizing his artistic interests and social life, to the point that the critic Gustave Geffroy described him as "a man of the world and reclusive esthete."

Between 1845 and 1853, Degas studied at the Lycée Louis-le-Grand, where he was a conscientious pupil, showing a particular aptitude for Latin, Greek, History, and Art. He passed his "baccalauréat" and enrolled to study law. However, he took time out from his studies to go and copy paintings in the Louvre Museum and the Cabinet des Estampes at the Bibliothèque Nationale where he was registered as a "pupil of Barrias." As soon as he got home, he would make straight for his studio where he would get his brothers and sisters to pose for him.

He soon came to the realization that he was not cut out for the legal profession, but wanted to become a painter. When he informed his father, the latter initially refused to accept his decision since he wanted his son to have a more lucrative way of earning a living. However, after a few months, during which Degas lived in a garret in wretched conditions, Auguste de Gas welcomed him home with open arms and, from then on, encouraged his son in his chosen career.

Degas soon realized that Félix Barrias was neither one of the best artists, nor one of the best masters. Through Édouard Valpinçon, he was advised by Jean-Auguste-Dominique Ingres to study at the studios of Louis Lamothe, one of Ingres's best pupils, and Auguste Flandrin. In these studios, Degas learned different techniques for composing a work of art and much more besides since, after only a few months, he was accepted by the École des Beaux-Arts, in Paris.

However, from the outset, Degas did not care for the academic style of painting or the approval of the French artistic establishment. Although well aware that leaving the École des Beaux-Arts would mean renouncing awards and scholarships, and prestigious commissions, he decided to teach himself, painting portraits of his close family and copying the grand masters, like most of his contemporaries. In this respect, he also had the full support of his father.

Degas's "baptism of fire" as a painter was marked by a significant event – his meeting with Ingres in 1855. "Yesterday I saw your god," Édouard Valpinçon told him. "Monsieur Ingres came to ask me to lend him his odalisque to exhibit in the room devoted to his work."

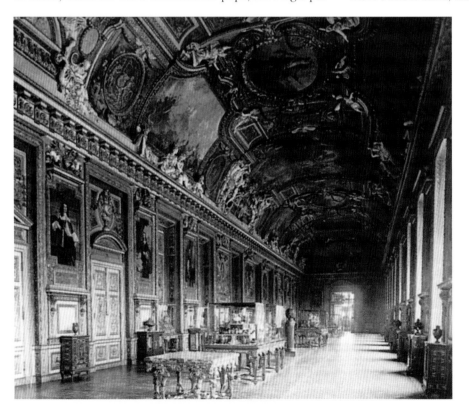

The Apollo Gallery, Louvre Museum, *Paris (late 19th century).*

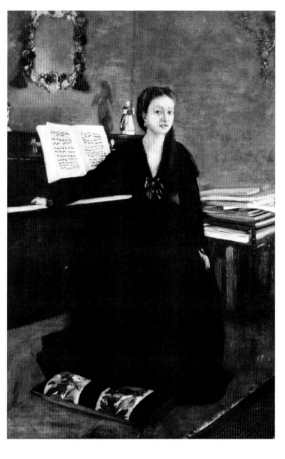

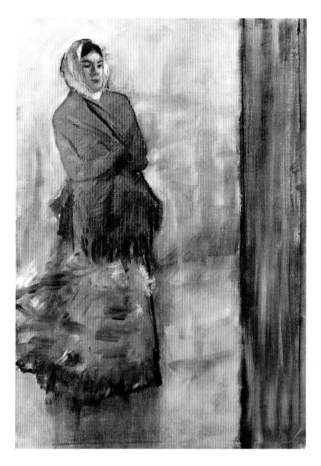

Madame Camus at the Piano, *1869, 139 × 94 cm, E.G. Bührle Collection, Zurich.*

Woman with a Red Shawl *1866, 75 × 62 cm.*

The request was prompted by the retrospective exhibition held in Paris on the occasion of the 1855 World Fair. The owner of the painting initially refused but Degas became so indignant that Valpinçon said: "Tomorrow, I will tell Monsieur Ingres that I have changed my mind. Call for me and we will go and see him together." (See page 24.) To the end of his life, Degas took great delight in explaining how, as they left his studio, Ingres suffered an attack of giddiness and fell, bloodying his face badly, and was helped by the young painter. Degas returned to see Ingres twice and received valuable advice from the master.

During the World's Fair, Degas came into contact with the different artistic styles currently being practiced in various countries. He made copies in his notebooks and continued to add to these when he visited different French museums.

In 1856 and with his father's encouragement, Degas decided to take the plunge and travel to Italy, to copy the works of the grand masters at first hand. Given his family background, he was familiar with Italian customs and spoke the language fluently. As a result, his perception of Italy was much more vivid and accurate than that of most of his French colleagues who had won scholarships to the Villa Medici, in Rome. This eighteen-month stay, divided mainly between Naples, Florence, and Rome, with journeys to Tuscany and Umbria, enabled him to extend his studies, in particular of 14th-century Italian painting.

The influence of this artistic period, combined with the techniques he had learned, led Degas to envisage a very ambitious work, *The Bellelli Family,* for which he did a number of preparatory paintings and drawings, and which took him almost ten years to complete. His encounters with the many artists living in Italy at the time, and his friendship with Gustave Moreau, combined with the thrill of being able to study the grand masters, led Degas to assert in later years that this had been the most extraordinary period of his life. But his father had been writing to him for months asking him to return home and he couldn't put it off any longer.

Although he continued to visit Italy regularly for over thirty years, in the spring of 1859, the artist settled in the French capital, where he saw the work of Eugène Delacroix at the Paris Salon – the associated annual exhibition of the École des Beaux-Arts. Delacroix's use of color extended Ingres's line-based technique that Degas had applied until then.

After studying so many frescoes by the grand masters, Degas embarked upon a period of historical painting, still regarded as the most elevated genre in its field. The artist drew upon his vast classical and biblical education, to which he added the grandeur of Giotto, Andrea Mantegna, and Veronese, eliminating the archeological references that were so much in vogue at the time.

He chose a painting in this genre – *War Scene in the Middle Ages* (also known as *The Sufferings of the City of New Orleans*) – when he exhibited at the Salon for the first time, in 1865. Unfortunately, it was badly presented and, on this occasion, Édouard Manet's controversial work, *Olympia,* was the center of attention.

Degas's *Scene from the Steeplechase: The Fallen Jockey* was much better received in 1866, a work in which he began to develop the horse-racing theme that he would work on for many years.

At the Salon of 1867, he had two works accepted under the generic title of "Family Portrait" – *The Bellelli Family* and *The Bellelli Sisters,* whose subjects have never been officially identified. Once again, his work caused little stir among the critics, whose attention was focused on the individual sections devoted to Gustave Courbet and Édouard Manet.

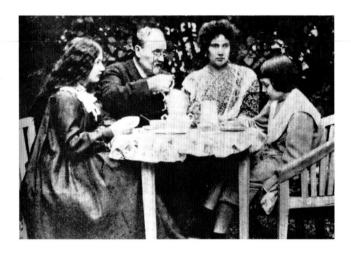

Émile Zola and family, photograph taken in the garden of the Zolas' summer residence at Médan. Zola was one of the critics who did most to promote and disseminate the Impressionist ideology. Degas liked and respected him greatly.

A year later, Degas exhibited what, according to many critics, was the first example of a more theatrical style of painting and an approach to a more contemporary theme – *Mlle. Eugénie Fiocre in the Ballet "La Source."*

In 1869, his portrait of Joséphine Gaujelin was exhibited, although it was extremely badly positioned. The jury rejected another work in which the painter had expressed great interest, *Madame Camus at the Piano,* which gave rise to another, much more ambitious and personal version of the portrait – *Madame Camus* (also known as *Madame Camus with a Fan*) – sent to the Salon of 1870. This second version heralded the artist's experiments with color that would reach their peak in the ballerina series.

In fact, Degas, who was so conservative in other ways, kept abreast of all the scientific research that might affect his painting – for example Michel Eugène Chevreul's treatises on color, the advances in photographic technique, and the study of human physiognomy – so that he could think about producing a work more in keeping with the age in which he lived.

This was one of the reasons why Degas decided to abandon the Salon after 1870. The other was that the standard of presentation did not meet the minimum requirements. Among the continual complaints, letters, and petitions from critics and artists alike, was a letter published by Degas in *Paris Journal,* in April 1870. In it, he suggested a much more spacious exhibition, in a maximum of two rows, a minimum distance of 20 cm (8 inches) between paintings, framed drawings, and works arranged as a function of their size.

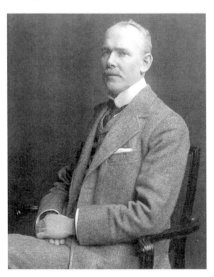

At the time, the artist was concentrating particularly on the themes of horses and ballerinas. In the 1860s, equestrian sports had become fashionable, promoted during the reign of Louis-Philippe and Napoleon III, and Degas began to go to the racetrack with Claude Monet. In this way, he developed the horse-racing theme with its realistic content, as advocated by the great theorists of the time, in a milieu befitting his social status.

His realism was greatly admired by the artists and critics who attended the regular gatherings at the Café Guérbois and, after the Franco-Prussian War of 1870, at the Café La Nouvelle-Athènes. Although Degas didn't go there that often, whenever he did, his opinion seemed to be taken as a pronouncement, with the result that he became known as "the inventor of social chiaroscuro."

Degas painted very few landscapes. The first examples were a handful of landscapes painted in Italy, in 1856, and a few more some five years later in Normandy. He also painted with Manet at Boulogne-sur-Mer, in 1869, but following the diagnosis of diabetic retinopathy (retinal changes leading to blindness) a year later, he began to take care of his eyes and protect them from natural light. This prevented him from painting *en plein air* like most of his colleagues: "For you the natural life, for me the artificial life." He became known as the "pioneer of the Impressionists of the night" because he would go to cafés-concerts and paint scenes lit by gaslight.

When the Franco-Prussian War broke out, Degas enlisted in the infantry but it soon became apparent that he couldn't see the color white. He was transferred to the artillery under the command of Henri Rouart, a former classmate at the Lycée Louis-le-Grand. Although they had lost touch in the intervening years, they rekindled their friendship and became inseparable.

Degas experienced the siege of Paris and the subsequent surrender to the Prussians. Fortunately, he was in Normandy when the Commune was declared, in March 1871, but the horrors of what was virtually a civil war disturbed him to the point that he decided to visit his mother's family in New Orleans. His brother René had also settled there in 1865 and married his cousin Estelle Musson. During his stay, Degas painted a number of family portraits but soon realized that: "One must not create Paris art and Louisiana art without any distinction. It would become a monde illustré." A shrewd artist, he knew that "only a long stay enables you to really get to know the customs of a race, that is, its charm," and, from then on, he did not leave a single drawing of the many journeys he made.

Nevertheless, with the exception of Manet's trip to Rio de Janeiro, he was the most widely traveled artist in the Impressionist group. His journeys were made for a variety of reasons – settling family business in Italy, visiting his mother's family in Louisiana, taking health cures, visiting friends, visiting museums, churches, and archeological ruins – and some of them are

Sir William Burrell, photograph c. 1920–23, Museums and Art Galleries, Glasgow. Burrell was a shipowner who built up a collection of some 8,000 top-quality works of art, including artifacts from Ancient Egypt, Greece and Rome, medieval European art, and works of art from the Far East. He owned works by such 19th-century artists as Eugène Delacroix, Paul Cézanne, Théodore Géricault, Édouard Manet, Jean-François Millet, and Alfred Sisley, as well as over twenty paintings and drawings by Degas, which are currently in the Burrell Collection, Glasgow.

Study for Woman with Chrysanthemums, *pencil drawing, Paul F. Sachs Collection.*

Édouard Manet, *pen and ink drawing.*

recounted in his letters. One of the most poignant was the trip to Montauban, in 1897, where he and sculptor Paul-Albert Bartholomé went to see drawings by Ingres. But in spite of using a magnifying glass, Degas could not even see the pages and needed help to do so.

After spending six months in the United States, Degas decided to return to Paris, soon afterwards establishing a routine that would continue for almost fifty years. When he finished work in the evening, he would change his clothes and head for the bourgeois district of the Parc Monceau and its cafés-concerts. He dined out at least three times a week, frequenting the best social and artistic venues of the time, and on the evenings he stayed at home he spent the time etching. For twenty years, he held a season-ticket for the Paris Opera, until his failing sight meant that he could no longer see the performance.

An unexpected event transformed Degas's relationship with painting up to this point in his career. His father's death in Naples, in 1874, revealed that the family's economic circumstances were much more precarious than they had believed. Auguste de Gas had neglected both his businesses and his assets, leaving an inheritance encumbered by debts. This included a loan to his youngest son René, who was unable to repay it. Together with the husband of his sister Marguerite, Degas assumed responsibility for the situation with a view to preserving the family honor.

The problems caused by the financial difficulties following his father's death meant that Degas was forced to paint commercially, producing works that were readily saleable and completing them more rapidly. This led him to develop the technique of pastel, a medium in which his favorite themes at the time were ballerinas and laundresses.

In 1873, the group of artists from La Nouvelle-Athènes, weary of requesting a Salon des Refusés – an exhibition of works rejected by the official Salon – and dissatisfied with the content of the latter, decided to found the Société Anonyme Coopérative des Artistes, Peintres, Sculpteurs, Graveurs, etc. The socie-

ty organized its own exhibitions, holding eight in all between 1874 and 1886. In spite of their being remembered by posterity as the Impressionist exhibitions, Degas preferred to refer to them as "independent", since he invited artists and friends such as Ludovic Lepic and Henri Rouart to take part. There were no objections from the rest of the group since their participation would help to defray the organizational costs. Degas was also responsible for setting up and publicizing these exhibitions, as evidenced by numerous bills from this period.

In the 1880s, Degas distanced himself from the group, maintaining a closer relationship with Mary Cassatt and Camille Pissarro, with whom he planned to launch a journal on etching and engraving, his technical obsession at the time. In 1883, Manet died and Paul Gauguin wrote: "Manet had a natural flair for leadership; now he is dead. He will be succeeded by Degas, the only Impressionist who can draw."

At the last Impressionist exhibition, held in 1886, Degas presented a "series of female nudes bathing, washing, drying themselves, combing their hair, and having their hair combed," his obsession in the latter years. At the time, the preliminary sketch and the completed work were one and the same thing. This gave his works a less finished appearance that made them more spontaneous.

This impression was enhanced by the fact that Degas was becoming increasingly interested in etching, a technique in which he continued to experiment, as he did with other pictorial techniques, since he was obsessed by the permanence of graphic art. On a number of occasions he complained: "No one will ever know just how much damage chemistry has done to painting."

Toward the end of the 1880s, the deterioration in his sight became more acute, as did his health in general, since he also suffered from respiratory and intestinal disorders. As a result, Degas was obliged to take various health cures in the summer and keep to a strict diet throughout the year. His letters reflect a great anguish that he only overcame by planning trips and journeys.

Ambroise Vollard, *photograph. In his biography of Degas, Vollard published some revealing confessions from the artist's last years.*

This physical decline coincided with an increase in his activities in the fields of photography, sculpture, and poetry. In a letter to Berthe Morisot, the Symbolist poet Stéphane Mallarmé wrote: "Degas is allowing himself to be distracted by his own poetry and is already writing his fourth sonnet. One is a little disconcerted by the appearance of this new art form in him which, in truth, is evolving very elegantly." Nine of Degas's sonnets have been published, impeccably formal in style, although fairly classical in nature.

Music was another interest that Degas pursued until his death. He often used to sing while he worked, and also at the end of the evenings spent with his friends, which he frequently brought to a close with Neapolitan songs. Given this habit and the fact that he was becoming increasingly irritable, his friends used to say that it was his grandfather's blood coming out, and that, as he grew older, the painter "was reverting to the Neapolitan type."

At social gatherings, his eccentricities and outbursts of rage were tolerated, since his friends knew he was basically a good man and that, on the days when he was in a good mood, he was cheerful and a great one for jokes. However, he was a difficult guest and the bête noire of housekeepers, since he didn't like flowers, perfume, certain behavior in children, or dogs… Art dealer Ambroise Vollard was brave enough to invite him to

Jean-Louis Forain, *photograph. To this painter and friend of Degas fell the task of reading the words that Degas had dictated for his own funeral.*

supper one evening and received the following reply: "Pay careful heed: My meal must be cooked without butter… No flowers on the table, and [served] at seven thirty sharp… I know you will shut your cat away, but I trust no one will be bringing dogs. And if there are ladies present, make sure they don't wear perfume. How disagreeable these smells are! When there are things that smell as good as toasted bread… Masking, as they do, that fine smell of dirt… Oh, and very little light. My eyes, my poor eyes!"

But this social life was greatly diminished by the Dreyfus affair, in 1895. Degas stopped seeing some of his best friends, who were of Jewish origin, for example the Halévys, the Strauses, and the Rothschilds. He even broke off with Pissarro, with whom he had always been very close. He also mistrusted Protestants, accusing them of being in league with the Jews.

His preferred companions were the poet, essayist, and critic, Paul Valéry, who made notes for his biography on the artist, Daniel Halévy, the son of his friend Ludovic, who later included his memories in an another monograph, and a few painters such as Jean-Louis Forain and Suzanne Valadon – in short, a select group of close friends.

With the passing years and his failing eyesight, Degas's artistic activities were limited to working with pastel – a medium in which he increasingly intensified the color – in the mornings, when his eyes allowed it, and on large drawings in the afternoon, to complete his working day. When his sight did not even allow him to continue producing monotypes, he devoted himself to sculpting figures but, dissatisfied with his own work, he only agreed to the casting of one bronze sculpture – the *Little Fourteen-Year-Old Dancer.* In 1897, he admitted to Vollard: "Bronze is eternal, but what I like is having to constantly begin over again." In 1903, he wrote to Alexis Rouart; "In this studio, you always have candles by you. Without work, what a sad old-age!"

In 1912, Degas suffered an irreversible decline. His sister Thérèse died and he took up his pen for the last time to write a heart-felt note to his nephews in Argentina informing them of the sad news. The Rouart brothers, Henri and Alexis, also died and, as if this were not enough, Degas had to leave the house he had lived in for almost twenty-two years. Virtually blind and unable to get used to his new home on the Boulevard Clichy, he lived in squalor and disorder, not even managing to unpack his collection of paintings, which were piled up on the floor.

The last images of Degas, photographs or images in Sacha Guitry's documentary film *Ceux de chez nous* (1915), show a Degas who has physically deteriorated. "I look like a dog," he used to say in the last years of his life.

Deserted by his elderly housekeeper, Zoé Closier who returned to her home town and died shortly afterward, his niece Jeanne Fèvre traveled from Argentina to take care of him in the final months of his life.

Degas died on September 17, 1917, at the age of eighty-three, while Europe was still in the throes of World War I. At his request, the funeral was only attended by his closest friends – Claude Monet, Mary Cassatt, Henry Lerolle, Léon Bonnat, Jean-Marius Rafaelli, Louis Rouart, Josep (sic) Maria Sert, Paul Durand-Ruel, Ambroise Vollard, and Jean-Louis Forain, who reproached Paul-Albert Bartholomé for inviting a representative of President Poincaré: "If Degas had known!"

1834-1854

1834

— Hilaire-Germain-Edgar Degas is born at 8, rue Saint-Georges, in Paris, on July 19. His father, Pierre-Auguste-Hyacinthe de Gas – born in Naples into a family of Breton aristocrats who had fled to Italy to escape the French Revolution – runs the Paris branch of the family bank. His mother, Célestine Musson de Gas, the daughter of a Creole from Porto Prince, was born in New Orleans.

1838

— Degas's brother Achille is born in Paris, on November 16.

1840

— Thérèse Degas is born in Naples, on April 8.

1842

— Marguerite Degas is born in Passy, on the outskirts of Paris, on July 2.

1845

— On October 5, Degas starts to attend the Lycée Louis-le-Grand, in the Rue Saint-Jacques, in Paris, where he meets Henri Rouart and Paul Valpinçon. They remain friends for the rest of their lives.

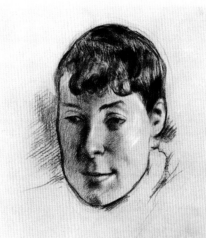

Marguerite Degas, pencil drawing,
Louvre Museum, Paris.

— His father takes him to the Louvre Museum and introduces him to such collector friends as Dr. Lacaze and Eudoxe Marcille, and artists, including the Romanian landscape painter Prince Grégoire Soutzo who would introduce him to the technique of etching.

— The youngest of the five De Gas children, René, is born in Paris, on May 6.

1847

— On September 5, Degas's mother dies at 26, rue Madame, in Paris. The family has been living on the Rive Gauche for only a few months.

1852

— The family is living at 4, rue Mondovi, in Paris, where Degas sets up a studio on the upper floor.

— After a turbulent period of social unrest, Louis Napoleon declares himself emperor as Napoleon III.

1853

— Degas finishes his studies at the Lycée Louis-le-Grand and passes the "baccalauréat".

— At his father's request, he enrolls to study law.

— He intersperses his university studies with painting lessons at the studio of Félix Barrias, where he produces his first work – a portrait of his maternal grandfather, Germain Musson.

— Degas is registered in the Cabinet des Estampes at the Bibliothèque Nationale, whose conservator, Achille Devéria, is a friend of his father's. Here, as well as copying works by Dürer, Goya, Mantegna, and Rembrandt, he learns different etching and engraving techniques.

— He abandons his law degree to devote himself to painting, which leads to a temporary distancing in his relationship with his father. He leaves the family home and moves into a garret. After a few months, his father acknowledges his son's dedication and asks him to return home.

1854

— Disappointed with Barrias' teaching, and on the advice of Jean-Auguste-Dominique Ingres, Degas studies at the studios of Louis Lamothe, one of Ingres's best pupils, and Auguste Flandrin.

1855-1859

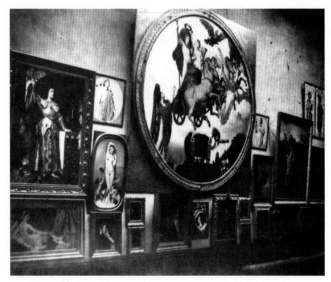

Photograph of the Ingres room at the 1855 World's Fair, Paris.

Confirmation of the Rule, fresco by Giotto, Upper Church, San Francesco, Assisi. Degas was so impressed by these paintings that he did not even take notes, saying that it would be impossible to forget them.

1855

━ Degas is accepted to study painting and sculpture at the École des Beaux-Arts, in Paris, France's most prestigious establishment for the teaching of academic art. Here he meets artists such as Joseph-Gabriel Tourny, Léon Bonnat, Elie Delonay, Ricard, Henri-Théodore Fantin-Latour, and Alphonse Legros, but tires of the academic style of painting and decides to embark upon his career and become a self-taught artist. This rejection of the artistic establishment means that he will never be able to win the Prix de Rome (which awards scholarships for several years' study at the Villa Medici in Rome) or receive the subsequent official and possibly even important private commissions.

━ At the World's Fair in Paris there is a retrospective exhibition devoted to the work of Jean-Auguste-Dominique Ingres

━ Degas meets Ingres through Édouard Valpinçon. Ingres advises him to: "Draw lines, a great many lines, from nature and from memory, and you will become a great artist."

━ He often attends the Paris Opera House, where his favorite performer is Adelaide Ristori, known as Ristori.

━ In summer, he takes the opportunity to visit the museums of southern France.

1856

━ Degas travels to Rome, where he devotes himself unstintingly to copying ancient works. Following an outbreak of malaria, he decides to spend some time with his family. He visits Naples, where he stays with his grandfather René-Hilaire de Gas and copies works of art in the Museo Nazionale, and then Florence, where he stays with the Bellelli family and starts work on their portrait.

━ He returns to Rome on October 7 and begins to copy classical works and practice the art of etching. He paints the portrait of painter and engraver Joseph-Gabriel Tourny.

━ In Florence, Prince Demidoff opens his rich art collection to the public. It features, among others, works by Camille Corot, Eugène Delacroix, and Jean-Auguste-Dominique Ingres.

Edgar Degas, pencil drawing by Gustave Moreau, 1857–59, Musée Gustave Moreau, Paris. Although their careers later followed different paths and the two artists grew apart, during the time they spent together in Italy, Moreau played an important role in Degas's artistic production, introducing him to the works of Eugène Delacroix and showing him the technique of pastel.

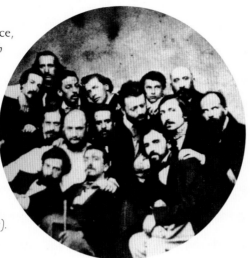

Group of artists in Florence, *c. 1856. The photograph includes a number of the painters known as the Macchiaioli, who frequented the Caffè Michelangelo – for example, Odoardo Borrani (third from the left on the top row), Telemaco Signorini (next to Borrani), and Vito d'Ancona (to Borrani's left, on the row in front).*

Marguerite Degas, *1858–60, oil on canvas, 80 × 54 cm, Musée d'Orsay, Paris. Born in 1843, Marguerite was ten years younger than her brother Edgar. The artist completed a number of oil paintings, etchings, sketches and studies of his sister, to whom he felt very close in later life. In 1891, he admitted to the artist Evariste de Valernes: "I don't write because writing tires me and, apart from short, terse notes, my sister Marguerite is the only person who receives letters from me from time to time."*

1857

— Degas returns to Paris and then travels to Florence.

— During a lengthy stay in Rome, he frequents the Caffè Greco and meets his friends Léon Bonnat and Robert Delaunay, the composer Georges Bizet, the sculptors Dubois and Chapu, Clère and Joseph-Gabriel Tourny, Émile Lévy, Aristides Maillol, Félix Henri Giacomotti, Edmond About, Clésinger, Aulanier, and especially Gustave Moreau, who form the group of French painters known as the "del cald'arrosti". He also attends the Villa Medici where he practices painting nudes. He continues to copy works of art in the city's churches and the Vatican museums.

— His grandfather asks him to return to Naples, where Degas paints him in two portraits and several preparatory works.

1858

— Degas spends the winter in Paris.

— His engraver friend Félix Bracquemond shows him some Utamaro prints and kindles Degas's interest in Oriental art.

— Once again, he passes the spring in Rome, at 18, via Sant'Isidoro. He meets up with Gustave Moreau, who is also living in the city.

— On July 4, he travels to Florence and visits the towns of Viterbo, Orvieto, Perugia, Arezzo, Città della Pieve, and Assisi.

— In August, he returns to Florence with his uncle, Baron Gennaro Bellelli, and frequents the Caffè where he meets up with his friend Gustave Moreau and the group of Italian painters known as the Macchiaioli, who reacted against the formality of academic art with bold "pools" of color known as macchia (stain or spot). He makes studies for a portrait of the Bellelli family, copies works by Veronese and Giorgione, and reads Pascal's *Lettres Provinciales*.

— His grandfather Hilaire de Gas dies in Naples on August 31.

1859

— Degas visits Sienna and Pisa with Gustave Moreau and copies works by Benozzo Gozzoli del Camposanto.

— On his way back to Paris in March, he passes through Genoa where he admires the works of Van Dyck in the Palazzo Rosso.

— In April, he settles in Paris after repeated requests by his father, who is beginning to realize just how talented his son is and writes to him advising him on his career.

— Degas takes a studio in the Rue Madame, where he begins a series of paintings on historical themes strongly influenced by the classical works copied during his visits to Italy. He then moves to a studio on an upper floor of 13, rue Laval.

Degas in the Uffizzi Gallery, *drawing by Gustave Moreau, 1859, 15.3 × 9.4 cm, Musée Gustave Moreau, Paris. Degas liked Moreau's eclectic style and his admiration for the Italian Renaissance.*

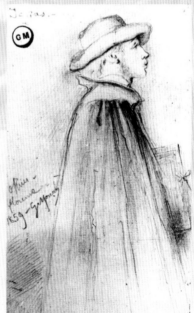

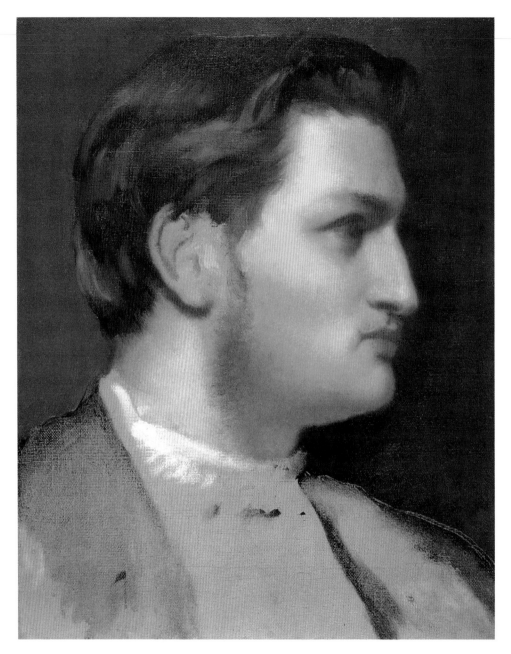

Paul Valpinçon (d. 1894)
c. 1855, oil on canvas, 40 × 32 cm
Minneapolis Institute of Arts, Minneapolis

Degas was thirteen when his mother died, and her death left him even more melancholy than before. His father, alarmed by the prospect of raising five children, enrolled his eldest son at the Lycée Louis-le-Grand, where he would take school lunches. Degas proved to be a conscientious pupil who showed a particular aptitude for Latin, Greek, History, and Art. It was here that he met the boys who became his lifelong friends – Henri Rouart, Louis Bréguet, and Paul Valpinçon. Paul's father, Édouard, was a collector and extremely knowledgeable about art. He was also a friend of Auguste de Gas, the artist's father, and the owner of the so-called *Bather of Valpinçon,* by Jean-Auguste-Dominique Ingres, which is why the painting bore his name.

It was Édouard Valpinçon who passed on Ingres's advice that Degas should study with Louis Lamothe, (see page 6). Degas was extremely close to the Valpinçon family and, from 1861, spent each summer at their chateau at Ménil-Hubert, in Normandy. Here he would work with Paul, who was also an enthusiastic painter. The Valpinçons even had a summerhouse erected in the garden so that the two friends could work in peace, without being disturbed by the younger children's games.

In this portrait, Ingres's technique – which typified the early years of Degas's artistic production – is very much in evidence. The painting is extremely polished and rigorously executed, and invests the subject with a sense of majesty. It conveys to the observer that the artist regarded his friend as "the good burgher of the Orne" or "the stout Valpinçon," through the forms used to convey his robust constitution.

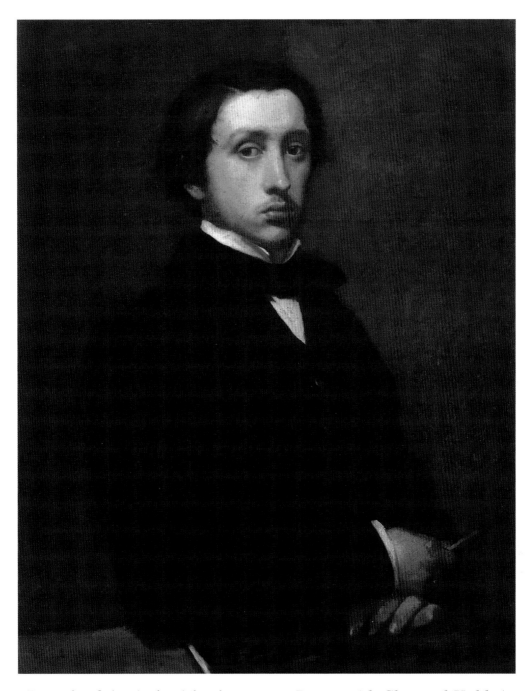

Portrait of the Artist (also known *as Degas with Charcoal Holder*)
1855, oil on canvas, 81 × 64 cm
Musée d'Orsay, Paris

In this self-portrait, the artist is depicted as a very young man who, even though he exudes a certain shyness and lack of confidence, looks directly at the observer, setting his lips, as if wanting to reveal a secret.

Perhaps this portrayal is rooted in the fact that, although Degas apparently presents himself in a pose typical of academic portraits, he has added two key elements – the charcoal holder in his right hand and the sketch folder with its protruding page, beneath his right arm. The artist had already decided to sacrifice the concerns of the family business to give free rein to his artistic career.

In spite of the fact that he looks like a young bourgeois, at the age of twenty-one Degas was struggling with indecision and misgivings, without losing an ounce of ambition, a trait that would characterize his entire career. At the time, he was studying at the École des Beaux-Arts and with his master Louis Lamothe, a former pupil of Hippolyte Flandrin, who in turn had studied with Jean-Auguste-Dominique Ingres. This was the year of the World's Fair, in Paris, where an entire room was devoted to Ingres's work. The young painter copied these works, attracted by the artist's highly polished style and rigor of execution. In fact, so interested was he in Ingres's work that, through Édouard Valpinçon, he was even introduced to the great master, who advised him to "draw lines, young man." Ingres believed that the touch of the pencil on the paper should be as light as a fly walking on a pane of glass.

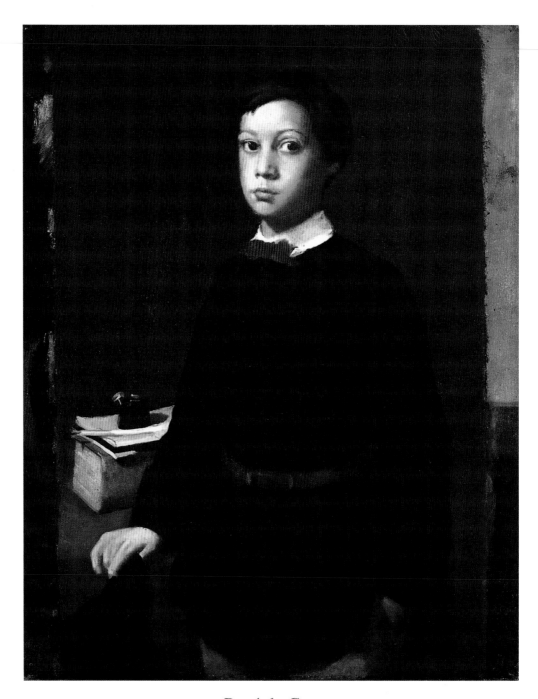

René de Gas
1855, oil on canvas, 92 × 73 cm
Smith College Museum of Art, Northampton, Massachusetts

In the mid- to late 1850s, Degas copied the works of such artists as Eugène Delacroix, Hans Holbein, Leonardo da Vinci, Michelangelo, Rafael, and Veronese, and drew inspiration for his portraits from others – in this instance from the Floretine painter Bronzino.

As well as copying images, Degas also scrupulously noted down his observations, which has been extremely helpful in revealing what he liked about each composition and how he applied it subsequently to his own works.

Here he uses the chiaroscuro of Ingres and the relaxed pose of Bronzino in his portrait of the youngest of the De Gas children. The artist always felt very close to all his brothers and sisters.

He praised René highly during his visit to New Orleans, during which he acted as interpreter, since Degas didn't speak English. At the time, René was married to his cousin, Estelle Musson, whom Degas greatly admired and of whom he was extremely fond. When René divorced her shortly afterwards, the artist was so annoyed that he didn't speak to his brother for almost twenty years. However, he was reconciled with René before his death and named him as his sole heir, since he was the only one of his brothers and sisters still alive. René was in fact responsible for compiling the first catalog of the contents of Degas's studio, identifying certain works, describing them and even discarding them, as in the case of some of the more erotic watercolors.

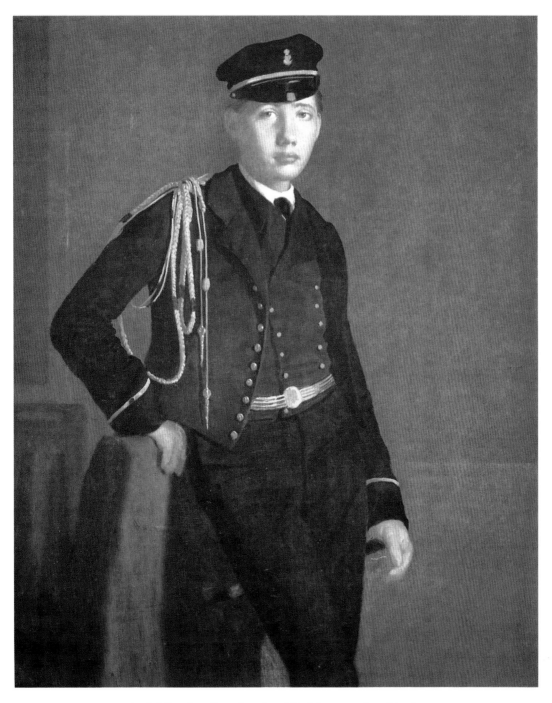

Achille de Gas in the Uniform of a Cadet
1856, oil on canvas, 64.5 × 46.2 cm
National Gallery of Art, Washington D.C.

Achille was the second eldest of the Degas children and four years the artist's junior. Born in 1838, he led an eventful life and died at the age of fifty-six, in 1894. He was a mediocre student who had enlisted in the Navy and, after being arrested for insubordination at the École Navale, was finally made a sub-lieutenant in 1862. Two years later, he left the service but re-enlisted when the Franco-Prussian War broke out in 1870.

The forage cap suggests that the portrait was painted when he graduated from naval college or after boarding his ship, most probably in 1856, before Degas left for Italy. It clearly shows the closeness between the two brothers and reflects the social milieu to which they belonged.

Boys in uniform were a recurrent theme at the time and one that was brilliantly executed by such artists as Thédore Chassériau and Jean-Baptiste-Camille Corot, whose works Degas appears to have had in mind when painting his brother. The portrait also echoes the extreme lightness of touch with which Ingres shaped and molded his subjects' faces.

Degas set the gold of the buttons and braid against the black uniform, at the same time using them to accent Achille's upper body. The reddish background serves to highlight his brother's stylized figure, while the features are softened by the use of the same tone to deepen the shading of the face.

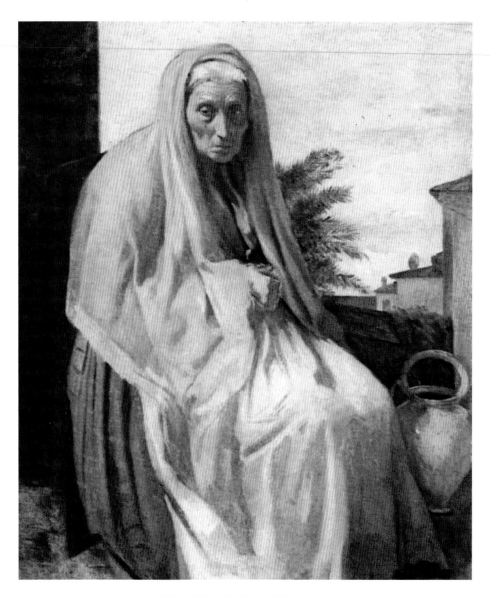

The Old Italian Woman
1857, oil on canvas, 76 × 61 cm
Metropolitan Museum of Art, New York

As soon as Degas began to visit Italy (he first went in 1857–59 and stayed for eighteen months), he started to develop his own individual style and, within it, his own language, based on communication through the structure of forms, in the most objective manner possible.

Although he had abandoned his studies at the École des Beaux-Arts, in Paris, which meant he was unable to study at the Villa Medici, in Rome, this establishment held an "open house" on Sunday afternoons. Here, Degas exchanged views with the French painters studying at the academy and also with its director, artist Jean-Victor Schnetz.

A pupil of Jacques-Louis David and friend of Théodore Géricault, Schnetz had a concept of art and artists that belied his small stature. He wanted his students to look beyond the Renaissance masters and value the work of 13th- and 14th-century painters. He also promoted the art of the gypsies, musicians, and beggars who populated the streets of Rome in the mid-19th century. This must have influenced Degas since he produced two oil paintings and a drawing on this theme.

However, some scholars think the figure of *The Old Italian Woman* reflects the study and influence of other works, including several by Giacomo Ceruti. The painting also relates to the tradition of Diego de Velázquez and Caravaggio, and is similar to works by other artists studying in Rome at the time, for example Léon Bonnat and Robert Delaunay. Later, Édouard Manet produced paintings such as *The Beggar* (Art Institute of Chicago), in which he took account of this influence. Even Pablo Picasso took up the baton in his Blue and Pink periods.

The fact that Degas chose a pyramidal form for the woman, who looks at the observer from the foreground, makes this the more monumental of his two canvases on the theme of old women. In the background, several beautiful villas – the symbol of the immutable splendor of another age, with all the charm of bygone days – provide a striking contrast to the failing faculties of the people who inhabited them, represented by this old woman.

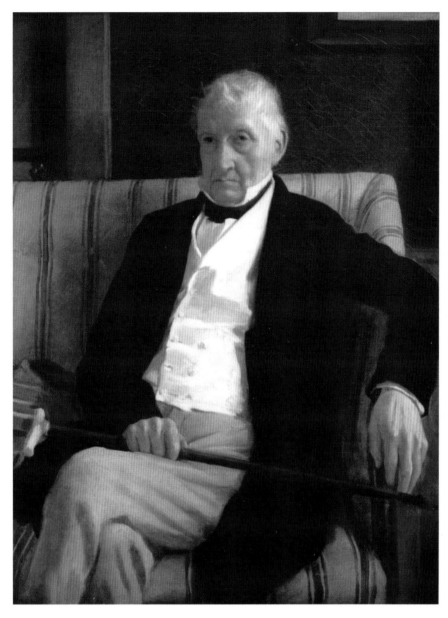

Hilaire de Gas, Grandfather of the Artist
1857, oil on canvas, 53 × 41 cm
Musée d'Orsay, Paris

The life led by Degas's paternal grandfather was worthy of a novel. As a young man, he fled the French Revolution and sought refuge in Naples, where he founded a bank and amassed a healthy fortune. In 1804, he married Jeanne Aurore Freppa, with whom he was extremely happy and who bore him ten children. The eldest was Auguste, father of Edgar Degas, whom Hilaire sent to run the Paris branch of the family bank. He also ensured that his daughters would enjoy the continuity of a good financial and social position by marrying them to Italian noblemen – Laura to Baron Gennaro Bellelli, Rosa to the Duke of Morbilli, and Fany to the Marquis of Cicereale, Duke of Montepasi. This meant that when Degas was in Naples, he stayed in the most aristocratic residences.

Hilaire de Gas was a highly respected and much-revered figure in this large family. Degas spent the summers of 1856 and 1857 with him, in his house in Naples and his San Rocco villa on the hill of Capodimonte, and sealed the bonds of deep affection by completing several portraits of the old man – a dry-point etching in 1857 and two oils, of which this is one.

Some scholars have regarded this portrait as the development of the etching, although here the subject's gaze is much lower. The portrait reflects Degas's admiration and affection for his grandfather, who died the following summer. In this respect, the poet, essayist, and critic, Paul Valéry said: "For Degas, a work was the result of an indefinite series of studies, then a series of operations."

The composition is based around the grid pattern formed by the horizontal lines of the back and seat of the sofa and the vertical lines of the background. However, the vertical stripes of the upholstery and the figure of the grandfather, with his right hand holding the diagonally placed cane, not only create a break in the geometrical composition but also reflect a certain freedom in the subject's pose, which is more dynamic.

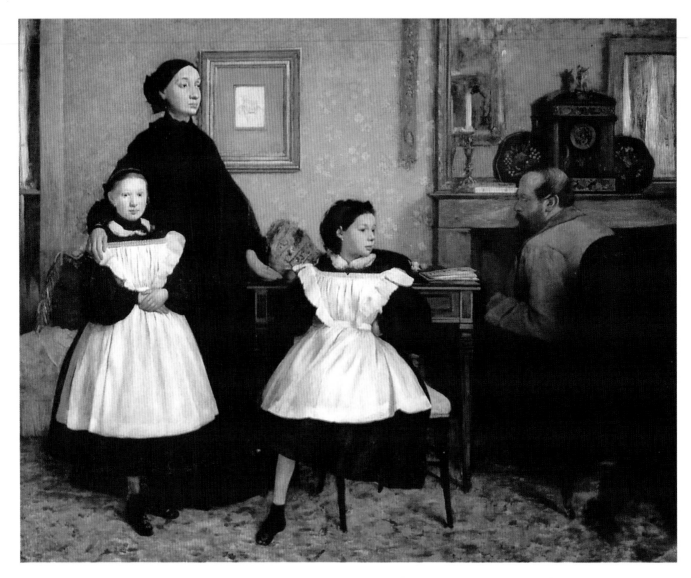

The Bellelli Family
1858–1867, oil on canvas, 200 × 250 cm
Musée d'Orsay, Paris

Degas stayed with the Bellelli family during his first visit to Florence in 1858. Baron Gennaro Bellelli had married Degas's aunt, Laura, and they pose for this portrait with their two daughters, Giovanna on the left, and Giulia, in the center.

Laura is pregnant and dressed in mourning for the recent death of her father, Hilaire, Degas's grandfather, who appears in the red-chalk portrait behind her. The portrait, a copy of an earlier drawing by the artist, is lavishly framed to highlight the family's social status. Laura poses proudly, avoiding her husband's gaze. She married Gennaro Bellelli, a lawyer and liberal journalist, in 1842, at the age of twenty-eight. Theirs was probably a marriage of convenience since, at the time, Laura was in love with someone else. In the year this portrait was painted, their marriage was already in crisis. Laura claimed that her husband had an "execrable character" and in one of the letters she wrote to her nephew she said: "Am I not right to always see the gloomy side of things?"

Giovanna, born in 1849, was a shy child, a trait that Degas highlights by portraying her with her hands crossed at her waist. She is also the only person in the group looking at the observer, which she does fixedly. By contrast, Giulia, who was two years younger than her sister, was much more outgoing. The artist shows her sitting confidently, with her hands on her hips, placed near her mother but her gaze turned distractedly toward her father. This has the effect of widening the space between the two extremes, mother and father, who express a certain tension. Bellelli is painted from behind, with a preoccupied expression, aware of his minor role within the family.

Generally speaking, the way in which the figures are drawn, especially the two girls, reflects the influence of Ingres. Giovanna's pose also reflects Ingres's influence, while the other figures are portrayed in unusual poses that give the work a feeling of spontaneity.

The strength and rigor of the scene are the direct influence of Italian Renaissance art since, at the time, the artist was studying the paintings and frescoes of local churches and museums.

1860-1864

1860

- During the first half of the 1860s, Degas paints historical and biblical themes.

- He copies works by Eugène Delacroix, which complete his technical training, until now based on the principles of Jean-Auguste-Dominique Ingres.

- In March, he travels to Naples where he meets up with his sisters, Thérèse and Marguerite. He goes on to Florence via Leghorn (Livorno) and returns to Paris a month later.

1861

- Degas enrolls as a copyist at the Louvre Museum.

- During the three weeks spent with Paul Valpinçon at Ménil-Hubert (Orne), in Normandy, he discovers a fascination with horse racing.

- His father becomes impatient: "Our Raphael is always working, but he has still not completed anything, and meanwhile the years are slipping by."

- Degas begins a series devoted to historical painting, with a marked preference for biblical, classical, and medieval events, but adopts a different viewpoint from the academic painters of the time.

- The opera *Tannhäuser*, by the German composer Richard Wagner, is performed in Paris for the first time.

1862

- At the Louvre, he meets Édouard Manet with whom he strikes up a long-lasting friendship and is introduced to Manet's circle of friends.

- He meets the critic Louis-Edmond Duranty, who will help him by becoming his greatest theorist.

- Madame Soye opens "La Porte Chinoise" on the Rue de Rivoli, a store selling Oriental objets d'art that is frequented by many artists.

Giovanni Fattori's *Battle of Magenta* is exhibited in Florence for the first time, gaining the first public recognition for the Macchiaioli movement.

Edgar Degas, c. 1862.

1863

- The "Salon des Refusés," an exhibition for painters who had been rejected by the official Salon, is held for the first time. The exhibition,

Degas and Evariste de Valernes, *1864–65, oil on canvas, 116 × 89 cm, Musée d'Orsay, Paris. Valernes was fourteen years older than Degas and had worked in Delacroix's studio. The two artists met when they were both copying paintings in the Louvre. Under Degas's influence, Valernes replaced his Romanticism with a more Realist style, painting contemporary scenes and even a study of Degas's ballerinas. As well as this portrait of them together, Degas also painted a portrait of Valernes seated. In spite of being of noble birth and having inherited a vast fortune in land and property, Valernes died penniless. In his last years, Degas helped him financially and, in 1894, paid 3,000 francs to buy back the portrait of Evariste de Valernes Seated, which he had previously presented to the artist.*

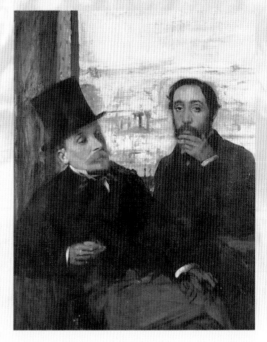

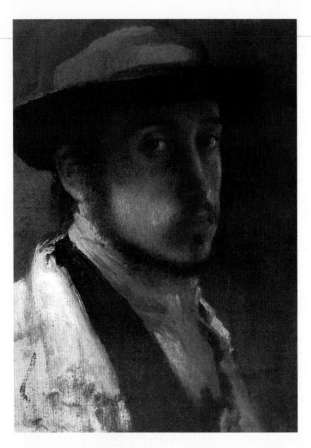

Self-Portrait, *1863, oil on cardboard, mounted on canvas, 26 × 19 cm, Clark Art Institute, Williamstown, Massachusetts.*

which includes works by such artists as Édouard Manet, Camille Pissarro, Johan Barthold Jongkind, Jean-Baptiste-Armand Guillaumin, James Abbott McNeill Whistler, and Henri-Théodore Fantin-Latour, causes a great stir, in particular Manet's *Déjeuner sur l'Herbe*. Degas reproaches him for his opportunist mentality and his desire to triumph "à la Garibaldi."

■ Degas's aunt, Odile Musson, and cousins, Estelle and Désirée return from New Orleans to escape the American Civil War. Their accounts inspired *War Scene in the Middle Ages* (also known as *The Sufferings of the City of New Orleans*) (1865), as well as arousing Degas's interest in the United States, which he visited a few years later.

■ Eugène Delacroix dies on August 13. He has greatly influenced a number of painters, including Paul Cézanne, both technically and thematically. Together with Ingres, Degas will regard him as one of his two great masters. It seems that their paths crossed, but they never spoke.

■ The "unofficial" artists of the day – including Frédéric Bazille, Paul Cézanne, Claude Monet, Pierre-Auguste Renoir, and Alfred Sisley – begin to meet at the Café Guérbois, at 11, grande-rue des Batignolles (now 9, avenue Clichy).

1864

■ Émile Zola writes an open letter, *L'ecran* (The screen), which is regarded as his artistic manifesto. In it, he states: "Every work of art is like a window opened upon creation. The space of the window encloses a sort of transparent screen through which objects are perceived, distorted to a greater or lesser degree, and subjected to more or less perceptible changes in their lines and color. These changes depend on the nature of the screen. It is not a real and exact creation, but a creation modified by the medium through which the image passes."

■ A retrospective exhibition devoted to the work of Honoré-Victorin Daumier is held in Paris. Daumier will greatly influence Degas's drawings of popular figures.

Gustave Moreau (c. *1860), oil on canvas, 40 × 27 cm, Musée Gustave Moreau, Paris. Degas wrote to Moreau: "I had your courage; when it fails me, I break up a little, as in the past" (September 21, 1858).*

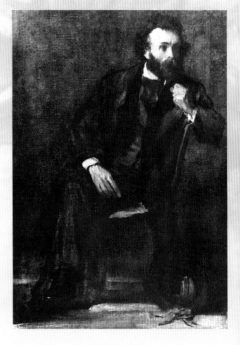

Study of a horse *(1861), page 68 of sketch book 13, Bibliothèque Nationale, Paris.*

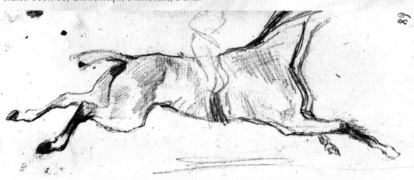

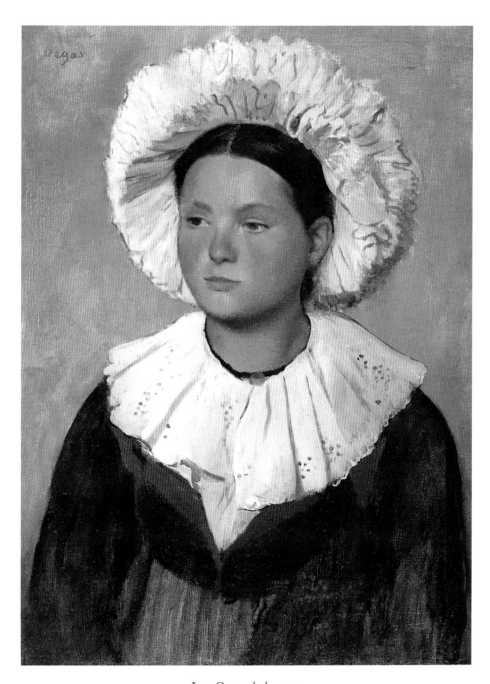

La Savoisienne

c. 1860, oil on canvas, 61 × 46 cm

Rhode Island School of Design Museum of Art, Providence, Rhode Island

The identity of the girl in the portrait is not known. Some scholars believe that Degas may have returned from Italy via Savoy in 1859, in which case he could have made a few notes on the region which was annexed to France in 1860 by the Treaty of Turin. It is a well-known fact that, when setting out or returning from a journey, the artist would often make a detour to see something that caught his attention.

Other critics think it more likely that the artist painted the girl in Paris, and that she belonged to one of the groups from Savoy who had settled in the capital and continued to maintain their customs and traditional way of dress.

The fact is that Degas painted the portrait shortly after his return from Italy and that, unlike his earlier portraits, it is no longer influenced by Ingres but by the Italian painters he had studied while in Florence, Rome, and Naples. Thus, the girl is painted in a style that reflects the influence of classical art; a style that would be echoed by the Postimpressionist painters and characterizes the faces in the works of Henri Matisse and Paul Gauguin. Its influence can be seen in Gauguin's *Four Breton Women Gossiping* (1886), in which the white elements of the women's costumes are also strongly emphasized.

The lines of the *La Savoisienne* are softly executed and, in spite of the contrasting colors – white, black, gray and ocher – and the girl's tanned skin, the work conveys an overall impression of serenity that has been achieved through the softly rounded forms. The portrait reflects Degas's idealized image of the working classes, and working-class women in particular.

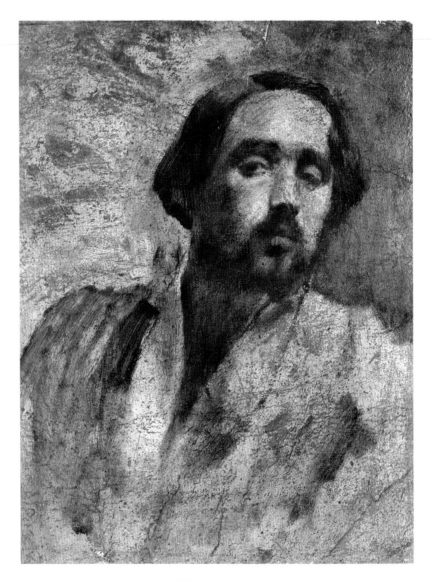

Self-Portrait Wearing an Artist's Shirt
1860–1862, oil on cardboard, mounted on wood, 54 × 41 cm
Museum of Mohamed Mahmoud Khalil and His Wife, Giza

This self-portrait is striking in that, unlike Degas's earlier portraits, it does not reflect the influence of Ingres but of Delacroix, which gives it the Romantic air of a confident painter who knows what he wants. This may partly be due to the technique of oil on cardboard, which allowed Degas to experiment with freer, rapid strokes applied with greater ease of movement, since the surface is smoother than canvas.

Degas's early career as a painter owed much to the influence of Ingres and his technical advice. In fact, he had decided to become a painter five years before producing this work, when he met the great master. He loved to tell the story of this meeting. Degas was visiting Paul Valpinçon when the latter's father, Édouard, called to greet him: "'Yesterday I saw your god,' he told me. 'Yes, Monsieur Ingres came to ask me to lend him his odalisque (later known as *The Bather of Valpinçon*) to exhibit in the room devoted to his work [a reference to the retrospective exhibition held in Paris on the occasion of the 1855 World's Fair]. But I gave him to understand that I wasn't prepared to run any risks with my painting, and I refused.' This selfishness irritated me and I told Valpinçon senior that you don't offend a man like Monsieur Ingres in this way. 'Very well,' he said, 'Tomorrow, I will tell Monsieur Ingres that I have changed my mind. Call for me and we will go to his house together.'

The next day, I arrived at the appointed time.... We spoke for a few moments and then left. I don't know how it happened but, as he was seeing us out, the great man slipped on the floor and, crash!, tall as he was, fell to the ground. I rushed over to him; he had blood on his head and did not utter a word. He had lost consciousness and was just coming round." This anecdote is what Degas referred to as his "baptism of fire", since it was he who washed the blood from the great man's injuries.

The next day, Degas called at Ingres's house to see how he was. The master thanked the young artist for his help and the latter ventured: "Sir, allow me to take advantage of this opportunity which will perhaps never present itself again, but I would like to become a painter. Art is driving me insane!" Ingres replied, "Draw lines, young man, a great many lines, from nature and from memory…"

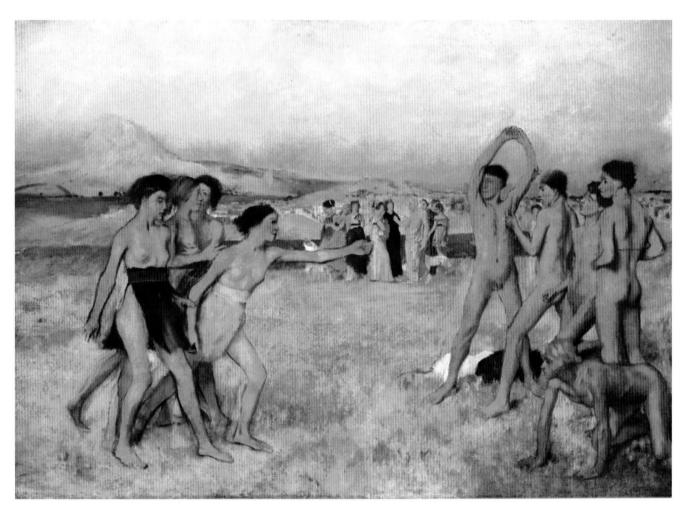

Young Spartans Exercising
1860–1880, oil on canvas, 109 × 155 cm
National Gallery, London

Between 1859 and 1865, Degas painted some major works on historical themes. He had just returned to Paris after an eighteen-month stay in Italy where he was influenced by the great classical paintings to which his first masters, Louis Lamothe and Félix Barrias had subscribed.

This painting is noticeably reminiscent of Jacques-Louis David's *Death of Bara* which Degas had copied in the Musée Calvet, in Avignon, several years earlier, while the influence of classical Greek art is also very much in evidence. His niece, Jeanne Fèvre, daughter of Marguerite Degas, said that "Degas had a very vivid, very intense and very intelligent sense of Ancient Greece."

Years later, Degas told Daniel Halévy that his *Young Spartans Exercising* had been primarily inspired by Plutarch's accounts, although as a student at the Lycée Louis-le-Grand, he would have read the Abbé Barthélemy's [Jean-Jacques Barthélemy, known as the Abbé] *Le Voyage du Jeune Anarchasis en Grèce* (1787), which was studied enthusiastically in most traditional French schools at the time. In it, Barthélemy writes: "Spartan girls are not educated like their Athenian counterparts. They are not kept at home spinning wool, nor are they forbidden to drink wine or eat their fill. On the contrary, they are taught to sing, dance, and fight, run in the arena, throw a javelin, and pitch quoits, bare to the waist and without a veil, in the presence of their masters, citizens, and even boys, whom they encourage to perform glorious deeds, either by their own example or with gentle words of praise."

The colors of this painting are austere, and the same tones are used for the background as for the figures. They are applied in large areas of color, as in the frescoes of the Italian Renaissance.

The young men adopt static poses, clearly inspired by neoclassical art, as if they were part of a bas-relief. Their naked bodies are portrayed with great naturalness and idealism since, to depict them, Degas drew his inspiration from the young men he saw in the Pigalle district of Paris. The very realistic characterization of these figures has been created by the individualization of their faces, each with a different expression, abandoning the facial prototype that appeared in the images of the First Empire.

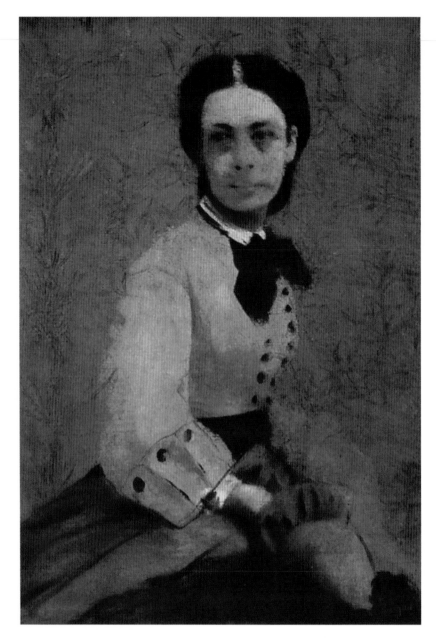

Princess Pauline de Metternich
c. 1861, oil on canvas, 41 × 29 cm
National Gallery, London

Unlike the anonymous subjects of Degas's genre paintings (laundresses, ballerinas, women washing or drying themselves, or combing their hair), in his portraits, it is extremely rare to find a model who doesn't reflect their innermost feelings. This is due to the fact that the artist had to know his subject well in order to give visible form to the predominant traits of his or her character.

The portrait was one of Degas's favorite genres. He began by using his four brothers and sisters as models, and gradually extended his range to include his Italian family, in 1857, and then his mother's American relatives, during his stay in New Orleans, in 1872.

In the interim between these two groups of portraits, others appeared which, although they were not of people with whom he was on intimate terms, the subjects did belong to his circle of friends and acquaintances. Given that Degas frequented the social and artistic elite of Paris, it should come as no surprise that, to start with, most of his models belonged to this milieu, as in the case of this portrait.

Princess Pauline de Metternich was the wife of the Austro-Hungarian ambassador at the court of Napoleon III. Here she is portrayed wearing a crinoline, against a wallpaper background invented by Degas, since it did not feature in the original photograph from which the portrait was painted. In a similar vein the Prince, who did feature in the photograph, was excluded from the composition by the artist.

Because this was one of the first occasions on which he used a photograph to paint a portrait, Degas wanted to emphasize the fact that the original image was in black and white. He therefore barely used any color in the oil, with only the ocher tones of the background and jacket adding a little light to the princess's face that, incidentally, remained unfinished.

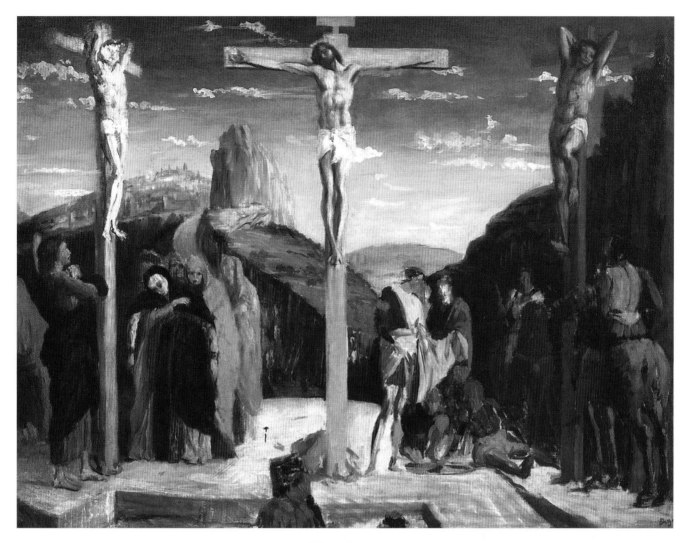

The Cross
(copy of *The Crucifixion* by Andrea Mantegna)
1861, oil on canvas, 69 × 93
Musée des Beaux-Arts, Tours

When Napoleon III successfully completed his Italian campaign, he requisitioned Andrea Mantegna's *The Crucifixion,* which formed the central panel of the altarpiece in the Church of San Zeno, in Verona, and had it taken to Paris. This is where Degas saw it before he traveled to Italy. It seemed to him that Mantegna was one of the grand masters to be emulated. At the time, he was beginning his artistic training and practiced copying different fragments of *The Crucifixion.* According to Degas: "The frame of a painting by Mantegna contains the world, whereas modern artists are only able to represent a corner of it, a mere moment, a fragment."

In the space of ten years, Degas copied dozens of canvases which, as well as Mantegna's *Crucifixion* and *The Triumph of Virtue* (both in the Louvre Museum in Paris), also included *The Rape of the Sabine Women* by Nicolas Poussin, and Hans Holbein's portrait of *Anne of Cleves* to which end the artist visited museums on a daily basis. Among the surviving studies of the figures from *The Crucifixion,* is the drawing of the beggar on the right of the composition.

Degas studied this work in depth in the galleries of the Louvre but, unlike most of the paintings he copied, he did not attempt to make an exact copy of Mantegna's original. His aim was to create the same sense of spirituality over and above the strong linear quality of *The Crucifixion,* enriching it with colors reminiscent of the palette of Venetian painters, especially Giovanni Bellini.

Unfortunately, the work was never finished which meant that Degas's intention was never fully achieved, although there is no doubt that his aim was to reinterpret the work of the Italian master.

This subtlety was lost on Degas's contemporaries and, when he died, the painting was put up for auction in the first sale of the contents of the artist's studio. In an article published in *Le Cri de Paris,* a critic described Degas's copy of Mantegna's *Crucifixion* as having "an imperfect touch, a tonality that was perhaps sharper than the original, but which is like the signature of the copyist."

Lieutenant de Sermet
1862, oil on canvas, 41 × 27
Museum of Mohamed Mahmoud Khalil and His Wife, Giza

Jean-Paul de Cabanel, Baron de Sermet, was born in Paris in 1837 and subsequently pursued a brilliant military career, rising rapidly to the rank of major-general and being decorated in France and abroad. After this portrait was painted, he was wounded in the Franco-Prussian War of 1870, taken prisoner in Germany, and again wounded in action.

This officer enjoyed an excellent reputation, not only in military circles, but also among Parisian high society, which is perhaps why Degas invested this portrait with a similar quality to those painted a few years earlier, under the influence of Ingres. The artist portrayed his subject's features in accordance with the documents of the time – brown hair, blue eyes, a straight nose, and an oval face – while creating the overall impression that he was "small but elegant," as he was described in military documents.

Degas portrayed him with the brave and determined character that the officer certainly possessed. In one of his notebooks, Degas wrote about portraits: "If a person is characterized by their laugh, then make them laugh... There are so many subtle nuances to represent!"

Degas and De Sermet probably met at the racetrack, when the artist began to take an interest in the sport and went to the races in Paris and Normandy. De Sermet was an accomplished equestrian and, according to information contained in a general survey, in 1862 reached the highest grade in this discipline.

There was certainly a mutual admiration between the officer and the artist, and they would have got on well since both were strong personalities. Degas admired and subscribed to the fact that people should receive decorations, but thought that the artists who received them were generally undeserving. It seemed to him that they were given to anybody.

However, in this portrait, Degas is not portraying the officer or his decorations, or even the social status enjoyed by the lieutenant – he is portraying the man.

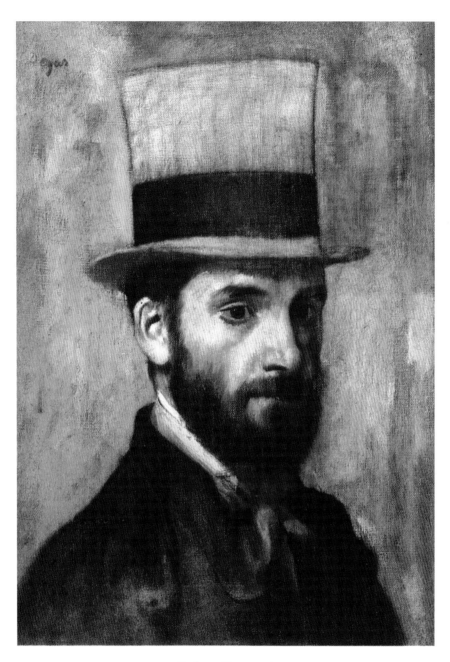

Léon Bonnat
c. 1863, oil on canvas, 43 × 36 cm
Musée Bonnat, Bayonne

Léon Bonnat was one of the best portrait artists of his time, painting portraits in which his subjects posed in an almost hieratic manner, creating an idealized representation of them, but with great realistic precision. For this reason, he became the official portraitist of the most important political figures of the day.

Bonnat and Degas must have met at the École des Beaux-Arts, in Paris, in 1855, and again in Rome, in 1857, when frequenting the Caffè Greco with the group of French artists know as the "del cald'arrosti", which also included painters studying at the Villa Medici – Elie Delonay, Henri-Théodore Fantin-Latour, and Gustave Moreau. Degas's friendship with composer Georges Bizet also dates from this period, a friendship that was later transferred to Bizet's widow, whom he used as a model in some of his paintings on the theme of milliners. Degas's involvement with the "del cald'arrosti" certainly helped him to weather the criticism leveled at him when he decided to distance himself from the Impressionists.

In spite of the personal admiration Degas and Bonnat felt in principle for one another, they both pursued very different artistic careers. According to Denis Rouart, the two friends did not see each other for a number of years, until Bonnat recognized Degas on a bus and asked him, "What has happened to that portrait you painted of me once? I would very much like to have it." Degas replied, "It's still in my studio, you can have it with pleasure." After a moment's hesitation Bonnat, who was trying to think of something to offer Degas in exchange, ventured, "But you don't like what I do!" Extremely irritated, Degas replied, "As you wish Bonnat, we have each followed our chosen path." And the matter ended there.

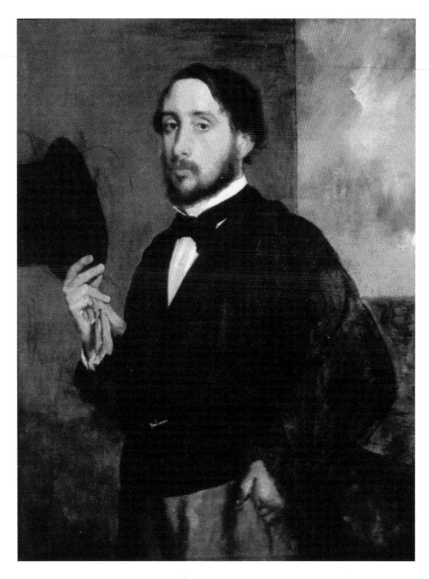

Self-Portrait (Degas Doffing His Hat)
1863, oil on canvas, 92.5 × 66.5 cm
Museu Calouste Gulbenkian, Lisbon

When Degas was in Italy between 1857 and 1859, he did not return to Paris until his father obliged him to do so by writing to him repeatedly. Even so, he returned to the French capital by way of Genoa in order to see the paintings of Antoon van Dyck.

During the eighteen months he was away, he spent his time traveling and seeing different works which he constantly copied in his notebooks. He was transfixed by the works of Signorelli in Orvieto: "I am in a dream which I don't know how to recall." That night he slept until noon.

In Città della Pieve, the birthplace of Perugino, he wrote: "All the woman look like Perugino's. Is this an illusion?"

The next day, he continued his journey via Assisi where, on his arrival, he was again transported: "I feel remorse for having seen so many beautiful things.... There is an expression and an astounding drama in Giotto. He is a genius." These feelings placed him in direct opposition to the painters of the Villa Medici, who scorned the Primitives and praised Italian Baroque painting. Although he described in his notebooks how the faithful performed their strange devotions, singing and shouting and "running around the altar rail ... with increasing frenzy – like dervishes," he was less moved by them than he was by the frescoes: "Sunday morning, Giotto, the sublime movement of *St Francis Driving out Demons, St Francis Talking with God....* I have never been so moved, nor will I ever be again; my eyes are filled with tears." In fact, he was so moved that he was unable to copy the frescoes of the basilica, but said that he did not need to because he would never be able to forget them as long as he lived.

Degas's last port of call in 1859 was Genoa, where he was again overwhelmed when he attended an exhibition of Van Dyck's works in the city. He asserted: "Nobody has ever given visible form to the grace and fragility of woman, the elegance and chivalry of man, and the difference between the two, as successfully as Van Dyck. In this great genius, there is more than natural ability.... I believe that he thought a great deal about his individual subjects, that he was permeated by their pervasive influence like a poet."

In homage to the great master, Degas painted this self-portrait in which he is doffing his hat in the manner of Van Dyck's portrait.

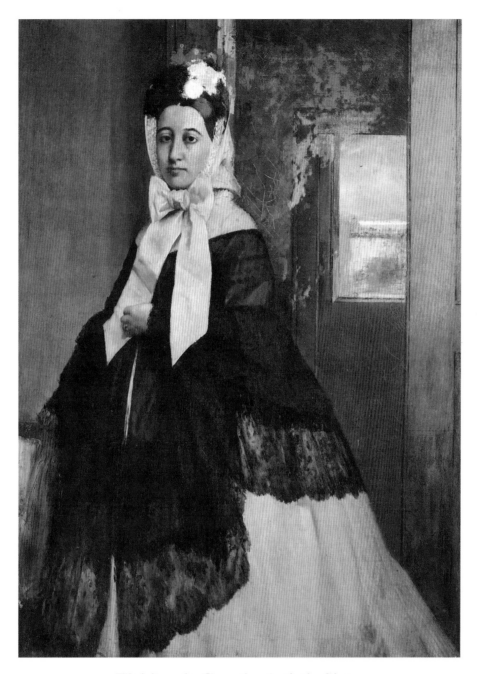

Thérèse de Gas, the Artist's Sister
1863, oil on canvas, 84 × 67
Musée d'Orsay, Paris

Thérèse was the third eldest of the De Gas children. She was born in 1840, in Naples, a city where she spent a great deal of time with her brother René and sister Marguerite before her marriage, and where she would live when she married her first cousin Edmondo Morbilli, in 1863. After being widowed in 1895, she led a complicated life, moving house seven times before she died in Bagnoli, a town near Naples, in 1912.

According to his brother René, Degas painted this portrait after Thérèse's engagement, in early 1863, at the family home in the Rue Mondovi, in Paris. Even so, the view through the window is that of the Castello de Sant'Elmo, in Naples, a watercolor painted by Degas three years earlier.

Scholars have been able to prove that this is an engagement portrait based on the fact that Thérèse is dressed in traveling clothes – about to leave for Naples, or recently returned from the city, since it is featured in the background of the portrait – and that she is wearing an engagement ring

To highlight this detail, Degas sets her left hand against the black shawl and turns the figure of his sister to the right. The predominately dark colors are contrasted with the large pale-pink bow tied at Thérèse's throat and the white flowers in her hair, which also adds light and softness to her serene face.

This portrait has been compared with that of the children of the poet, Charles Baudelaire – which Degas greatly admired – both for its serene beauty and the combination of its pale colors with black and bright pink.

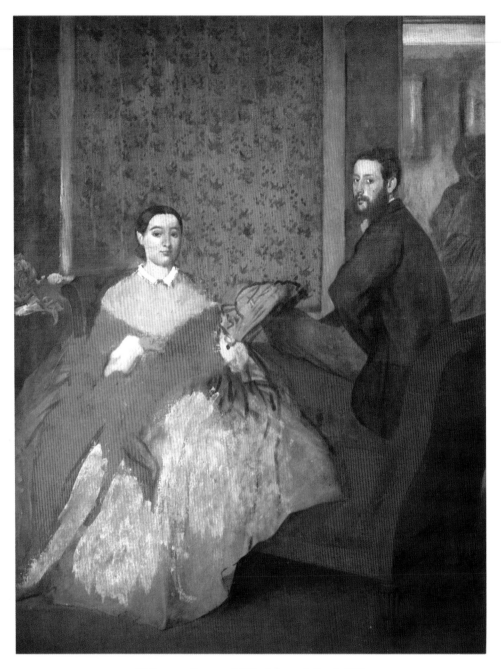

Edmondo and Thérèse Morbilli
1864, oil on canvas, 117 × 90 cm
National Gallery of Art, Washington

This portrait dates from 1864, a year after Thérèse's marriage to Edmondo Morbilli. At the time, Thérèse was carrying a son whom she later lost. This is why she is wearing loose clothing and is wrapped in a shawl, resting her hand on her stomach.

The couple give the impression that they were talking quietly together in the drawing room of their house when they were interrupted by the artist, toward whom they both turn, looking at him attentively.

In spite of the strong chromatic contrast between the green of the wallpaper in the background and Thérèse's red shawl, the couple's faces have a serene expression and catch the observer's attention. Certain parts of the painting are unfinished and others have been scraped off and corrected, which increases the sense of spontaneity.

Thérèse posed for a number of Degas's paintings, in which the artist always highlighted his sister's remoteness from the family home, emphasizing her melancholy expression and even her alienation, as in the portrait of 1869. At the time, Thérèse had traveled to Paris to visit her family, and Degas painted her soon after her arrival, somewhat disorientated in the drawing room, with her hat in her hand and wearing her traveling clothes, as she appeared in the engagement portrait (see page 31). Behind her is the easily identifiable pastel by Jean-Baptiste Perronneau, which Degas later inherited, and which created an even greater contrast between the objects that remained permanently in the family home, unchanging, and the sister who had spent six years living in another country and had just arrived, like a stranger within this familiar space.

1865-1869

1865

■ Degas exhibits for the first time at the Paris Salon which opens, as always, on May 1 in the Palais des Champs-Élysées, and where he continues to exhibit regularly until 1870. On this first occasion, he sends *War Scene in the Middle Ages* (also known as *The Sufferings of the City of New Orleans*) but its rather dull appearance does not obtain the anticipated reaction from the critics. Only Pierre Puvis de Chavannes appreciates the quality of the nudes, reminiscent of his own *Bellum*, exhibited at the 1861 Salon.

■ Degas spends the summer with the Valpinçon family, at Ménil-Hubert, in Normandy.

1866

■ Degas begins to frequent the Café Guérbois at 11, grande-rue des Batignolles (now, 9, avenue Clichy). Here he meets other young artists and writers such as Zacharie Astruc, Belot, Philippe Burty, Paul Cézanne, Léon Cladel, Louis-Émile-Edmond Duranty, Henri-Théodore Fantin-Latour, Antoine Guillemet, Édouard Manet, Claude Monet, Camille Pissarro, Pierre-Auguste Renoir, Alfred Sisley, Vignaux, James Abott McNeill Whistler, and Émile Zola, who become known as the "Batignolles group" and most of whom will later launch the Impressionist movement. In their discussions on contemporary art, they all express their opposition to the academic style of painting.

■ Degas begins to distance himself from the studied compositions of Gustave Moreau, choosing instead to follow Charles Baudelaire's dictates on modernity.

■ He exhibits *Scene from the Steeplechase: The Fallen Jockey at the Salon*, which is well received by the critics, including Edmond About who refers to "the vivid and agile composition of Monsieur de Gas." Another, unnamed critic states, "The qualities of this painting, which has a touch of the English style about it, are clarity and purity of tone … but, like the fallen jockey, the painter does not yet have a thorough knowledge of his horse."

■ The Salon rejects various works submitted by Paul Cézanne, Édouard Manet, Pierre-Auguste Renoir, Antoine Guillemet, and Antoine Solari. In *L'Événement,* the progressive daily newspaper that defends the "new style of painting," the writer and critic Émile Zola publishes a series of seven articles on the Salon, under the pseudonym Claude, which he later collects together and publishes in book form as *Mon Salon.*

■ Some of the artists whose work has been rejected write to the Minister of Fine Arts, the Comte de Nieuwerkerke, requesting the reinstatement of the "Salon des Refusés," which is with no jury and "open to all serious works," but their request is denied. The reaction to Paul Cézanne's letter is noted in the margin: "His request is impossible, since we have been able to see just how undesirable the presentation of the rejected works would be for the dignity of art, and it will not be reinstated."

Grand Prix de Paris, by Olivier Pichat, and other works exhibited at the Salon of 1866, Album Michelez. Degas believed that the horse-racing theme met the needs of the time. Pichat's painting was brought to the Salon by the emperor Napoleon III.

Page from a notebook with studies of figures and hands, 1865, pencil and ink on paper, Louvre Museum, Paris. Degas continued his self-taught apprenticeship as a copyist in the Louvre until 1868. In particular, he worked on such details in the paintings of the grand masters as the muscles of the body and the hands.

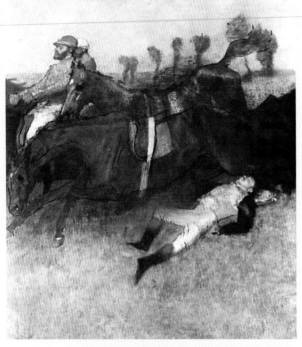

Scene from the Steeplechase: The Fallen Jockey, *1866, oil on cardboard, 180 × 152 cm, Mellon Collection, Upperville, Pennsylvania. Degas exhibited this painting at the Salon of 1866. His brother Achille posed as the fallen jockey.*

1867

▬ The Goncourt brothers publish the novel *Manette Salomon,* which champions an extremely realistic portrait of Parisian social life and an esthetic that is closer to Oriental art. Degas will state on more than one occasion that his artistic production was influenced by the work.

▬ Through the intervention of the critic, Jules-Antoine Castagnary, Degas exhibits two works at the Salon under the generic title "Family Portrait", one of which has never been officially identified. Once again, the Salon rejects works by Frédéric Bazille, Paul Cézanne, Antoine Guillemet, Alfred Sisley, and Pierre-Auguste Renoir, among others. Three hundred people sign a letter objecting to the severity of the jury and asking for the reinstatement of the "Salon des Refusés."

1868

▬ Degas registers for the last time as a copyist at the Louvre Museum.

▬ His portrait of *Mlle. Eugénie Fiocre in the Ballet "La Source"* is exhibited at the Salon but receives little recognition.

▬ Émile Zola publishes seven more articles on the Salon in *L'Événement.*

1869

▬ In February, Degas travels to Brussels with his brother Achille, where he sells several paintings, including one to the Belgian minister Van Proet. The art dealer Joseph Stevens offers to draw up a contract that Degas apparently refuses.

▬ He exhibits his portrait of Joséphine Gaujelin at the Salon, but it is very badly placed. The jury rejects his portrait of *Madame Camus at the Piano,* which gives rise to another version, *Madame Camus,* sent to the Salon of 1870.

▬ Degas pay regular visits to the Morisot family.

▬ He spends the summer in Étretat and Villers-sur-Mer, preparing to paint a series of seascapes and visiting the Manets who live in nearby Boulogne. Here and in Saint-Valéry-en-Caux, he goes out painting with Édouard Manet and paints some small landscapes.

He begins to publish installments on the Spanish school in the collection *Histoire des peintres de toutes les écoles,* a history of the different schools of painting.

Boulevard Haussmann, *Giuseppe de Nittis, watercolor, private collection, Milan. At the time, Degas greatly admired the artist.*

The Café Guérbois, *Édouard Manet, 1869, ink on paper, Fogg Art Museum, Cambridge. It was here that the Batignolles group was formed, consisting mainly of young painters who later launched the Impressionist movement.*

War Scene in the Middle Ages (also known as *The Sufferings of the City of New Orleans*)
1865, oil on paper mounted on canvas, 81 × 147 cm
Musée d'Orsay, Paris

It appears that Degas did not base this painting solely on historical accounts of medieval wars, but above all on the atrocities committed by the soldiers of the North during the occupation of New Orleans in May 1862. These events were described to the artist by his aunt, Odile Musson, and cousins, Estelle and Désirée, who had fled the city and sought refuge in France in 1863.

The account that most moved Degas was that of Estelle Musson who had been left a widow with the battle, since her husband was sent to the Confederate front line. Estelle would later marry the artist's brother, René de Gas.

Unlike the paintings on historical and mythological themes by Classical and Romantic artists, *War Scene in the Middle Ages* (The Sufferings of the City of New Orleans) does not reflect a narrative cycle but a particular event within history, a trait that would characterize Degas's historical works.

When it was exhibited at the Salon of 1865, the painting did not catch the attention of the public or critics, perhaps because, in that same year, a liberal jury had accepted Édouard Manet's *Olympia*. Compared with this scandalous but revolutionary theme, Degas's painting could not fail to look more like an example of academic art, even though it was extremely unorthodox.

In spite of depicting a war scene, in which soldiers are attacking victims in the foreground, with the city burning in the background, Degas did not over-dramatize the painting. Although he had certainly done this in his preparatory drawings, where the figures of the women were contorted with pain, they do not have this dramatic quality in the oil painting.

This feeling of indifference is reinforced by the space between the figures of the victims and also by the empty area in the center of the painting. This use of the central space was already extremely characteristic of such early compositions as *The Bellelli Family* (page 20), and Degas would continue to use it in all genres throughout his career. It is particularly outstanding in his paintings of ballerinas.

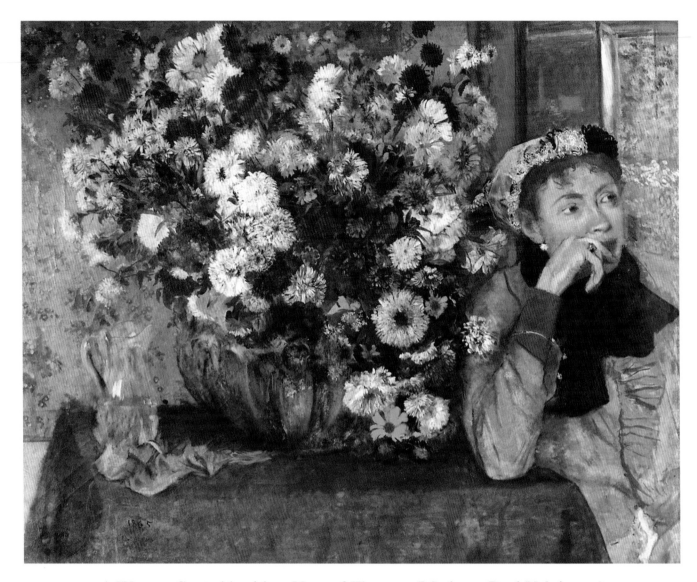

A Woman Seated beside a Vase of Flowers (Madame Paul Valpinçon)
(also known as *Woman with Chrysanthemums*)
1865, oil on canvas, 74 × 92 cm
Metropolitan Museum of Art, New York

The studied nature of this composition has led several art historians to believe that Degas may have initially only paint-ed the vase on the table, adding the female figure years later. This theory appeared to be borne out by the fact that next to the date of the signature (1865) is another obliterated date which, for years, had been read as 1868 or 1858. But an analysis using infrared rays and a microscope has given 1865 as the definitive date.

It therefore appears that the figure was added in that year, when Degas considered the painting finished, a fact that is also confirmed by his study for the figure (see page 9), which he drew in the same pose in the same year, 1865.

The features of the woman's face are similar to those of Degas's sister-in-law, Estelle Musson, whom he held in high regard and who, from an early age, had suffered from failing eyesight, as the artist himself had begun to do at the time. However, in the most recent studies made of this work, the woman was identified as Marguerite-Claire Brinquant, who had become the Baroness Valpinçon when she married Paul Valpinçon – a close friend of Degas's from the Lycée Louis-le-Grand – on January 14, 1861. The room could well be the living room of the Valpinçon's chateau at Ménil-Hubert, in Normandy. This would mean that the canvas was painted at the end of September, when Degas spent a few days with the couple, as he did on so many occasions.

The woman is posing as if she has not long been out of bed (she is wearing a housecoat and scarf), and has just arranged the large bouquet of recently cut flowers which, as well as chrysanthemums, includes other variously colored flowers. This theory is borne out by the presence of the jug of water and the gardening gloves. But the scene is more than a painting of manners – Degas wanted to express his regard for Madame Valpinçon who, in spite of being placed on the extreme right of the canvas and looking out of the picture, is in fact the main protagonist of the work.

Even so, the subject and the flowers remain isolated from each other and also from the observer, although this does not prevent them from complementing one another. The flowers highlight the woman's sensitivity and reflect such psy-chological traits as inner tranquillity, gentleness, a sense of beauty, attention to detail, and a meticulous approach to things.

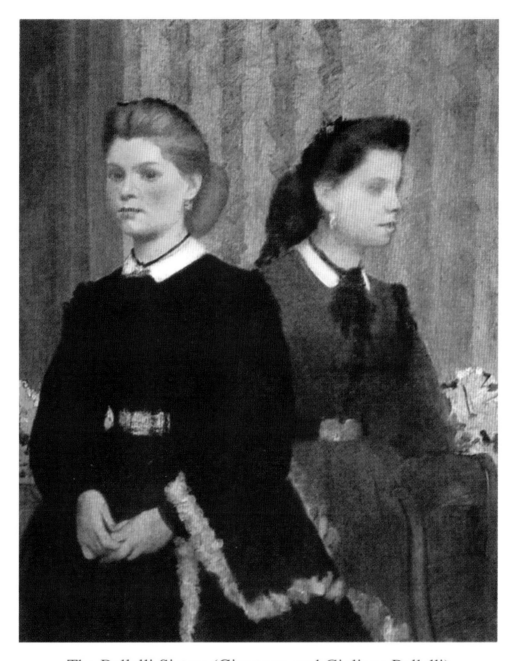

The Bellelli Sisters (Giovanna and Giuliana Bellelli)
1865–1866, oil on canvas, 92 × 73 cm
County Museum of Art, Los Angeles

Giovanna and Giulia Bellelli are the artist's nieces, whom he painted on a number of occasions when staying at the family home in Florence. Degas felt great affection for the Bellellis, due to their sad family circumstances. The marriage between his Aunt Laura and the Baron Bellelli was one of convenience, and the latter felt marginalized in his own home. To make matters worse, he had been exiled from Naples for political reasons, and the family had to settle in Florence, uprooted and far from their familiar surroundings.

Apparently forgetting the paintings submitted in *1865 (War Scene in the Middle Ages:* The Sufferings of the City of New Orleans) and 1866 *(Scene from the Steeplechase: The Fallen Jockey),* Jules-Antoine Castagnary, the critic responsible for information on the Salon between 1857 and 1870, described Degas as "a newcomer showing remarkable ability, which attests to the artist's accurate perception of nature and life."

The portrait reflects the influence of *The Two Sisters* (1843) by Théodore Chassériau, which Degas described as "the most beautiful portrait of the century." He may have been drawn to the painting because, like his own mother's family, the Chassériaus were of Creole descent. *The Bellelli Sisters* also reflects the influence of his two great masters, Ingres and Delacroix.

In fact, the double portrait was a genre that was very much in vogue at the time and, as well as being influenced by Chassériau's painting, Degas also drew inspiration from similar portraits by Rouget and Ingres. But, unlike these works, Degas sought to emphasize the difference between his two models rather than their similarity.

Head of a Woman
1867, oil on canvas, 27 × 22 cm
Musée d'Orsay, Paris

The identity of the woman in the portrait is not know for certain. At the time, it was thought to be one of Degas's aunts, Rose Adelaïde Morbilli, his father's sister and mother of Edmondo Morbilli, who married the artist's sister Thérèse. However, at the time the portrait was painted, Rose Adelaïde was in her seventies.

Although this is one of the most expressive portraits painted by Degas, it is also fairly unusual in the sense that most of his models were identified relatively easily, if not when they were painted, at least after his death, when his brother René was declared sole heir and compiled the first catalog of the content's of the artist's studio.

The process of identification proved easy for two reasons. In the first place, because Degas used his close friends and family as models and, in the second, because the social and cultural status of his friends and acquaintances meant that they tended to be more or less in the public eye. The critic Louis-Edmond Duranty said that Degas was on the way to becoming the "painter of the cream of society."

However, in spite of the fact that the subject of this work is unknown, in the first issue of *L'Impressioniste,* critic Georges Rivière compared it to the work of the 16th-century master portraitists Jean and François Clouet, describing it as "a wonderful drawing, as beautiful as the most beautiful [portrait] by the Clouets, the greatest of the Primitives."

In this portrait, the woman's gaze is distant, as if she is lost in thought. On the one hand she has been painted with the great realism characteristic of Degas's paintings from the 1870s onward, and, on the other, she retains the aura of serenity usually associated with classical painting.

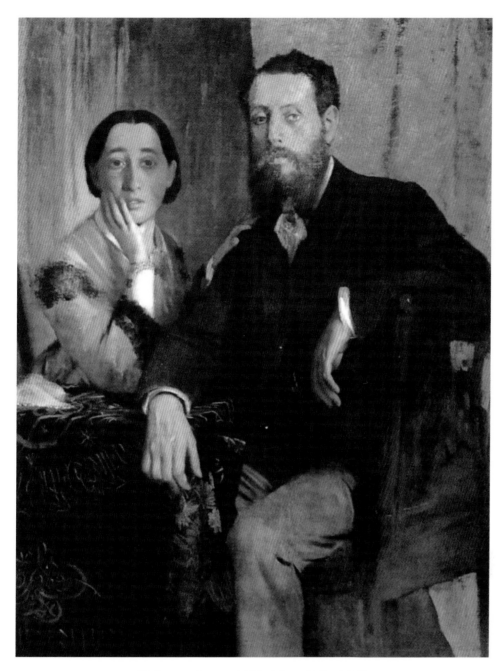

Edmondo and Thérèse Morbilli
1867, oil on canvas, 116 × 88 cm
Museum of Fine Arts, Boston

In this work, Edmondo Morbilli has a much stronger physical presence than his wife, Degas's sister Thérèse, compared with the portrait painted by the artist three years earlier (see page 32). Here, he is portrayed as more corpulent, his posture more self-assured, and with an air of aristocratic reserve. He also occupies a more prominent position in the foreground, whereas in the earlier work he was seated slightly behind his wife. However, Degas offsets this dominance by placing him to the right of the composition.

The colors of this portrait are much softer, without the contrasts of the earlier work, creating a greater sense of serenity that is primarily conveyed by the neutral tones of the background. The corpulence and rosy skin of the artist's brother-in-law are set against his sister's gentleness, reflected in her pale face which is overshadowed on the left by the figure of the duke. The combination of colors is reminiscent of the Tuscan and Venetian Mannerists, possibly a reference to the fact that the couple lived in Naples.

The subjects are posing as if for a daguerreotype but, even so, they have the naturalness and confidence of people posing for someone they know. This is one of the things that make the portrait stand out from the double-portrait genre so popular at the time.

Thérèse is portrayed as a shy woman, with a melancholy air, partly covering her face with her right hand, while the left rests on her husband's shoulder, a symbol of her confidence in him.

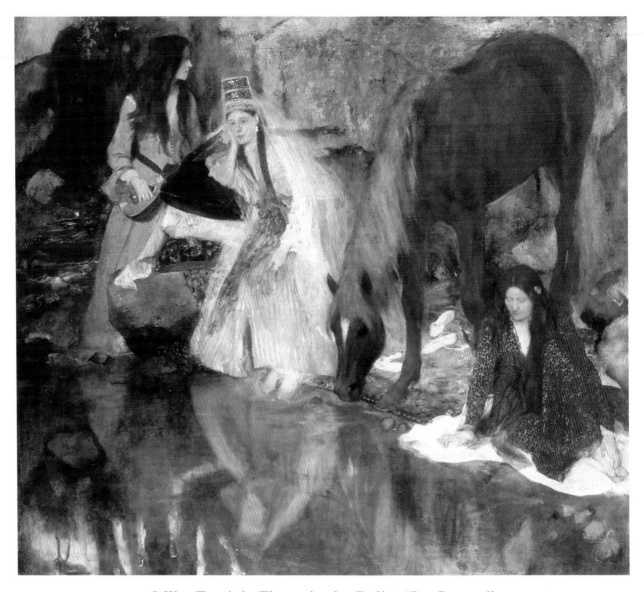

Mlle. Eugénie Fiocre in the Ballet "La Source"

1867–1868, oil on canvas, 103 × 145 cm
Brooklyn Museum, New York

The ballet *La Source* was composed by Leon (Ludwig) Minkus and Léo Delibes, with libretto by Charles Nuittery and Saint-Léon, who was also the choreographer. It therefore had all the ingredients of a great success, borne out by the fact that the dress rehearsal, held in Paris on November 12, 1866, was attended by Ingres and Giuseppe Verdi.

The ballet was extremely popular for a number of years, so much so that it was chosen to inaugurate the new premises of the Paris Opera House in the Palais Garnier on January 5, 1875. In spite of the difference in form, this was Degas's first painting of a contemporary ballet, witness the pink ballet shoes glimpsed between the horse's legs.

The painting is also the first example of a contemporary theme based on the theories outlined by Gustave Courbet in his manifesto in 1861. Degas started the work in 1867, with the intention of sending it to the Salon the following year, having discovered a way in which he could paint modern heroes in their own clothing, according to the principles of Charles Baudelaire, but with a grandeur that had hitherto been the prerogative of the historical and mythological genres.

Although the painting shares various similarities with the portraits of Ingres, from soft lines copied directly from the model, to clearly immobile postures, the background pertains to a more subjective perception of nature, typical of Gustave Courbet and executed with broad, thick brushstrokes.

The reflection of the water, the barest suggestion of rocks in the background, the three young women in attitudes of repose, and the use of discreet colors invest the scene with an air of exoticism and sensuality reminiscent of the paintings of Gustave Moreau and the Symbolist movement that he came to represent years later. The abundance of detail is also reminiscent of the works of Nicolas Poussin, which Degas saw so often in the Louvre.

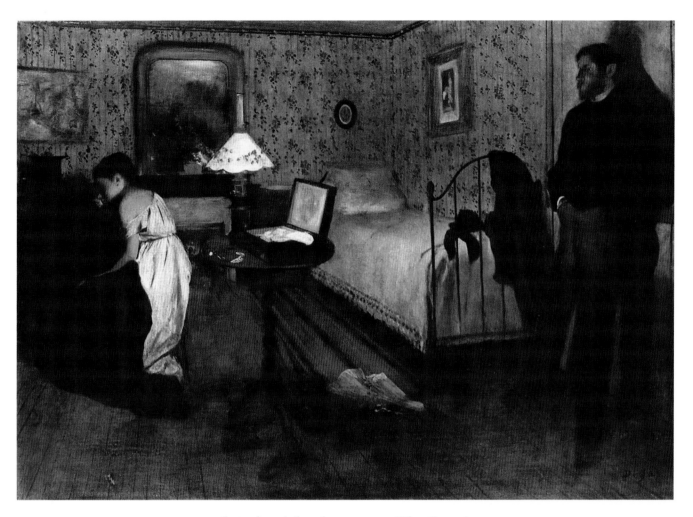

Interior (also known as *The Rape*)
1868–1869, oil on canvas, 81 × 116 cm
Philadelphia Museum of Art, Philadelphia

In spite of the fact that this work has become widely known as *The Rape*, artist Paul Poujard, who was also a friend of Degas, said that the latter never referred to it in this way: "This title is not part of his vocabulary. It was probably invented by a writer or a critic."

The change of title can be attributed to the fact that all the elements in this painting help to create an atmosphere of great tension. First of all, there are the dark, muted colors of the foreground, with the brightest colors reserved for the wallpaper in the background.

Then there is the artificial light of the lamp that illuminates the woman's shoulder with great intensity, while the male figure lurks in the shadows. In his notes, Degas wrote that "the feel of evening, lamplight, a candle, and so on" should be particularly emphasized. The faces of both figures are barely visible – the woman's face is hidden, the man's is indistinct due to the chiaroscuro effect of red and black tones, reminiscent of firelight – as if both are devoid of will.

In all the preparatory drawings for this painting, the man appeared with his legs apart and his hands in his pockets. At the time, the critic Louis-Émile-Edmond Duranty expressed the view that "hands can still be eloquent even in pockets."

The figures are also placed at the two extremes of the composition, separated by the furniture in the room, which appears to have been taken from the maid's room in Degas's father's house, in the Rue Mondovi. The inventory taken after his death, in 1874, lists, "a round table, a chest of drawers [or commode], a sewing box, a small table, two straw-bottomed chairs, a small mirror, an iron bedstead, and a quilt."

The composition is thought to have been inspired by the account of the wedding night in Émile Zola's *Thérèse Raquin*, following Thérèse's marriage to her lover and the murderer of her first husband. "[Laurent] closed the door carefully behind him and stayed leaning against it for a while, looking around the room with an anxious, embarrassed expression on his face. A fire was burning brightly in the grate Thérèse was sitting on a low chair Her lace-trimmed petticoat and bodice stood out stark white in the brilliant light of the fire. The bodice had slipped down, revealing a pink patch of shoulder half hidden by a lock of her black hair." (*Thérèse Raquin*, Émile Zola, translated by Andrew Rothwell, OUP, 1992, p. 118.)

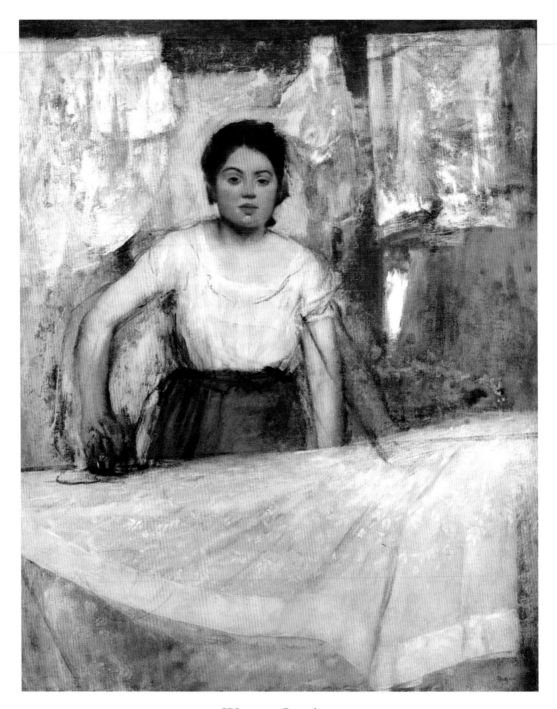

Woman Ironing
c. 1869, oil on canvas, 92.5 × 74 cm
Neue Pinakothek, Munich

In April 1873, Degas moved into 72, rue Blanche, in Montmartre. Because it was not in the center of Paris, the district could accommodate large premises suitable for hanging out washing and, as soon as Degas left the house, he would see the laundresses at work. It should be remembered that, at the time, clothes had to be washed and ironed without the help of any labor-saving devices, and large numbers of women were employed in this type of work.

For many years, Degas dined out three times a week. As he returned home, he would often see the laundresses ironing by gaslight, which highlighted their features with the contrasting effects of light and shadow. Meticulous in his observations, he made notes and drawings of all the gestures involved in this work, gestures which are reflected here in the double outline of the woman's arms – the left, which had to stretch to move and separate the clothing in order to iron it, and the right, which controlled the movement of the iron. The woman's skirt also has a double outline to emphasize the movement of her upper body.

The oppressive atmosphere is represented by the rows of white garments hanging behind the young woman, and also by the clothes she is wearing. In addition to her scanty clothing, the heat of the atmosphere has been given visible form by the pink skin of her cheeks, collar bones and, above all, her right arm, which has been more heavily shaded to reflect its tension.

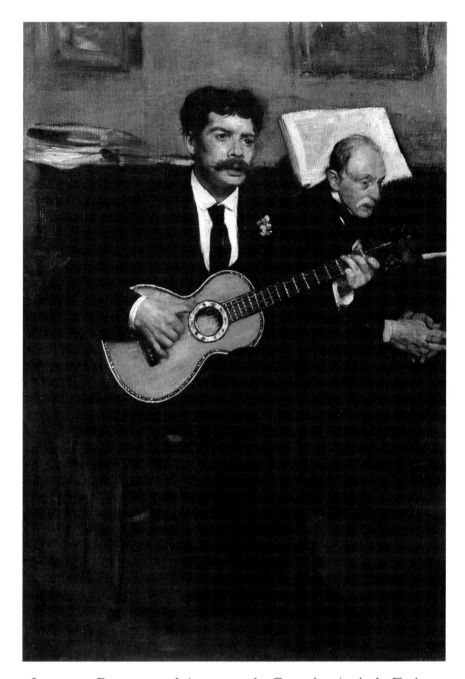

Lorenzo Pagans and Auguste de Gas, the Artist's Father
c. 1869, oil on canvas, 55 × 40 cm
Musée d'Orsay, Paris

Auguste de Gas was not the typical banker portrayed in the works of French novelist Honoré de Balzac. On the contrary, although he ran the Paris branch of the family bank founded in Naples by his father, Hilaire de Gas, he was a refined and cultured man. He was not wealthy, but good natured and easy to get on with. He loved art and, above all, music.

Pagans was a young Spanish musician who had already made a name for himself in Paris when Degas painted this portrait, and often attended the soirées hosted by the Manets and Auguste de Gas.

Degas painted several portraits of Pagans, singing and playing the guitar, while the artist's father, seated nearby, listened spellbound. One of these portraits, exhibited at the Exposition Degas organized at the Galeries Georges Petit, in Paris, in 1924, was knocked down for 85,000 francs by auctioneer Enrique Fevre a year later. Before Pagans returned to Spain in 1882, Degas painted another portrait of him, this time alone, since his father had died eight years earlier.

In the portrait here, the subjects are in the living room of the De Gas home, with its familiar furniture, the piano, and musical scores in the background highlighting the banker's face. Perhaps this is why Degas was so fond of the portrait, kept in memory of his father and which always hung in his room.

The portrait is based on a photograph, now in the Louvre, and is painted realistically both in terms of the execution of the figures and the space they occupy. However, Degas also drew his inspiration from Édouard Manet's *The Guitar Player* and the technique used by Manet, which was influenced by Spanish painting.

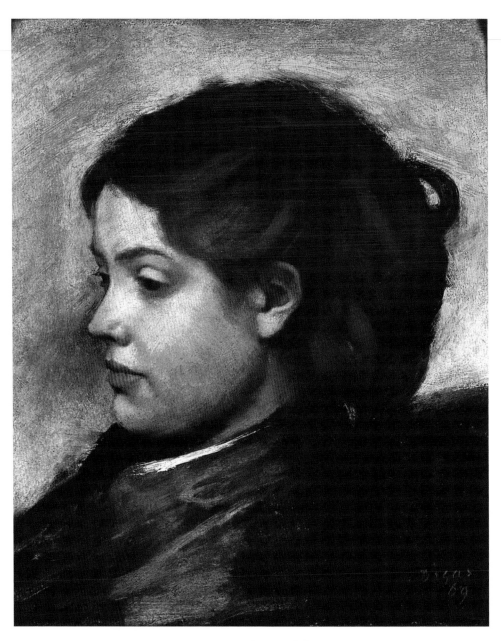

Mademoiselle Dobigny
1869, oil on wood, 31 × 26 cm
Kunsthalle, Hamburg

Although Mlle. Dobigny was well known as a model in artistic circles, she lived in straitened economic circumstances in the Montmartre district of Paris. Throughout her life, she posed for various artists, including Camille Corot, Henri Rouart, and Pierre Puvis de Chavannes. Some scholars have also identified her in another of Degas's paintings – *Sulking* (1869) [Metropolitan Museum of Art, New York], in which she stands in the center of the composition, looking directly at the observer.

Degas greatly admired the young women he encountered each day, when walking through the streets of Paris. According to Berthe Morisot, herself a painter and pupil of Édouard Manet, Degas felt an "extraordinary admiration for the intense humanity of the young women of the city." He more or less regarded what went on in the streets of the capital as a performance, and was always making notes and drawings in his notebooks of scenes and faces that he later used for his paintings.

Degas used his classical knowledge to give his working-class subject an air of majesty, drawing on the classical tradition which always portrayed great figures in profile – a technique that enabled the artist to produce a representation that was similar to the subject, without accentuating the details of their features. In other words, the subject appeared more as a conventional type rather than an individual. In spite of this, the model has retained her rosy skin and certain distinctive features characteristic of her working-class status.

The same duality adopted by the artist for this painting reflects his relations with women at the time since, socially, his behaviour was always ambiguous. In public, he paid tribute and flattered them to excess, and yet he was quite capable of being discourteous at any moment when alone with them.

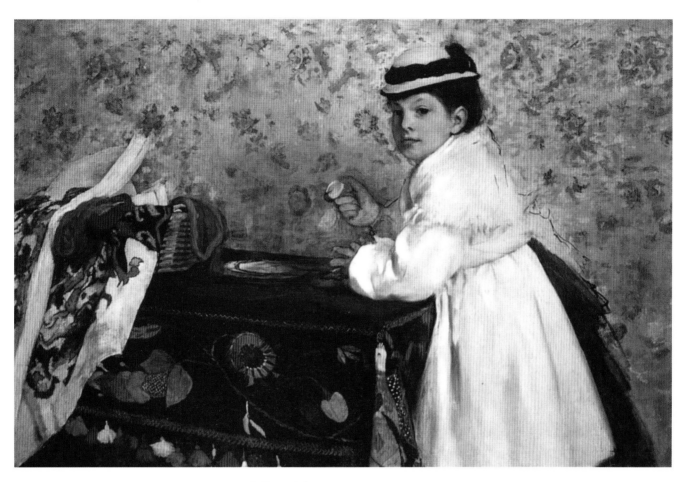

Mlle. Hortense Valpinçon
1869, oil on canvas, 73 × 110 cm
Minneapolis Institute of Arts, Minneapolis

This little girl is the daughter of Paul Valpinçon, a close friend of Degas's from the Lycée Louis-le-Grand, and the portrait was painted during one of the artist's visits to the latter's home at Ménil-Hubert, in Normandy. Hortense, at the time nine years old, is painted with a spontaneous expression, as if the artist had captured her by chance, next to the table and sewing basket, with a half-eaten apple in her hand.

The painting is reminiscent of the portrait of *Alaide Banti* painted four years earlier by Giovanni Boldini, a friend of Degas's and of Alaide's father, artist Cristiano Banti. Like Hortense, Alaide is leaning against a table. The use of color is also similar in that Boldini painted a background that complemented the girl's clothing, just as Degas has done in this portrait of Hortense. But whereas Alaide is wearing light-colored clothes with a black pinafore, Hortense has a white blouse and pinafore with a black skirt that outlines her body against the wallpaper of the background.

Although there are certain technical parallels between the two paintings, in Boldini's portrait, Alaide seems distracted, probably suffering from the boredom of convalescence imposed by a recent illness, while Degas wanted to accentuate the brightness of Hortense's expression, her gaze focused directly on the observer, with all the curiosity typical of a nine-year-old child.

This liveliness is heightened by the patterned background, a flower print which, although light in color, is painted with great energy and freedom of movement.

The artist's friendship with the Valpinçons continued and he saw Hortense grow up. After spending the summer of 1884 with them in Normandy, he wrote to his friend Henri Rouart: "I have here two young women, Hortense and Mademoiselle Pothau, who speak of marriage from morning 'til night. It is incredible what must pass through those heads."

Hortense married Santiago Fourchy. However, Degas, who had known her from birth, continued to enjoy the couple's company, as evidenced by a series of photographs from 1900, in which the three of them are seen parodying a ballet (see page 121). The artist continued to visit Hortense after her father's death, in 1894.

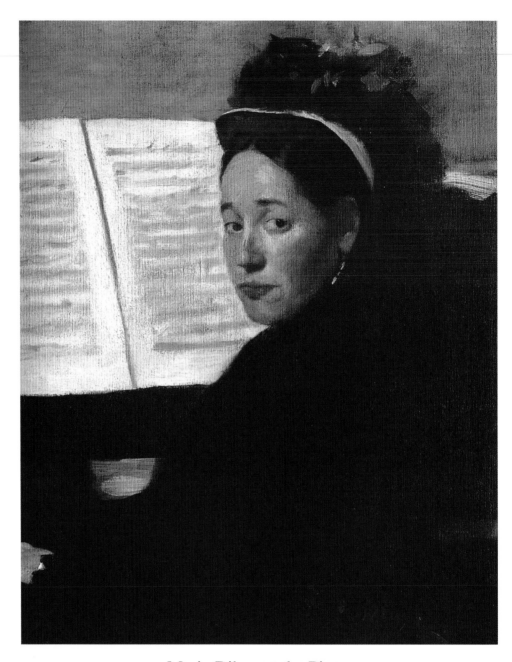

Marie Dihau at the Piano
1869–1872, oil on canvas, 39 × 32 cm
Musée d'Orsay, Paris

Marie Dihau was a famous pianist from Lille, in northern France, who often performed with the orchestras of Édouard Colonne and Charles Lamoureux which had amalgamated. She was a cousin of Henri de Toulouse-Lautrec and, when she moved to Paris in 1872, she introduced the two painters.

Marie was also the sister of Désiré Dihau, who wrote songs and played the tuba in the orchestra of the Paris Opera House. Degas not only painted his portrait on a number of occasions, he was also a close friend during the 1870s. The friendship subsequently cooled when Degas discovered that Dihau had asked Lautrec to illustrate the cover of his musical scores. Degas took this badly since, although Dihau and Lautrec were cousins, he considered himself a much better painter than the artist from Albi.

Marie's pose is reminiscent of Johannes Vermeer's *Girl with the Pearl Earring,* in which the subject is also seen from behind. Although she has pendant rather than pearl earrings, like the Dutch master, Degas wanted to set the pendants against a black background.

This pose enabled the artist to create an innovative composition, in which the pianist is not painted in profile, like most of the paintings in this genre, or from the front with the piano in the background, as in *Madame Camus at the Piano* (see page 7), also painted in 1869.

But the painting is also pervaded by references to the works of Georges de La Tour and Jean-Baptiste-Siméon Chardin, which implemented the theories advanced in Louis-Edmond Duranty's *La Nouvelle Peinture* (1876). According to Duranty, the place in which a person was painted was extremely important, and they should also be surrounded by the objects most representative of their interests or occupation. He believed this was the only way successfully to convey the true personality of the subject.

1870-1874

1870

— Degas concludes his series of paintings on historical and biblical themes and decides to paint scenes from everyday life.

— He exhibits at the Salon for the last time, submitting his portrait of *Madame Camus.*

— He rents another apartment comprising one room and a kitchen opposite the studio he has rented at 13, rue Laval, in Paris.

— On July 19, France declares war on Prussia and, in September, the Prussians lay siege to Paris. As a result of the war, Pierre-Auguste Renoir is drafted, Frédéric Bazille is killed in action, Camille Pissarro seeks refuge in England, and Paul Cézanne leaves Paris for Provence. Édouard Manet enlists as a volunteer, while Degas enlists in the National Guard. However, when his first sight defects are diagnosed, exacerbated by the harsh conditions of a winter on the front line, he is transferred from the infantry to the artillery under the command of his boyhood friend Henri Rouart.

— After the defeat of Sédan and the surrender of Napoleon III, the Republic is proclaimed on September 4.

1871

— Peace is restored when France and Prussia sign the Treaty of Versailles, on February 26.

— Horrified by the political events following the declaration of the Paris Commune, Degas spends part of the summer in Normandy, with the Valpinçons. He then goes on to London, where he is drawn to the naturalist style of contemporary English painting and hopes to be able to find an outlet for his work.

— When painting the portraits of several of his musical friends for *The Orchestra of the Opera* (1870) (see page 49), he includes the figures of ballerinas for the first time. In a few months' time, they will constitute a series in their own right, and one of the most important in his artistic production.

1872

— Degas begins to frequent the rehearsal room of the Opera House, in the Rue Le Peletier.

— In April, he moves into an apartment at 77, rue Blanche, which consists of a dining room, kitchen and alcove, with a large studio and two small bedrooms on the upper floor.

— In summer he takes part in the fourth Exhibition of the Society of French Artists and then the fifth, on November 2, both organized by the Durand-Ruel gallery at 168, New Bond Street, London.

— In October, he and his brother René set sail for New Orleans, traveling via London, Liverpool and New York, to visit their brother Achille and their mother's family. While there, he paints a number of works, including *The Cotton Office, New Orleans.*

— Claude Monet paints *Impression: Sunrise* – exhibited at the first Impressionist exhibition, in 1874 – after which the Impressionist movement is named.

— In July, Émile Zola signs a contract with editor Georges Charpentier for the publication of his Rougon-Macquart cycle, in which he gives an account of the social, cultural, and artistic situation in France.

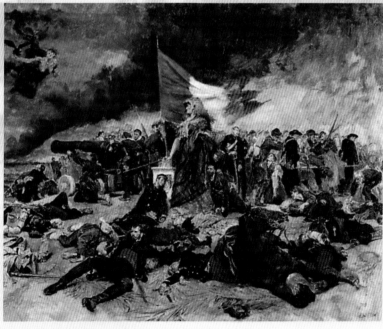

The Siege of Paris - *Jean-Louis-Ernest Meissonier,* 1870, *Musée d'Orsay, Paris - depicts the bloody siege in which Degas fought against the Prussian troops. Degas regarded the artist as a "giant among dwarfs," to the point that he copied his horse in* Napoleon III in the Battle of Solférino.

Seamstresses of the Red Shirts, Odoardo Borrani,
*1863, oil on canvas, 66 × 54 cm. Degas admired and was
greatly influenced by the interiors painted by the
"macchiaioli", but was impervious to the political and
social references of Italian Unification, in spite of visiting
the country each year between 1857 and 1888.*

1873

■ Degas returns to Paris in April, where he moves into 72, rue Blanche, in the Montmartre district.

■ In spring and winter respectively, he takes part in the sixth and seventh Exhibitions of the Society of French Artists, organized by Paul Durand-Ruel at 168, New Bond Street, London.

■ After the Franco-Prussian war, the Batignolles group meets in the Café La Nouvelle-Athènes.

■ Degas becomes increasingly interested in ballet. In the same year, a fire destroys the Opera House in the Rue Le Peletier.

■ His work begins to be bought by major collectors such as Ernest Hoschedé and the famous baritone, Jean-Baptiste Faure. Paul Durand-Ruel, one of the best-known art dealers of the time, is also keen to buy his works and organize exhibitions, which gives rise to a development in Degas's artistic production.

■ On December 27, together with Paul Cézanne, Claude Monet, Berthe Morisot, Camille Pissarro, Alfred Sisley, and other artists (most of whom attend the meetings at the Café La Nouvelle-Athènes), Degas founds the Société Anonyme Coopérative des Artistes, Peintres, Sculpteurs, Graveurs, etc. Their aim is to organize exhibitions independently of the official Salon, to sell their works directly, and publish a periodical, all of which is in direct opposition to the principles of the academic school.

1874

■ Degas moves to Turin, where he finds his father seriously ill. When the latter dies in Naples, on February 23, he leaves a complicated inheritance that obliges Degas to sell his house and art collection, and, for the first time, to paint commercially in order to settle his father's debts.

■ He takes an active part in the first exhibition of Impressionist painters, a group formed by the artists of the Société Anonyme, held from April 15 to May 15 in the studio of photographer Félix Nadar, at 35, boulevard des Capucines. Édouard Manet never takes part in these exhibitions because he refuses to allow his paintings to be exhibited alongside Paul Cézanne's who, in Manet's own words, is "a bricklayer who paints with his trowel." In reality, Manet's greatest ambition is to take part in the official Salon. The opening is attended by just under two hundred people. Degas exhibits ten

works at the exhibition – oil paintings, drawings and pastels. The term "Impressionist" is coined sarcastically by Louis Leroy, a critic for the satirical magazine *Le Charivari,* based on the title of Monet's *Impression: Sunrise.* However, it catches on and is used to define the new group of artists, even though Degas would have preferred another term that highlighted the realistic aspect of this new style of painting. The exhibition, which causes quite a stir among the public, ends up making a loss with each participant having to contribute 184 francs 50 centimes.

■ Degas takes part in the ninth Exhibition of the Society of French Artists organized by Paul Durand-Ruel at 168, New Bond Street, London.

■ He receives a visit from Edmond de Goncourt, who expresses his admiration in the daily press: "Until this moment, and in my experience, he is the man best able to capture, in his representation of modern life, the soul of that life."

The last general meeting of the Société Anonyme Coopérative des Artistes, Peintres, Sculpteurs, Graveurs, etc. is held on December 17. A unanimous decision is taken to liquidate the society in view of the absence of official support and its lack of financial success.

The Barricade, *Édouard Manet, 1871, lithograph, Pushkin Museum,
Moscow. Unlike Degas, Manet was inspired by his experiences during the
Franco-Prussian War and produced a series of works while on active service.
They reflect the influence of Francisco de Goya's works on the same theme.*

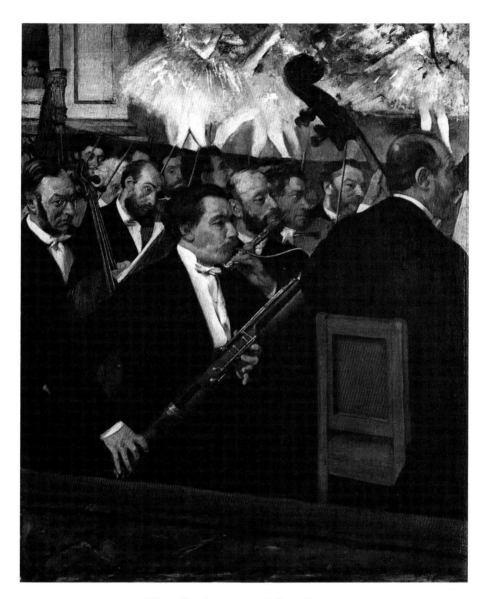

The Orchestra of the Opera
c. 1870, oil on canvas, 56.5 × 46.2 cm
Musée d'Orsay, Paris

The composition of this work is unusually bold in that the musicians are painted in an apparently casual manner, as if they were in a photograph. Those in the background are in fact a series of independent portraits, juxtaposed by the artist, in the manner of a collage, to form the composition. Also, while the musicians in the painting were friends and acquaintances of Degas's, they were not all members of the orchestra of the Opera House.

Equally bold is the fact that the painting only depicts the lower part of the performance taking place on stage, with the ballerinas cut off at shoulder height by the top edge of the painting. The musicians occupy the middle ground, while the foreground is taken up by the balustrade confining the orchestra. The vertical format of the work helps to emphasize the three areas of the composition.

The distribution of color is also a product of these three areas. Thus, while the lower part of the canvas is painted entirely in browns, grays, and blacks, the upper part is painted in a range of blue, pink, ocher, and white tones that add brightness to the stage.

The light is strongly contrasted (as happens in the orchestra at the theater or opera) so that, while the musicians in the foreground are in shadow, the bodies of the ballerinas are strongly lit from below by the footlights. This was the first time Degas used the artificial lighting of a stage, something he would continue to do for his representations of ballet and café-concert performances, regardless of whether they were executed in oils, pastels, etchings, or a combination of techniques.

The arrangement of the musicians is totally haphazard and entirely a function of the artist's composition. Thus, he placed the double bass near the position that should be occupied by the conductor, so that the neck of the instrument stands out against the tutus of the ballerinas. His friend Désiré Dihau appears in the center of the composition playing the bassoon, while in *Musicians in the Orchestra* (1871–72), Dihau also appears in the center but this time playing the double base.

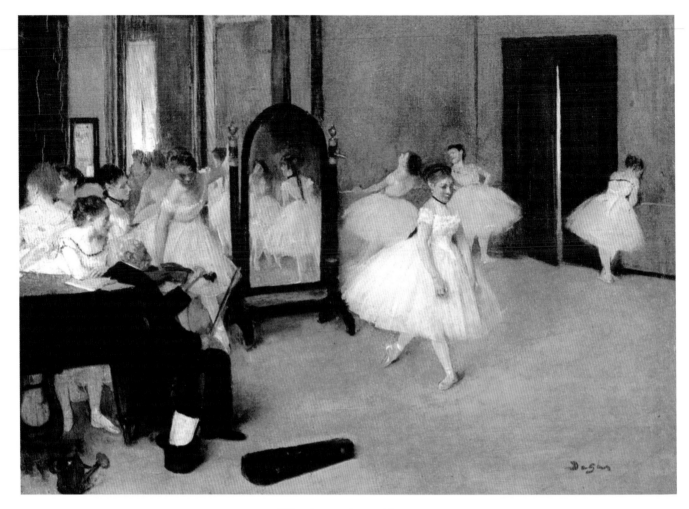

The Dancing Class
1871, oil on wood, 20 × 27 cm
Metropolitan Museum of Art, New York

In the early 1870s, Degas began to develop certain principles that would later form the basis of the Impressionist movement. Among them was the fact that color did not have an intrinsic value, but was a product of its relationship with the colors around it. Although, unlike the rest of the Impressionists, he never managed to accept the pre-eminence of color over line, in time he invested it with greater importance in order to highlight the motifs and even the spatial composition of his works.

It is strange that there do not appear to be any preliminary sketches for a painting such as this, nor are there any blemishes or corrections on the painting itself. Degas probably painted it in one go, which he rarely did with his oil paintings.

The Dancing Class was painted in 1871 and placed in the Durand-Ruel gallery in January 1872. Jacques-Émile-Édouard Brandon, the artist who owned the painting at the time, allowed it to be exhibited at the first Impressionist exhibition in 1874 and, from that point on, Degas became known as "the painter of ballerinas." He even referred to himself in these terms on a number of occasions, with a great sense of humor and without seeming to mind that he had a much more varied repertoire and was more than an artist who simply painted dancers. However, he was aware that his works reflected dance scenes in a way that no other painter had ever managed to do, so that in a certain sense he was reinventing the genre for which he would become famous.

Among the many works that make up this series, this one stands out for the presence of the musical instruments, the piano and violin, featured on the left of the composition, and the violin case on the floor, which emphasizes the oblique perspective toward the right of the painting. The watering can on the floor also appears for the first time, an element that Degas would use frequently in his paintings of ballerinas to help define the space.

Also worthy of mention are the mirrors in the middle- and background. Technically, they add a greater sense of depth and spatial complexity and, by reflecting the ballerinas obliquely, emphasize the perspective of the painting. To this end, the artist includes them in other paintings in this series, as well as in other works, including *The Absinth Drinker* (1875).

Symbolically, the mirror is regarded as the symbol of the soul, and Degas used it as such in other paintings of ballerinas and also in portraits, like the one of Madame Jeantaud (1875), to add depth to the psychological study of his subjects.

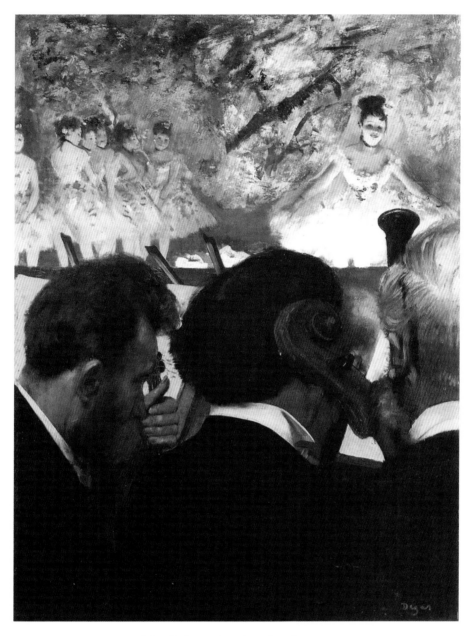

Musicians in the Orchestra
1871–1872, oil on canvas, 62 × 49 cm
Städtische Galerie im Städelschen Kunstinstitut, Frankfurt am Main

This painting represents a fleeting moment in the performance of a ballet, just as the ballerina in the center is taking her bow as the star of the show.

The ballerina seems much smaller than the musicians due to the distance between them.

There is an unusual chromatic balance since dark browns and blacks have been used for both the background and foreground, in stark contrast to the white dresses of the ballerinas and the musicians' immaculate collars. There is also a contrast between the texture of the starched collars of the musicians' shirts and the ballerinas' diaphanous tutus.

Above all, *Musicians in the Orchestra* is an exercise in light, which Degas uses in an almost traumatic manner, highlighting the dancers to the point of almost dazzling the prima ballerina, whose face suggests that she is slightly dazed by the glare of the footlights.

In the center of the three musicians, Degas's friend Désiré Dihau is playing the double bass, while in *The Orchestra of the Opera* (1870) he is playing the bassoon. Even so, this painting is not exactly a portrait since the musicians are seen from behind, with ill-defined features, in contrast to the ballerinas in the background.

To paint his ballerinas, Degas attended ballet performances for years, filling his notebook with sketches and notes. Before that, he also used to watch rehearsals in the classroom and from the stalls. Finally, in order to paint these canvases, he painstakingly gathered information from masters and pupils about the ballerinas who posed in his studio, where the works were actually painted.

Degas the collector

When Auguste Degas died, his son found himself obliged to sell part of his art collection, including four pastels by La Tour, in order to settle his father's debts. Perhaps this was why he later began to buy art again, though in a more haphazard manner. Between the late 1880s and 1905, collecting became a major obsession and he not only bought paintings but also walking sticks, scarves, and tapestries.

Degas was born into a social and economic milieu where collecting was an everyday phenomenon, having become increasingly popular during the early 19th century with the rise of the bourgeoisie. His father was a great collector of art and his favorite works included various 18th-century portraits. The most famous of these was probably the pastel by Jean-Baptiste Perronneau, which Degas included in a portrait of his sister Thérèse and which he later inherited.

But his father, who had a secondary interest in business, was also a great friend of some of the most important collectors of the day, for example Dr Lacaze who, in 1869, bequeathed his collection of works by Chardin and Rembrandt to the Louvre Museum, and Édouard Valpinçon, the father of Degas's classmate and lifelong friend Paul, who owned the so-called *Bather of Valpinçon* that bore his name. He was also on friendly terms with such great collectors of 18th-century art as Prince Grégoire Soutzo, who was himself a landscape painter and accomplished etcher, and Eudoxe Marcille. On Sundays, the only day that Degas did not have to attend classes, his father would take him to the Louvre to meet these collectors.

The genre of the collector's portrait flourished alongside this growing interest in collecting. Honoré-Victorin Daumier had drawn caricatures on the theme and, in 1882, Paul Mathey did a drawing of Degas, seen from behind and looking at engravings as one of a group of collectors.

Degas himself acquired several works in which collecting was the central theme, and even painted others that reflected this interest, for example *The Collector of Prints* (1866) and the portrait of *James-Jaques-Joseph*

Tissot (1868) (both in the Metropolitan Museum of Art, New York) – the latter ended their friendship when he learned that Degas had sold his collection. His friendship with the Rouart brothers, on the other hand, lasted until his death. Henri Rouart's passion was said to be contagious, since he had started by corrupting his brother Alexis and ended up converting the caretaker, who pulled off deals by buying works that he later showed – and sold – to Rouart. As a collector, Henri Rouart liked Chardin, Goya, and Fragonard. However, he was primarily known for his more avant-garde acquisitions, to the point that, since museums were not yet exhibiting modern art, most of it was to be found in Rouart's house, which was a must-see for any aspiring young artist.

Rouart had such an extensive collection that there was no more room on the walls of his house in the Rue Lisbonne for paintings, which were placed on easels, chairs, and even hung on doors. According to the poet and essayist Paul Valéry, "from the entrance hall to the attic, there was nothing but a succession of exquisitely chosen paintings." It was to be hoped that Degas, who was from a similar family and social background, would try to rebuild his art collection, insofar as his finances would allow. In the beginning, the artist referred to his interest with pride and a sense of humor. When moving house, he once said: "The Hotel Ingres is changing its location and is being transferred to 23, rue Ballu." At the time, he already harbored the dream of creating his own personal museum, where he would exhibit his own works and those of his favorite artists. In fact, as soon as his finances improved in the mid-1880s, his passion for collecting increased and he acquired historical works by Tiepolo and El Greco, although specializing mainly in 19th-century French paintings.

With regard to the independent artists, he began to buy paintings from his colleagues either because he admired them or to exchange works. On other occasions he even bought them to help his fellow artists. This was what happened in the case of ten paintings by Paul Gaugin, and the painting he presented to his friend De Valernes and later bought back for him. On the other hand, if he became annoyed with any of his contemporaries, he returned their work, as happened with Édouard Manet's

Buyers at the auction of Edgar Degas's studio, *Paul Helleu (1918), pencil and black, red, and white chalk on the cover of the catalog of the second studio auction, 26 × 38 cm, private collection.*

Plums. When Manet realized what had happened, he damaged the portrait that Degas had given him – *Monsieur and Madame Édouard Manet* – in which he is seated near his wife who is playing the piano. When they patched things up, however, Degas wanted to buy back the painting, but Manet had already sold it. Degas remembered the incident for the rest of his life: "I did a really stupid thing that day," he lamented.

Degas acquired seven of Paul Cézanne's paintings, and works by most of the Impressionists, except Claude Monet, whom he condemned for his lack of drawing. He

He sometimes bought paintings by artists he liked – for example he acquired 20 paintings and 88 drawings by Ingres, 13 paintings and 129 drawings by Delacroix, 1,800 lithographs by Daumier, 2,000 prints by Gavarni, and 7 landscapes by Corot. Like many artists of the day, he also collected Japanese prints, and owned a hundred or so by Hokusai, Kiyonaga, Sukenobu, and Utamaro.

acquired every example of Manet's graphic work, plus various paintings, to the point of becoming obsessive after the artist's death in 1883.

The anecdote recounted by gallery owner Ambroise Vollard concerning Manet's *Execution of the Emperor Maximilian* is illustrative of this obsession. According to Vollard, when Manet died, his brother-in-law had divided the work into several fragments, thinking they would be easier to sell. Vollard had the chance of buying one of them and, knowing that Degas had the fragment of the sergeant ordering the execution, went to show him his acquisition. "Degas thought this was sacrilege and began shouting excitedly, 'There's also the family! Try the family!' Then, attempting to recover his composure, he placed himself between me and the painting, his hand resting on it as if he were taking possession: 'You are going to sell me this. And you will go to Madame Manet's and tell her I want the sergeant's legs which are missing from my fragment, and also whatever is missing from yours – the group formed by Maximilian and the generals. Tell her I will pay whatever she asks.'" But the gallery owner returned empty handed – Suzanne Manet had used the other fragments to light the fire. With great patience, and in spite of his aversion for restorers, Degas reconstructed the canvas, leaving the missing fragments blank. But as luck would have it, after his death, the National Gallery in London acquired the work and the conservators decided to revert to the fragments. Perhaps it was destiny that had brought the artist face to face with

the restorers once again, since it appears that this lack of understanding was one of the things that, over time, persuaded Degas to abandon the idea of creating his own museum. The last straw was his visit to the Musée Gustave Moreau. Although he had once been a close friend of Moreau, he felt that the museum was "a truly sinister place," more like a hypogeum than a museum – "all those canvases collected together gave the impression of a Thesaurus, a Gradus ad Parnasum."

Degas kept his own canvases with as much satisfaction as he collected the works of other artists, only selling what was strictly necessary in order to live. In a letter thanking the collector Havemeyer for the sum of 500 francs in payment for one of his pastels, he admitted that "unfortunately, I needed the money."

Henri Rouart, who never accepted any of Degas's works but acquired them through gallery owner Paul Durand-Ruel, had to refuse to let the artist correct one of his favorite paintings, *Dancers at the Bar* (Phillips Collection, Washington D.C.), since he knew that, if he allowed him to do so, Degas would never return it to him. In fact, he knew him to be so reluctant to part with his own work that, in spite of having received payment on account from Jean-Baptiste Faure in 1873, the artist refused to part with two large-format paintings on the racecourse and laundress. In 1887, the baritone finally took him to court and he was ordered to hand over the two paintings.

At the time, Degas had stopped selling his works from his studio. Whenever a visitor asked to buy a canvas, he would show them out saying, "This is not a marketplace, it is a place of work." When he found out that some of his buyers were selling his works to make a profit, he stopped speaking to them, ignored them completely, or kept exchanges to a bare minimum: "No more than at the box office." It was extremely difficult to acquire one of his works, even for art dealers such as Ambroise Vollard who, in 1890, had abandoned his law studies to open an art gallery in the Rue Laffitte.

Degas was such an avid collector that Paul Durand-Ruel, his dealer and administrator, had to hold him in check from time to time. But the artist persisted. There are

The Execution of the Emperor Maximilian, *Édouard Manet, 1876, oil on canvas, 196 × 259.8 cm, Museum of Fine Arts, Boston.*

any number of notes from this period asking for advances, like the one written in 1889: "Do not deny me the little copy of Ingres, do not do me this affront or cause me this displeasure. I really must have it."

Degas attended auctions, where he would get angry because he believed he was made to bid up the price so that he paid more, or because he thought the rest of the buyers were unworthy. "Clear off!" he told one buyer, "You have no right to own this painting!" He also began to encounter growing competition from museums, associations, and collectors who regarded art as a financial investment. "There are no more disinterested buyers like you and me; they look at us as if we were idiots," he said to fellow artist Étienne Moreau-Nélaton. To make matters worse, many buyers used him as a point of reference. If Degas bid, they did the same. If he showed no interest, they stopped bidding.

While he lived in the Rue Victor Massé, his collection did not present a problem, since there was ample space to exhibit the works under good conditions. According to official documents, in his room he had the portrait of his father listening to Lorenzo Pagans, a diptych by Kiyonaga, two Italian landscapes by Camille Corot, two still lifes by Édouard Manet, a painting by Paul Gaugin, a drawing by Suzanne Valadon, watercolors and a sketch by Eugène Delacroix, and even an El Greco laid on his bed like a counterpane. In the living room next to the garden were a Corot and a Manet, and, in the study pastels and engravings by Bartholomé, Forain, Jeanniot, Lepic, and Rouart. His bust of Paulin and other sculptures by Bartholomé and Barye stood in the dining room. In the larger living room, he hung his favorite works, including several by Ingres. In 1901, he wrote to Hector Brame: " I haven't known how to do anything but accumulate beautiful paintings and no money." However, in the early 20th century, the price of works of art soared and Degas complained bitterly: "If my works sell at these prices, what will happen with those by Delacroix and Ingres?" There was even a time when he declared, "It is impossible to lay your hands on a Delacroix!" and what is even more tragic for any artist, "I can't afford to buy my own paintings!" He had confided to Daniel Halévy, "I buy and buy, I can't stop." In the Rue Victor Massé,

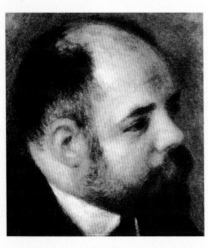

Gallery owner Ambroise Vollard (1867–1939) was one of the art dealers most familiar with the works collected by Degas. He wrote a biography of the painter and was involved in auctioning his works after his death.

his collection was hung on every wall in the house, but it was under threat.

In 1912, the house was put up for sale. Degas was given first refusal but said that the price was beyond an artist's means. Vollard, foreseeing the difficulties of a move, urged him to buy it, "You would only have to open a few portfolios to get the 300,000 francs!" But the painter flatly refused, preferring to move house, in spite of his failing physical faculties. When he moved, Degas agreed to let Vollard, Georges Rivière, and the sons of Paul Durand-Ruel help him transport the paintings, but made each of the many journeys between the two houses with them, so as not to lose sight of his precious works of art. But he refused to entrust the pastels or etchings to anyone, and transported them himself.

Given his Creole origins, once a week Vollard organized a tasting of dishes from La Réunion, his native island, which Degas used to attend. Little by little, the artist agreed to Vollard's exchanges. In his biography on Degas, the art dealer admitted how tedious this game was, comparing it to the game you play with a dog in order to get its bone. In Degas's case, the painter would exchange one of his own paintings for works in Vollard's gallery.

Practically blind, Degas was unable to get used to his new home. Apart from the paintings that hung in his own room, the rest were left just as they were, without being hung, piled up on the floor, or stacked against the wall. The few people who visited the artist in his last Paris home, on the Boulevard Clichy, found that the rooms had become virtual forests of easels, placed so closely together that you could hardly walk between them.

Degas died on September 27, 1917. When Durand-Ruel and Vollard went into his house, they found hundreds of paintings propped one against the other, framed pictures whose glass was covered with dust and grease, and wax sculptures that had degraded over the years. With the help of Degas's family, it took them several months, working six hours a day, to catalog the contents of the artist's studio.

The liquidation of his assets was one of the greatest artistic events of the day, since it took five auctions sell off all these works. These auctions were organized by Paul Durand-Ruel, Ambroise Vollard and the Bernheim-Jeune gallery and held in 1918 and 1919. The first four coincided with the German occupation and were punctuated by the firing of shells every fifteen minutes. In spite of this, buyers came from all over the world. The Germans did not want to miss such an opportunity and bought works through Swiss and Swedish intermediaries. The collection built up by Degas was dispersed once and for all.

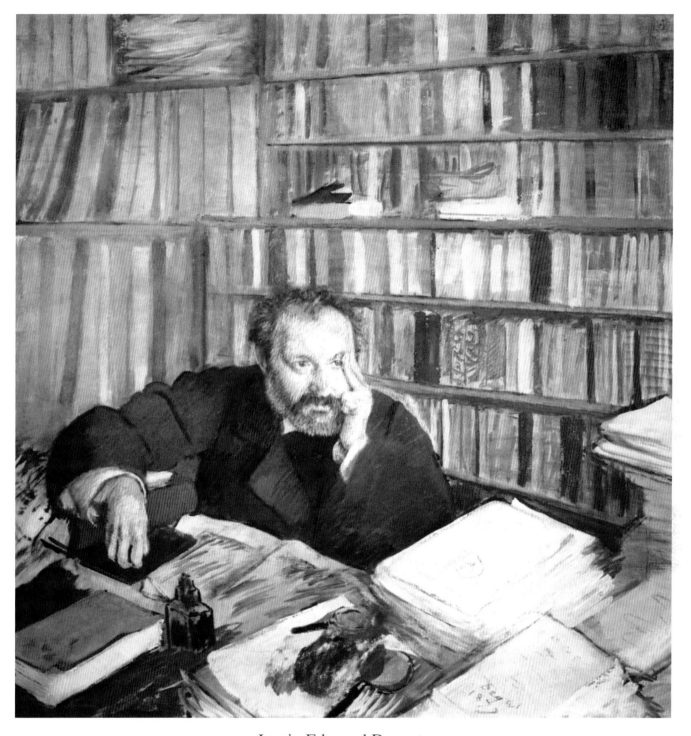

Louis-Edmond Duranty
1879, tempera, watercolor, and pastel on canvas, 101 × 100 cm
Burrell Collection, Glasgow

In the second half of the 19th century, the portrait of the art critic had become an established genre, a reflection of the importance of their role vis-à-vis the general public. They were basically responsible for explaining – in periodicals aimed at a general readership or in specialist reviews – works of art that were not easily intelligible to the public at large and which had been rejected by the artistic establishment.

Louis-Edmond Duranty (1833–1880) was a critic and writer, who had been the pupil of Jules Champleury and, with him, was one of the main representatives of the Realist movement. He published various novels between 1860 and 1878, which were criticized for their austere composition, and far removed from any virtuosity.

In *La Nouvelle Peinture* (1876), a brief treatise relating to the group of artists whose work was exhibited in the Durand-Ruel gallery, he clearly defined the characteristics of the so-called new painting: "What we need," he said, "is the special note of the modern man, in his dress, in all his social habits, in his house, in the street… through a gesture, an entire sequence of feelings." However, the work was criticized for being overly influenced by the ideas of Edgar Degas.

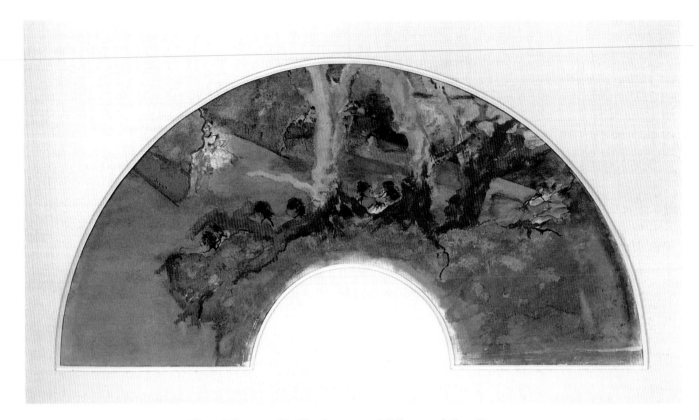

Fan Mount: Ballerinas and View of the Stage
1878–1879, gouache with gold applied on silk, mounted on paper, 31 × 61 cm
E.W.K. Bein Collection, Bollingen

Paintings on fans represent a marginal but not uninteresting simultaneous part of Degas' painting and graphic work. This indispensable accessory of the fashionable lifestyle of his times, and not only of Paris lifestyle, provided the painter with an eccentric but rather pleasant opportunity where all the typical features of his painting efforts were manifested.

The author did not undervalue this subject and covered it in a demanding manner befitting him. The drawings made in a studio according to a model or sketches where photographs helped him naturally became drafts for the paintings on fans. Truthful reflections of the life of Paris theatres and of their backstage always provided Degas with an inexhaustible source of themes.

In this rather marginal work, just as in his wall paintings and drawings, he also captures the fleeting moments, sort of journalistic-like close-ups of reality where the borders cut off the bodily shapes, as well as the all-revealing detailed knowledge of the environment of his models. He does not celebrate their feminine beauty; on the contrary, he ruthlessly studied and painted them in postures and movements, which painters had avoided up until then.

Gauguin, who much admired Degas, wrote that his female dancers were not women but machines in motion. Even when their light gauzy skirts fly nobody thinks of what is under them.

Even in his paintings on fans, Degas is a historiographer of a certain aspect of the Paris life of his times, the life that he captures in a most fleeting and yet most durable manner, combining the Impressionist ephemeralness with the strength of continuance, worthy only of the works of the greatest classics.

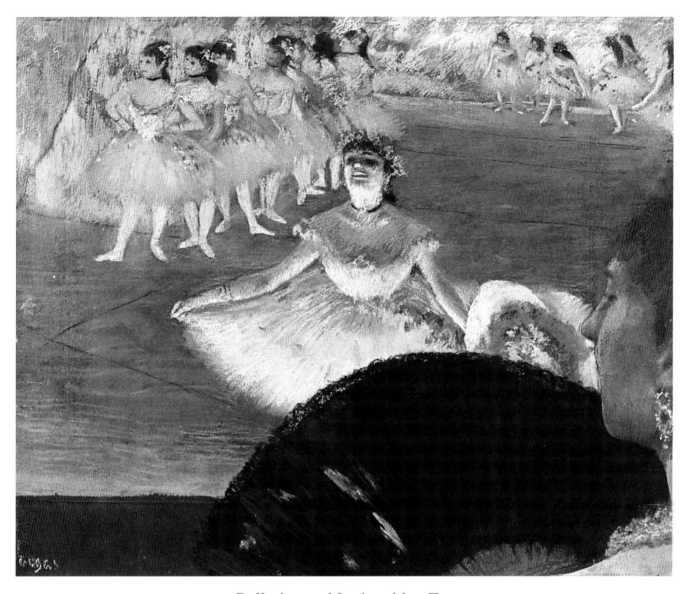

Ballerina and Lady with a Fan
1878, pastel, 40 × 50 cm
Rhode Island School of Design Museum of Art, Providence, Rhode Island

Although the scene of the ballerina taking her bow had been repeated in other paintings, for example *Dancer with Bouquet* (1877), the artist has here taken it a step further. In this work, the Japanese influence is represented by the fan, which is not only an oriental element but – placed between the stage and the spectator – also serves as a repoussoir or counterpoint within the composition.

The repoussoir was a favorite device among the Impressionists, who had copied it from the Japanese paintings and prints that they often collected. Camille Pissarro, with whom Degas was in contact during this period, was familiar with the *Hundred Views of Mount Fuji* (1883) by Hokusai, whose influence is very much in evidence in Pissarro's plein air landscapes painted in and around Pontoise.

Degas, on the other hand, used the device in his interiors, in accordance with his principles: "A painting should have a certain air of mystery, something whimsical and fanciful about it. If the artist always dots his 'i's', he becomes boring. Even when painting from nature, it is essential to compose, although there are those who believe this is forbidden. Corot also felt compelled to compose from nature and this is above all where his charm lies. A painting is an original combination of lines and tones that complement each other…"

Indefatigable, Degas continued to experiment, and in 1880 painted *Ballet Seen From an Opera Box*, a new interpretation of this painting, in which the more vertical format eliminated the female figure, showing only the fan in the foreground, and the stage with the ballerinas in a different position, in the background.

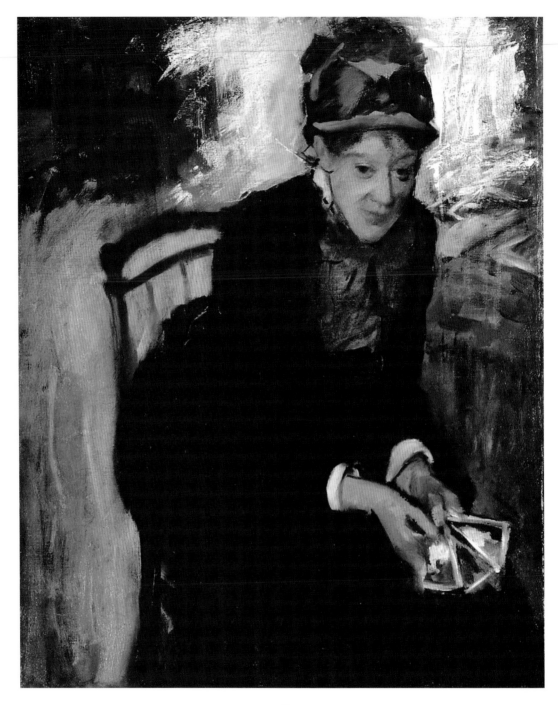

Mary Cassat

c. 1884, oil on canvas, 72 × 59 cm
National Portrait Galley, Washington D.C.

Degas painted a great many portraits and made numerous drawings of Mary Cassatt (the most memorable portrait is *At the Milliner´s*). In this painting, he wanted to convey the vivaciousness of his subject who is depicted in a natural but somewhat "unfeminine" posture – leaning forward, listening attentively to the conversation, her legs slightly apart and her arms resting on her thighs, holding a few photographs in her hand.

Unusually, Degas has painted Cassatt as he had previously portrayed his sister Thérèse, in two portraits, and Madame Jeantaud – dressed to go out, or as if she had just arrived, still wearing her coat and hat, with the bow tied at her throat. This also indicates that she was someone who led an active social life.

Here, Cassatt is not represented as an artist, surrounded by paintings attesting to her artistic interests, as in the portrait of *James-Jacques-Joseph Tissot*, painted in 1868. However, neither does Degas lapse into the overly feminine style used by Édouard Manet to portray his sister-in-law, Berthe Morisot, on several occasions. Manet always emphasized Morisot's large, dark eyes, or represented her – as in Repose (Berthe Morisot) – in a classical pose, with a haughty expression.

Degas used only the whites, blacks, and dark browns typical of his early portraits, although here they are applied with much greater freedom of movement using extremely expressive strokes, as in the area of white that serves as a background for Cassatt's attentive gaze.

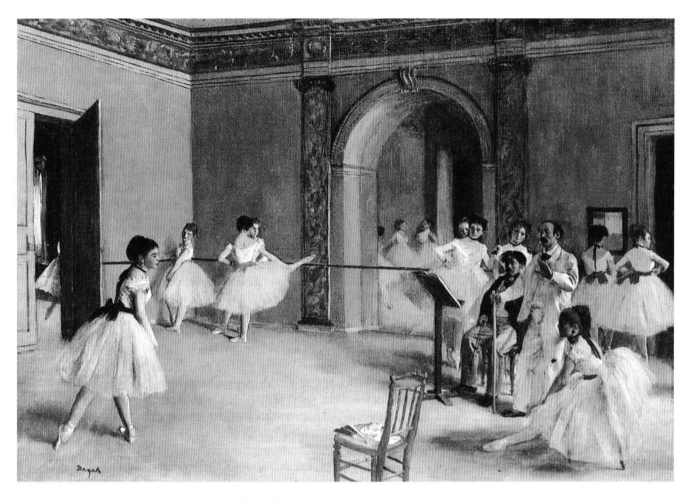

The Foyer of the Opera House
1872, oil on canvas, 32 × 46 cm
Musée d'Orsay, Paris

Degas was the first artist to paint the reality of life behind the scenes – the rehearsals and examinations, the weariness of the dancers, the need to take care of their clothes, and the social influences that went on backstage. "They call me the painter of ballerinas," he wrote and repeated throughout his life, appropriating the expression coined by the public and critics at the first Impressionist exhibition of 1874.

Writing about his brother's work, in 1872, René de Gas referred to "the small painting that really strains your eyes." He could well have meant this one since, not only was it painted in great detail, but the surface area of the canvas seems to expand due to the rich sense of space developed by the artist in the 1870s.

This is helped by the fact that he has placed a large mirror in the center of the background which, as well as practically duplicating the space of the rehearsal room, enriches it by giving the impression that there are two separate rooms, each with its own light and texture. Only the clearly defined red bar which runs across the back of the painting indicates that the real space ends at the wall.

The sense of space is also increased by the open door on the left, offering a glimpse of a ballerina's leg. The device of hinting at other areas was typical of the Dutch school, which strongly influenced him in his early career. The effect of showing part of the body, which is completed in the observer's imagination, would become extremely characteristic of Degas's work, not only in his paintings and drawings, but also – and this was much more developed in the later years – in his sculpture.

Another characteristic of Degas's paintings of ballerinas, which also helped to increase the spatial dimension, was the empty space in the center. In this case, the pose of the ballerina on the left suggests that she is about to perform a pirouette, which the observer can intuitively complete. To better frame its execution, the artist placed an empty chair in the foreground, which separates the observer from what is going on in the rehearsal room, while at the same time including him or her in the circle of dancers surrounding the ballerina, and with whom she or he appears to be watching the scene.

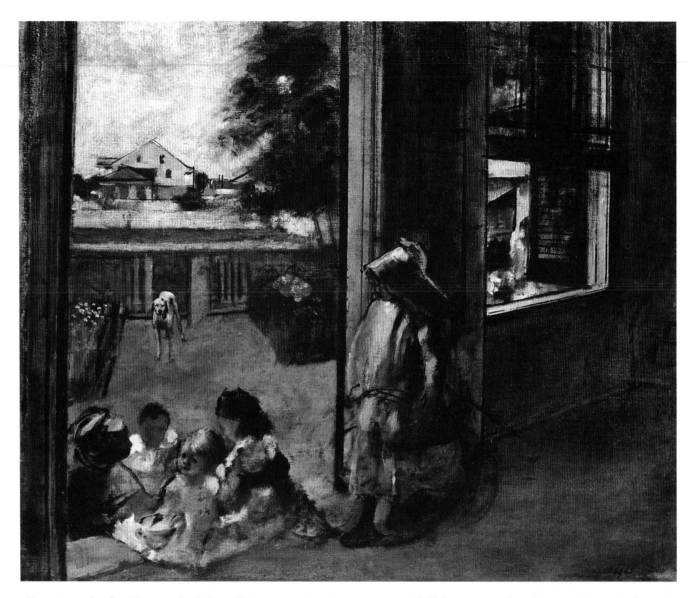

Courtyard of a House in New Orleans (also known as *Children on the Steps, New Orleans*)
1872–1873, oil on canvas, 60 × 75 cm
Danish Museum of Art and Design, Copenhagen

Degas's maternal grandfather, Germain Musson, owned a cotton business in New Orleans. In 1830, following his wife's death, he moved to France with his children so that they would receive a better education. However, one of his sons, Michel, decided to return to Louisiana to run the family business. Although he fathered seven children, only three girls survived – Désirée, Estelle, and Mathilde.

In 1866, Degas's brothers, René and Achille, moved to Louisiana to found a wine importing business. René married his cousin Estelle, who later became blind and whom he divorced years later.

Here, the artist used part of the Musson family home on Esplanade Avenue as a background for the scene, which may have been painted from the room reserved for the artist, where he could paint undisturbed.

The girl standing to the right of the door is Carrie Bell, the daughter of his cousin Mathilde Musson and William Bell, who worked in the cotton business of his father-in-law, Michel Musson, and who appears in *The Cotton Office, New Orleans* (1873). His wife Mathilde posed for the *Portrait of a Young Woman*, painted in the same year.

The two children sitting near the nanny have been identified as Odile de Gas (facing the artist) and her brother Pierre (behind her). In the background is the family dog, which Degas named Vasco da Gama.

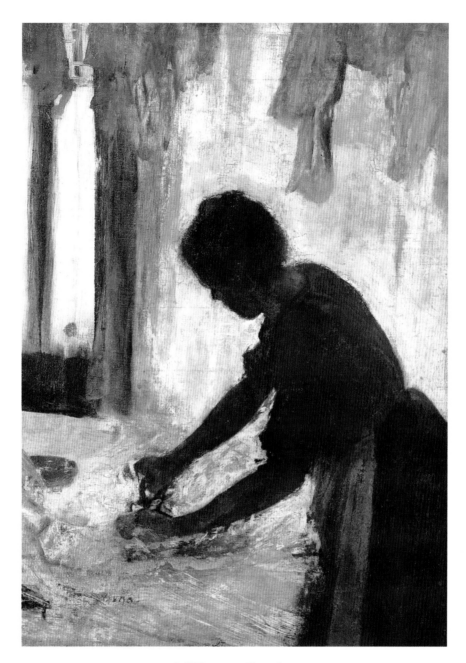

A Woman Ironing
1873, oil on canvas, 54 × 39 cm
Metropolitan Museum of Art, New York

This is one of the first in a series of paintings of laundresses that Degas began on his return from New Orleans. As soon as it was finished, it was bought by the Durand-Ruel gallery for the not inconsiderable sum of 2,000 francs. A few months later, it was bought by the baritone Jean-Baptiste Faure, together with five more of the artist's works. When it was exhibited at the second Impressionist exhibition, in 1876, together with four other works on the same theme, critics such as Émile Zola commended it highly, and considered it perpetuated the tradition of Honoré-Victorin Daumier. However, this opinion was not unanimous.

There is no doubt that the work represents a new form of painting, the result of the influence of the novel *Manette Salomon* – published by the Goncourt brothers in 1864 – on Degas's work, an influence that the artist himself always acknowledged.

There is a striking contrast of light and shadow between the figure in the foreground and the exaggeratedly white clothes hanging in the background. The movement of the arms was corrected by Degas after Faure had bought the painting.

This apparently banal favor complicated the artist's life since he received the painting on loan, the baritone having bought five other paintings from the Durand-Ruel gallery that Degas wanted to retouch. Faure paid 8,000 francs for the works, on condition that Degas painted four or five larger versions for him, for which he paid 1,500 francs on account. But the death of the painter's grandfather and father, and the attendant financial and administrative arrangements delayed the execution of the works. The matter ended badly for both of them, and Degas sold the painting back to Durand-Ruel in 1892.

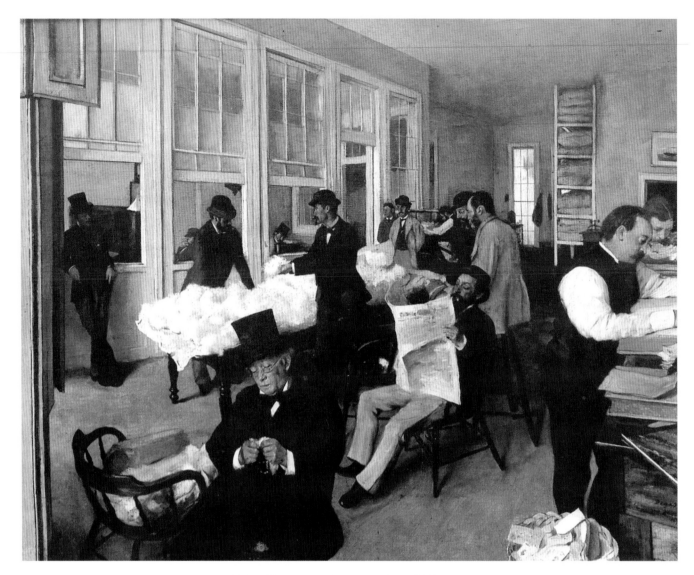

The Cotton Office, New Orleans
1873, oil on canvas, 73 × 92 cm
Musée des Beaux-Arts, Pau

This canvas was painted while Degas was staying with his relatives in New Orleans, a city made wealthy by the cotton trade and which, at the time, was the fourth major city in the United States. "Here one speaks of nothing but cotton and trade," wrote Degas. "Here people live for cotton and by cotton." In the picture, the artist offered a general impression of the tranquillity and future prosperity of the United States.

This is Degas's most original work, since the theme of an office full of people did not have many precedents in the history of painting, but in fact came closer to the literary realism of the time. In early 1873, he wrote to the artist James Tissot: "I have attached myself to a fairly vigorous picture which is destined for Agnew [a London art dealer] and which he should place in Manchester (for if a mill owner ever wished to find a painter, I would be the one), *Intérieur d'un bureau d'acheteurs de coton à la Nouvelle Orléans* A raw picture if ever there was one...." Possibly because he painted it with an English gallery in mind, Degas drew on influences from the works of Tissot and Whistler.

Even so, the artist gave it an atmosphere reminiscent of Spanish and Dutch Baroque interiors, where people were also portrayed in everyday situations, and especially the interiors of the businesses being established in the 18th century. Édouard Manet was extremely familiar with this period of history and also used the contrasts of black and white typical of the time. Here they are used by Degas for the brilliant white of the cotton and papers that stand out against the black suits and accessories of the figures.

The treatment of light and space is also typical of Dutch painting, as are the many windows and the way in which the panes of glass are painted. Another typical feature of the Dutch school is the attention to detail, for which Degas used extremely fine brushes. With these he was able to give greater precision to the wastepaper basket in the foreground, on the right, which would become a symbolic motif echoed by other US artists, for example the Irish-American painter, William Michael Harnett (1848–1892).

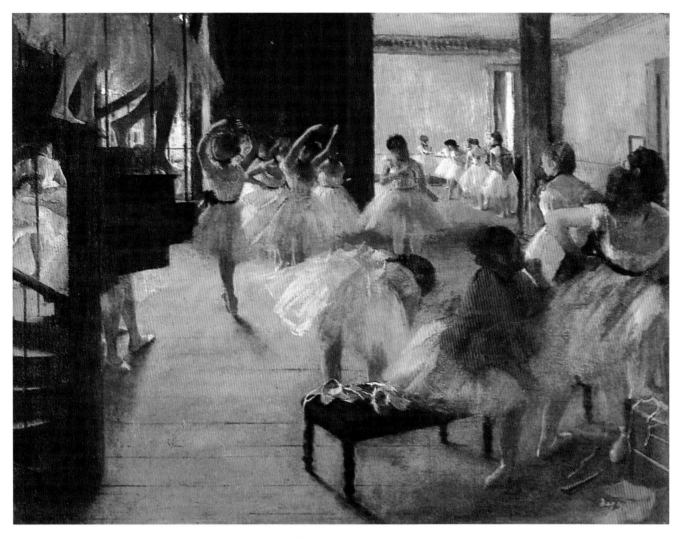

Dance Class
1873, oil on canvas, 48 × 62 cm
The Corcoran Gallery of Art, Washington D.C.

In the early 1870s, Degas began the ballerina series, which was undoubtedly his most important, but also his best known. It is not known for certain how the artist became interested in ballet, although several of his friends (Ludovic Halévy, Albert Hecht, and the Comte Lepic) were habitués at these performances. Furthermore, it was a genre that lent itself to certain characteristic aspects of the artist's work – on the one hand, it allowed him to touch upon an everyday theme by exploring the ballerinas' lifestyle and, on the other, the dancing took place in enclosed spaces, which enabled him to apply his techniques of painting interiors.

When he started the series, Degas would not allow himself to visit the rehearsal room of the Opera House, in the Rue Le Peletier (the building was destroyed by fire in the year this work was painted), but only empty premises. Thus, the rehearsals and examinations in this first series were not copied from real life, but were artistic creations.

Although things changed in the 1880s, after Degas had written to his friend Albert Hecht in 1882 asking him to approach the director of the Opera House on his behalf, this *Dance Class* still belongs to the group of paintings that were the product of the artist's imagination. In the later series, once Degas had worked out the composition of the painting, the ballerinas would go to his studio and pose for the movements he required. This painting represents a break during the dance class, although the ballerinas' gestures are much more studied and elegant than those of the dancers painted in this context in subsequent decades. This studied elegance is enhanced by the contrived atmosphere, reminiscent of an interior from the Dutch school – the brushstrokes are smooth and light, the finish extremely detailed, while the light is brighter in the background, especially in the room on the right.

Even so, the critics of the day saw this scene as inelegant, since several ballerinas were attending to such banal tasks as tying the ribbons of their ballet shoes or adjusting their waistbands. The ballerina in the foreground, wrapped in a red shawl, is even sucking her thumb. But the fact is that the artist wanted to portray the reality of the ballerinas' life in detail, in other words, what went on behind those graceful performances on stage.

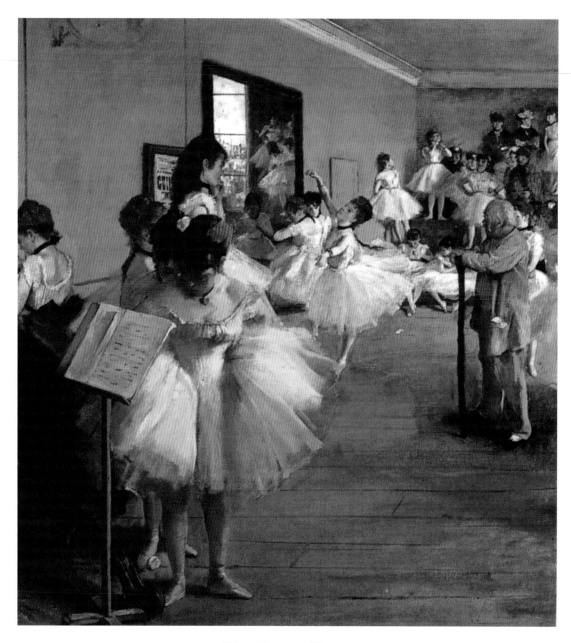

The Dance Class
1874, oil on canvas, 83 × 76 cm
Metropolitan Museum of Art, New York

In a letter published in *Paris Journal* on February 13, 1874, the Goncourt brothers wrote that Degas tried to explain with words and gestures what he wanted to represent on his canvases: "The artist shows his paintings, occasionally illustrating his explanation by mimicking a choreographic movement, by imitating – according to the ballerinas' jargon – one of their arabesques. And he is really amusing to see, on tiptoe, arms linked above his head, combining the esthetics of the dancing master with the esthetics of the painter, while speaking of the dull, muddy tones of Velázquez and the outlines of Mantegna."

In these paintings on the theme of ballet, the pupils form an arc around the dancing master, Jules Perrot, who is leaning on his cane, as they perform the most diverse gestures – adjusting their bodices, scratching themselves, raising a hand to their mouths, and talking amongst themselves.

In this particular work, the artist painted a more restrained version of his Dance Class of 1873, eliminating the pilasters of the wall, and the many lines that formed the vanishing point. The space is more austere, enclosed by walls painted a strong shade of green, while the large mirror on the left completes the oblique perspective of the composition.

The wooden floor does not follow the orientation of the figures toward the back of the composition, but consists of horizontal boards that reduce its depth. Paul Valéry was not mistaken when he wrote, "Degas is one of the few artists to have invested the floor with importance. He has [painted] some remarkable floors.... The floor is one of the essential elements in the overall view of things. The reflection of light depends largely on the nature of the floor."

1875-1879

1875

— In summer and winter, Degas takes part in the tenth and eleventh Exhibition of the Society of French Artists organized by the Durand-Ruel gallery at 168, New Bond Street, London.

— The new premises of the Paris Opera House at the Palais Garnier are inaugurated on January 5th.

1876

— Degas exhibits twenty-four works at the second Impressionist exhibition of the Société Anonyme Coopérative des Artistes, Peintres, Sculpteurs, Graveurs, etc., held in the Durand-Ruel gallery, at 11 rue Le Peletier. The critic Georges Rivière writes the first article on the Impressionist movement and, on April 12, Louis-Edmond Duranty publishes *La Nouvelle Peinture*, a brief treatise relating to the group of artists whose work was exhibited in the Durand-Ruel gallery. In it, he discusses the so-called 'new' painting, with its strongly realistic subject matter, primarily based on the theories of Degas, to whom some even attribute its authorship.

— In spring, Degas takes part in the twelfth Exhibition of Pictures by Modern French Artists and, in November, the seventh Exhibition of the Society of French Artists, both held at the Deschamps gallery, 168, New Bond Street, London.

— In September, the Symbolist poet Stéphane Mallarmé publishes *The Impressionists and Édouard Manet* in London, in which he praises Degas's paintings.

— Degas takes part in the third Annual Winter Exhibition of Modern Pictures that opens in Brighton on September 7th.

— He also works unstintingly on etchings and monotypes.

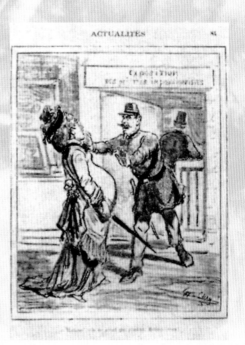

Study of a ballerina at the bar
1875–1876, pastel and charcoal on paper, 46 × 29 cm, Wildenstein Collection, Paris. From the late 1870s onward, Degas drew increasing numbers of individual studies of ballerinas.

1877

— On April 4, the third Impressionist exhibition opens on the upper floor of 6, rue Le Peletier. Degas presents three groups of monotypes and twenty-three works in oil and pastel on the themes of ballerinas, cafés-concerts, and nudes.

— Degas moves to an apartment at 4, rue Frochot, comprising a dining room, large living room, two bedrooms with separate access a small sitting room, and kitchen. He also had a large photographic studio, three small studios, and a small sitting room on one of the upper floors of the same building. After a few months, he was obliged to move again, this time to 50, rue Lepic.

Two cartoons by Cham published in the satirical magazine Le Charivari, in 1877. The Impressionist exhibitions continued to attract a great deal of negative criticism.

Lady in Town Clothes, *c. 1879, pastel on gray paper, 48.5 × 42 cm, Walter Feilchenfeldt Collection, Zurich. Degas wanted to represent the different types of people he encountered in Paris, going beyond their formal appearance in order to highlight their faces.*

1878

— Degas takes part in the exhibition of paintings, drawings, etchings, and sculpture by living artists, organized by the Société des Amis des Arts (Friends of Art) and held in the society's rooms at the Musée des Beaux-Arts, in Pau. *The Cotton Office, New Orleans* is bought by the museum for 2,000 francs and becomes the first of Degas's paintings to be acquired by a French public institution.

— Through Louisine Elder, a friend of Mary Cassatt's, Degas exhibits *The Dance Class* at the eleventh Annual Exhibition of the American Watercolor Society, in New York.

— He sees the photographs of Eadweard (sic) James Muybridge published in the science journal *Nature*, showing the deconstructed movement of galloping horses.

1879

— The fourth Impressionist exhibition – which Degas wants to call the Salon des Indépendants (Exhibition of Independent Artists) – is held from April 10 to May 11 at 8, avenue de l'Opéra. He exhibits five fan mounts and twenty other works in oil and pastel.

— He continues to work on his etching techniques and plans to publish a periodical on etching and engraving, *Le Tour et la Nuit,* with Mary Cassatt and Camille Pissarro.

— He moves into an apartment at 19 bis, rue Fontaine, which comprises a studio, landing, and bedroom.

Degas Astounded, *Pablo Picasso, April 9, 1971, drawing, Musée National Picasso, Paris. In the late 1870s, Degas began to paint nudes and, to this end, visited the brothels of Paris.*

Marcellin Desboutin, *Degas, c. 1876, oil on canvas.*

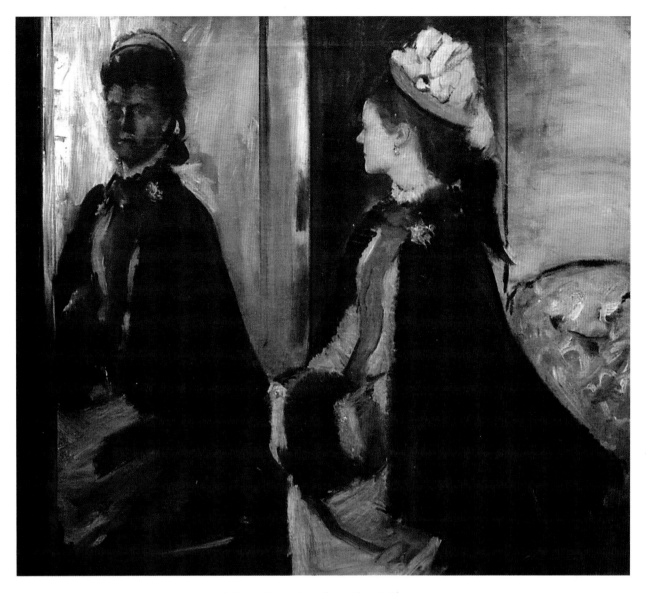

Mme Jeantaud at the Mirror
c. 1875, oil on canvas, 70 × 84 cm
Musée d'Orsay, Paris

Madame Jeantaud was the wife of a soldier who had served at the front with Degas during the Franco-Prussian War (1870), and who features in the *Portrait of Jeantaud, Linet and Lainet* (1871).

This portrait is a reinterpretation of the classic at-the-mirror genre that had been popular since the Renaissance. The subject is portrayed in profile, while the reflection in the mirror looks directly at the observer.

This not only serves to give depth to the painting, but also psychological depth to the subject, a device used in other paintings by Degas, for example *The Dancing Class* (1871) (see page 50).

Apart from the mirror, there are a great many classical influences in this painting, due to what Degas's biographers have described as a sort of "reference anxiety" which makes him want to give the portrait an air of majesty, typical of the 17th century, but which also reflects the smooth brushstrokes of Jean-Baptiste-Siméon Chardin.

In fact, Degas was greatly inspired by Chardin, and by his earlier experience as a portraitist. The woman is wearing a cloak and carrying a muff, which suggests that she is about to leave, or that she has just arrived. The artist created this same impression in the portrait of his sister Thérèse, painted in 1863, and like his sister, the woman in this painting is also turned to the right.

The lack of light on the face reflected in the mirror is surprising, making the expression almost impossible to decipher. The poet, essayist, and critic, Paul Valéry, said that Degas's habit of obscuring his subjects' faces was due to the fact that the artist had lived most of his life alone, and that "his gloomy gaze never saw anything through rose-tinted glasses."

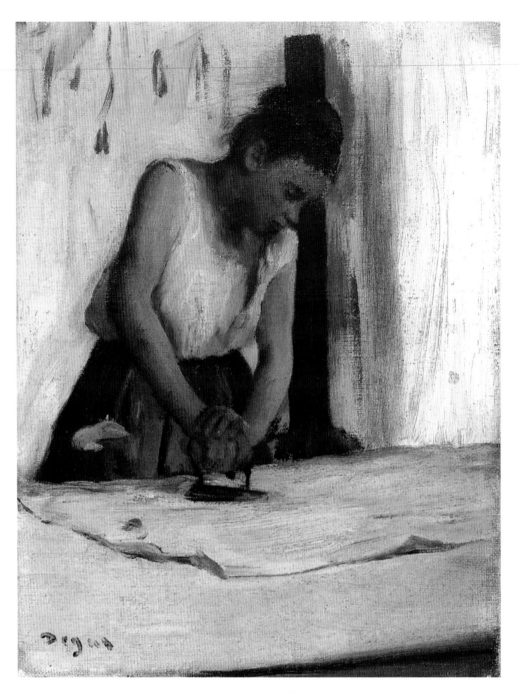

Woman Ironing
1875, oil on canvas, 25 × 19 cm
Norton Simon Museum, Pasadena

According to the poet Charles Baudelaire, "The artist, the real artist, will be the one who evokes the epic aspect of modern life, who makes us see and hear, with paintings and drawings, how great and poetic we are, with our bows around our necks and our patent-leather boots." Degas followed Baudelaire's theories on art, both in press articles and in his poetry, with great enthusiasm. It is known for a fact that he kept the volumes of his *Complete Works,* lent to him by Édouard Manet, for quite some time, in spite of Manet's repeated requests for their return.

Every day, Degas used to walk through the streets of Paris in search of models for his works, making sketches in his notebook of a gesture or feature that might help him to define one of his figures. "I don't like horse-drawn carriages. You don't see anyone. I prefer the omnibus. You can observe people. We are made to observe each other."

However, in paintings such as *Woman Ironing,* the artist was not making a social statement. One of the great aims of the Third Republic had been public education, and this made Degas see red: "Education consists of teaching an incompetent man a great many crafts that enable him to live. In the past concierges' daughters learned to dance, now they have municipal diplomas...." And: "Education! What a crime! Look at the Bretons. As long as they make the sign of the cross they are brave. But take away their faith and they become cowards. What a crime!" He had most to say on the pleasure of art: "Art for the people. How dreary! But nowadays, even the lowliest shopkeeper's assistant dresses like a gentleman!"

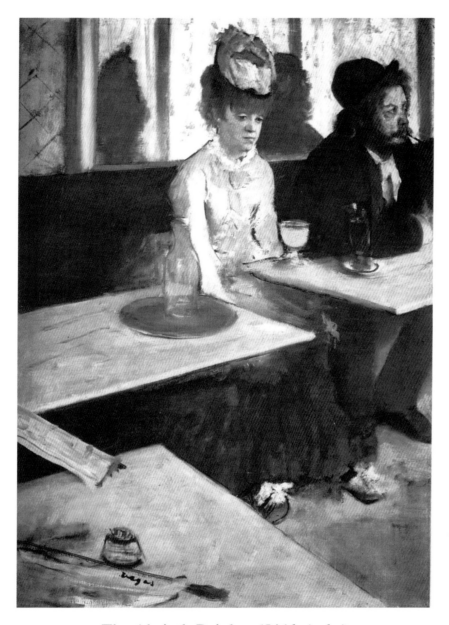

The Absinth Drinker (*L'Absinthe*)
1875–1876, oil on canvas, 92 × 68 cm
Musée d'Orsay, Paris

In this painting, Degas depicts the interior of the Café La Nouvelle-Athènes, one of the most important public meeting places in Paris. This was where artists met and held informal gatherings, which gave rise to all kinds of discussions and exchanges of information.

As such, the café was an extremely important setting, not to say the protagonist, in the literary works of Joris-Karl Huysmans and especially Émile Zola's *L'Assomoir* (*The Drunkard,* although the French literally means "club" or "cudgel"), which was published in installments in 1876. Even the critic and writer Louis-Edmond Duranty published a novel entitled *L'Absinthe*. The café also features prominently in the paintings of Marcellin Desboutin, Manet, and Toulouse-Lautrec. Degas preferred the cafés-concerts that appeared in a great many of his works, enriched by the effects of artificial light that fascinated him so much.

While Degas regularly frequented the cafés-concerts, which belonged to the best Paris hotels, he went to cafés much less often. Even so, it is known for a fact that he met with the Impressionist painters at the Café Guérbois, at 11, grande-rue des Batignolles (now, 9, avenue Clichy), until the outbreak of the Franco-Prussian War in 1870. After the war, the group met at the Café La Nouvelle-Athènes, where the regulars included Manet and the painter and etcher, Desboutin, who posed as one of the models for this painting, smoking his familiar pipe.

The female model is actress Ellen Andrée, another friend of Degas's, who also posed for paintings by Henri Gervex, Manet, and Renoir. Here, Degas makes her the focus for the sordidness of the scene. *The Absinth Drinker* is not about the light-hearted drinkers featured in traditional paintings, but the effects of alcohol drunk to excess. It also characterizes one of the most detested roles in the new urban society – the drunken woman.

69

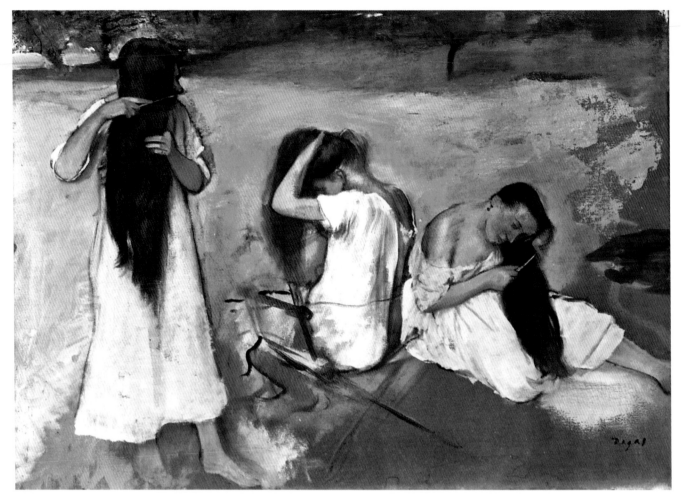

Women Combing their Hair
1875–1876, oil on paper mounted on canvas, 35 × 47 cm
Phillips Collection, Washington D.C.

Although this scene appears to have been painted outdoors, Degas completed the work by inventing the background that was executed rapidly using thick brushstrokes.

Generally speaking, Degas refused to paint directly from nature, *en plein air,* since he believed – like all Ingres's disciples – that an artist should first of all copy from the great masters before putting themselves to the test by executing a painting directly from the motif.

This is why, in the early 1870s, he clashed with painters like Monet, Pissarro, and Cézanne, who believed that the observation of nature was fundamental to the 'new' painting. Degas was also bothered by the sun and the dampness of the atmosphere, which affected his sight, so that it is not known for certain just how much he disliked painting landscapes.

The fact remains that Degas did not paint *en plein air* and, when he painted landscapes, he did so, as in this instance, from memory – he may have observed details such as these while on holiday. Occasionally, he expressed a liking for a particular landscape and, like this one, included it in his interiors. In the summer of 1870, while spending a few days at the home of Paul Valpinçon at Ménil-Hubert, in Normandy, he painted a few landscapes from the window of his room since, as he acknowledged in one of his letters, "From time to time, I put my nose to the window."

Although at first glance it may seem that Degas has painted three different models in *Women Combing their Hair,* he has in fact painted the same woman in three different poses, as if in a frieze. He was very fond of this device and used it in an oblong format in his ballet scenes.

Here, there is room to add the distinctive characteristic of the model seen from three different angles, as if in a cinematographic sequence.

The model herself is not important. Nor has a great deal of attention been paid to painting the details of her face. Her long red hair – which appears increasingly in Degas's scenes of women combing their hair – has been made the real protagonist of this painting.

It was in the 1870s that Degas began to paint women combing their hair and washing themselves, a theme that he would gradually explore in more depth.

Woman with Dog
1875–1880, oil on canvas, 40 × 48 cm
Nasjonalmuseet, Oslo

This painting was acquired by and remained in the gallery of Ambroise Vollard, who would certainly have appreciated its innovative composition.

In fact, the viewpoint is extremely unusual, foreshortened and almost from behind, showing no more than the woman's basic profile, obscured by her hat. This fleeting glimpse is countered by the figure of the dog, which is portrayed in much more detail and with an almost geometric profile.

The brushstrokes are rapid and the lines vigorous, while the colors are applied in broad areas that are barely blended. This helps to create the forms, which are highlighted by a thick black line that contrasts with the white of the hat and the woman's pale face, separating them from the light blue background.

Degas's subjects revealed the "heroism of modern life" to which Charles Baudelaire referred, and which was to be found in an infinite variety of forms in 19th-century Paris, capital of the world. However, as he began to explore Realism, in the 1870s, Degas tended to paint women whose faces were obscured, as in *Ballerina and Lady with a Fan* (1878) (see page 57) or in shadow, as in *Mme Jeantaud at the Mirror* (1875). This may have been due to the artist's ambiguous relations with women at the time.

This was patently obvious in a number of his writings, for example the letter to Henri Rouart, written in 1872 during his stay in New Orleans: "I am thirsting for order. I do not even regard a good woman as the enemy of this new method of existence. A few children for me of my own, is that excessive too? No, I am dreaming of something well done, a whole, well organized (style Poussin), and Corot's old age. It is the right moment, just right. If not, the same order of living, but less cheerful, less respectable and filled with regrets."

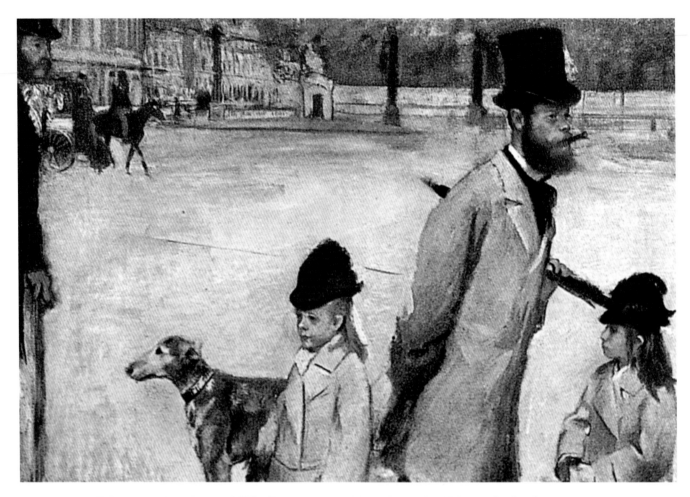

Vicomte Lepic and His Daughters Crossing the Place de la Concorde
1876, oil on canvas, 79 × 118
State Hermitage Museum, St Petersburg

Daniel Halévy told a story about Degas that clearly illustrates the impression people had of him: "'What have I been hearing?' he shouted one day, entering the house of a charming young woman – one of his favorite hostesses – like a whirlwind and addressing her from the threshold. "What have I been hearing? You are telling everyone that I am not a bad person, that they are mistaken about me. If you take this away from me, what do I have left?"

In fact, the artist had forced himself to appear hard and indifferent. He sometimes did this to provoke the good-natured Camille Pissarro, who was known for his defense of social rights, by pointedly asserting that "art was not for the poor." Even so, he regarded Pissarro as his friend and had made plans with him and Mary Cassatt to launch a journal on etching and engraving.

On other occasions, however, he did it to defend several mediocre painters who belonged to his circle of friends, for example the Vicomte Lepic, who was an accomplished etcher but did not make the grade as a painter. "And what about your Lepic?" Renoir asked sarcastically one day. "Isn't he here? A great deal of talent … but what a shame he rings hollow!"

Thanks to the redevelopment of Paris by Baron Georges-Eugène Haussmann, artists began to paint their subjects against the background of a new city. In this scene, Degas not only wanted to depict the open spaces created as a result of this development, but also the use made of them. Just as on the city's streets and squares, people began to appear, moving quickly as they crossed from one side to the other.

Here he portrays his friend, the Lepic, lost in thought, with his umbrella under his arm, facing in the opposite direction to his daughters and his dog – the vicomte was also a "supplier of good dogs."

In contrast to the scene, the man on the left appears to have stopped and turned to look at the protagonists of the painting, while a horse walks elegantly across the far side of the square. The Place de la Concorde is portrayed as a large and mainly empty space, where movement may occur at any moment and in any direction.

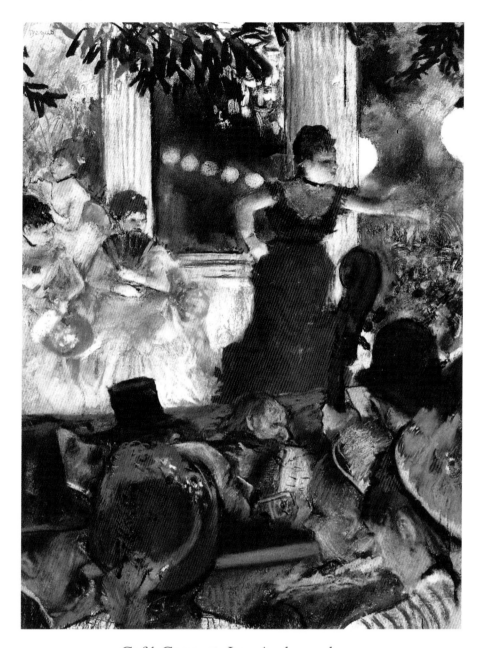

Café-Concert, Les Ambassadeurs
1876–1877, pastel over monotype 37 × 27 cm
Musée des Beaux-Arts, Lyon

Degas divides this scene horizontally, as he had already done in *The Orchestra of the Opera* (c. 1870) and *Musicians in the Orchestra* (1871–1872) (see pages 49 and 51). In this way he differentiates between the audience in the foreground and the stage in the background, although both planes are linked by the singer's left arm extended toward the audience.

The fact that the view of the stage from the foreground is obscured by hats and the neck of the double bass, gives the scene greater authenticity by creating the impression that the observer is seated among the audience.

The neck of the double bass was a motif used by Degas in his paintings of orchestra musicians, and became one of the symbolic leitmotifs of his work. As well as being attracted by its form, its dimensions enabled him to separate or create unity within scenes – a detail that was adopted by subsequent painters.

This work was exhibited at the third Impressionist exhibition, in 1877, and was highly acclaimed by critic Georges Rivière: "What art in the female figures sketched in the background, with their muslin dresses, behind their fans, and in the audience in the foreground, watching, their heads erect, craning their necks, captivated by the ribald song and provocative gestures!

"This woman, if I am not mistaken, is a contralto steeped in brandy…

"The singer's gesture as she leans toward the audience is extraordinary, and is unquestionably a consequence of her success. This woman does not keep to what actors call 'lines.' No, she appeals to the audience, questions them, knowing they will answer as she wants them to – answer her, as she controls the despot whose vices she flatters."

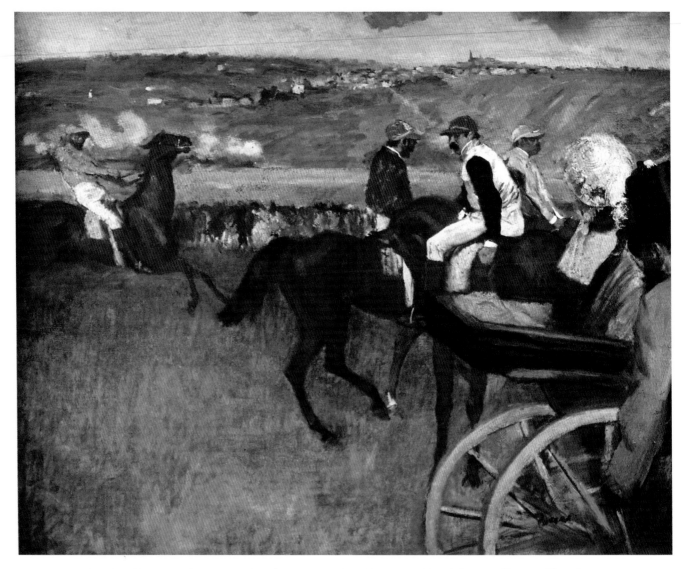

At the Races, Amateur Jockeys on the Course, Beside an Open Carriage
1876–1887, oil on canvas, 66 × 81 cm
Musée d'Orsay, Paris

This painting was commissioned by the French baritone Jean-Baptiste Faure and Degas is thought to have started it in 1876. However, he made a great many alterations and took so long to finish it that, after eleven years, Faure instituted legal proceedings.

The composition is inspired by photography, since the carriage and one of the figures in the foreground, on the right, are cropped by the right-hand edge of the painting. Degas had already used this device in *Carriage at the Races* (1869) in which the family of his friend Paul Valpinçon are featured in the carriage on the right of the composition. However, in that painting, the artist focused more on the portrait of the Valpinçons who are looking at what is going on in their carriage and not at the races. Here, on the other hand, the people in the carriage are looking at the horses, which draws the observer's gaze in the same direction, especially toward the horse in the second plane, on the left, whose movement contrasts with the immobility of the carriage in the foreground.

The horse plunging forward at the sound of the passing train, with its tell-tale trail of smoke, creates a double effect. Not only does the movement of the train serve to reinforce that of the horse, but it also comments on the technological advances of the time, of which Degas was always extremely critical.

A jockey trying to a control horse was the subject of many earlier studies, in the form of sculptures modeled in wax or preliminary drawings, both elements separately and together. This confirms the theory that many hours of study and research went into these apparently simple and casual compositions. It is therefore hardly surprising that, in spite of Faure's insistence, the painter took his time until he considered the work completed.

Dancer with Bouquet

c. 1877, pastel over *peinture q l'essence,* [oil-paint thinned with turpentine
after the oil has been partly extracted with blotting paper], 65 × 36 cm
Musée d'Orsay, Paris

Degas analyzed the various poses of the human body in his sketches, making numerous studies of each pose, before he painted them in oils. The simplicity and spontaneity of the final drawing belied the extent of this preliminary work.

Paul Durand-Ruel, Degas's sole dealer, said that, from 1870 onward, collectors "only wanted ballerinas". Because the artist was experiencing financial difficulties following his father's death, and found himself obliged to produce salable work in order to settle the debts of the estate, he concentrated on producing paintings and pastels on the ballerina themes, to which he jokingly referred as "my commodities."

In these works, Degas tried to develop a rapid method of execution that would enable him to increase his production so that his dealer could sell more. However, he still explored the technique used, interchanging experiments with various chemicals to find out which surfaces and pigments were the most durable.

In fact, Degas would identify so closely with this genre that, as an artist and amateur poet, he dedicated a series of poems to the theme.

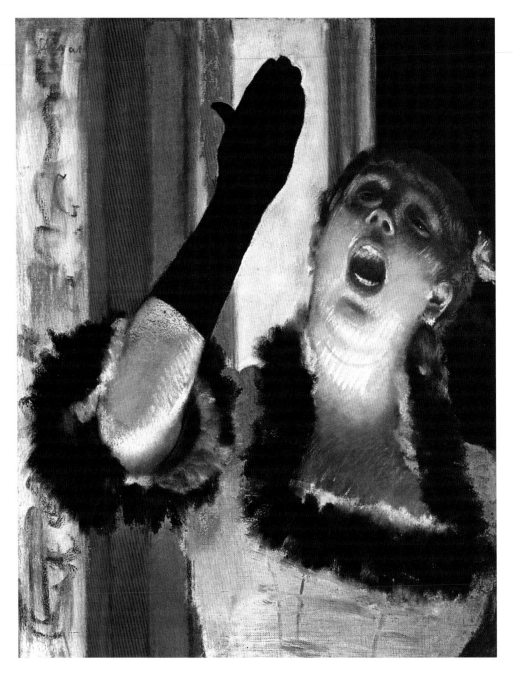

Café-Concert Singer (also known as *Singer with a Glove*)
c. 1878, pastel (mixed media) on canvas, 53 × 41 cm
Fogg Art Museum, Cambridge, Massachusetts

The woman portrayed here is not actually a singer but Alice Desgranges, a well-known pianist who posed for Degas. However, the real protagonist of the portrait is not the model but her glove which, suprisingly in this composition, is in the foreground. The technique used is in fact closer to caricature than formal painting, since it picks up on a distinctive feature of the subject of the portrait.

In the two preparatory pastels on this same theme, it is noticeable that the glove has increased in size as the body of the model has been reduced, with the glove assuming even greater presence in the final composition.

To highlight the glove as much as possible, the artist set it against a pale background, with vertical stripes that follow the general direction of the arm, while the right-hand side of the painting has been covered with a broad black band that echoes and reinforces the color of the glove.

Degas analyzed – and emphasized – the movements of the model as she sang. He made use of the artificial light to highlight the singer's gesture, the wide-open mouth, and raised forearm, virtually turning her into a caricature of herself, with distorted features, in spite of the fact that her face corresponds to the viewpoint of the composition.

To soften this snapshot full of contrasts, the artist used pale pink for the singer's dress, and the flower in her hair, barely visible on the right of the composition, and also flushed her skin with pink reflections.

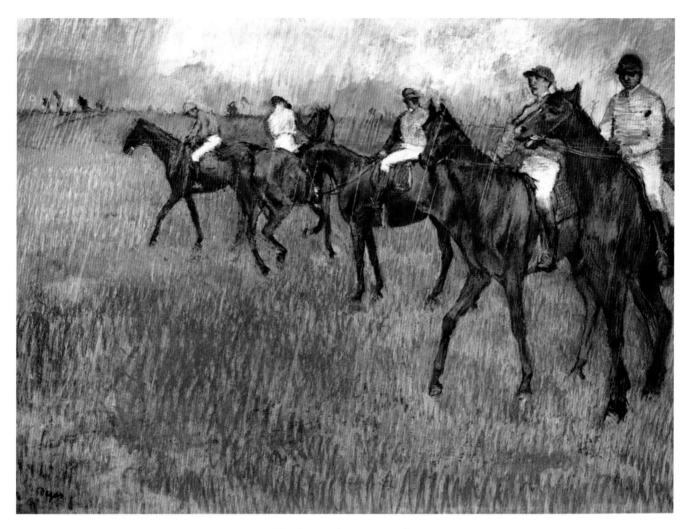

Jockeys in the Rain

c. 1886, pastel, 47 × 65 cm

The Burrell Collection, Museums and Art Galleries, Glasgow

In early 1886, Degas was in Naples resolving matters related to his grandfather's inheritance. On January 7, he wrote to Paul-Albert Bartholomé: "Here I am nothing more than an embarrassing Frenchman. The family is going away. All the world, almost, is divided. May they soon return me to my palace of flames like the Valkyrie, that is to say to my studio heated by a good stove.... I am going to walk down as far as the Palazzo Gravino, that is to say the post office, to send off four letters of four pages each – then in a tram reach Posilipo via Santa Luce as if it were the Trocadero."

One of the activities that Degas must have missed were the horse races held in spring and fall, where he used to go regularly to make sketches and take notes. As well as this wealth of observations, the following year, the artist was able to draw on the 781 figures on the movement of animals published by Eadweard (sic) Muybridge.

This painting echoes the plainness of the landscapes in other horse scenes painted in the 1880s – for example, *Before the Start* (see page 77), painted in an elongated format – and takes it even further. There is also an increasing prominence given to color, which has a greater intensity and is all the more striking since it has been applied with broad brushstrokes.

The theme of rain was inspired by the Japanese prints of Hiroshige, and also by the work of his friend Camille Pissarro, who had devoted as series of etchings to the theme of rain of which Degas had an edition.

To highlight the direction of the rain, the artist has used complementary colors on the coats of the horses in the upper diagonal of the composition, while the left-hand side is predominately green.

Degas abandoned his paintings of horses in the 1890s at the height of their development, to concentrate on the more intimate compositions of women washing and drying themselves.

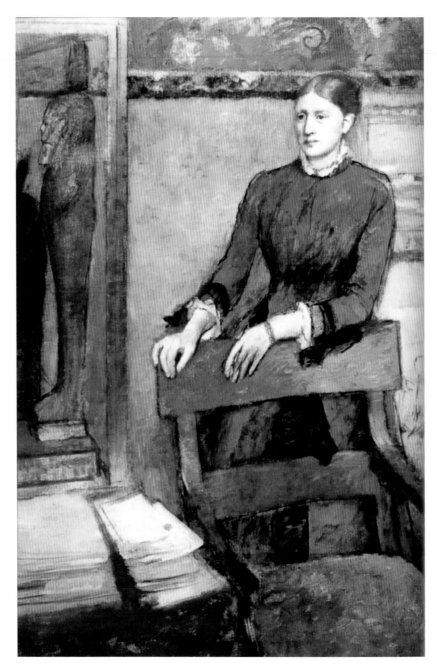

Hélène Rouart in her Father's Study
1886, oil on canvas, 161 × 120 cm
National Gallery, London

The subject of this portrait is Hélène, daughter of Henri Rouart, one of Degas's closest childhood friends. Rouart was a distinguished businessman who was also an art lover and great collector of paintings. His daughter had inherited his artistic leanings, to the point of leaving the family home to devote herself to painting watercolors.

Degas painted her portrait as he liked to do with all his subjects – surrounded by the objects that best reflected their character, and devoid of the clothes and jewelry typical of bourgeois portraits of the time. Thus, on Hélène's left, is an Egyptian mummy belonging to her father's collection.

Although Degas had never liked ostentatious portraits, and over the years had dared to reject and even destroy some of these commissions, in this instance he felt obliged to make an exception since he wanted to portray the environment in which she had grown up.

In fact, in this painting, Degas was stating a fact confirmed by everyone who visited the family mansion in the Rue Lisbonne – that the Rouart house contained the best art collection they had ever seen.

On October 16, 1883, the artist concluded a letter to Henri Rouart, who was in Venice, as follows: "Had I accompanied you I should have given a prelude to the portrait of your daughter, in the heart of Venice, where her hair and her complexion were once famous. But I remained here because there are such things as rents."

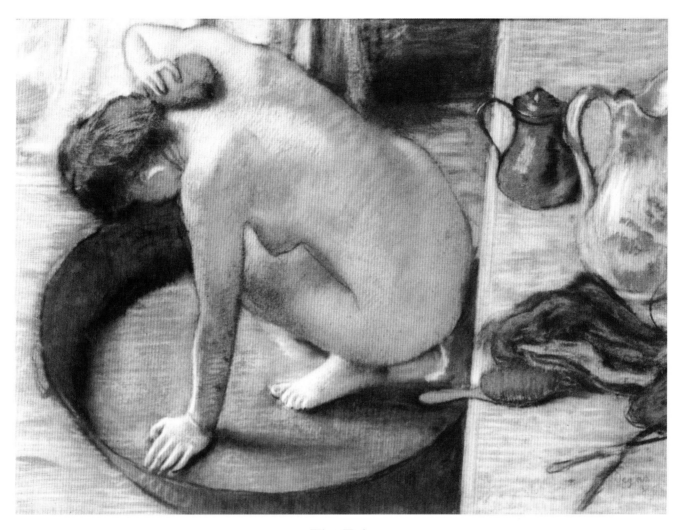

The Tub
1886, pastel, 60 × 83 cm
Musée d'Orsay, Paris

This pastel depicts a woman squatting, seen from behind as she is washing her neck. Her posture calls to mind a description published by art critic Félix Fénéon in the *Revue Indépendante,* in February 1888: "Some women are depicted inside the tubs, in the way they have of squatting like pumpkins. One, with the tip of her chin resting on her chest, is scrubbing the back of her neck. Another, in a contortion that forces her to turn round, with her arm clamped to her back, is rubbing the area of her coccyx with a soapy sponge. A long, angular spine stretches over; forearms detached from pear-shaped breasts reach vertically between the legs to dabble in the water of the tub in which the feet are soaking."

In his desire to achieve the greatest possible realism, Degas made his models adopt the most contrived postures to represent the moment of washing one of the less accessible areas of the body.

The light also appears contrived, shining strongly on the woman's shoulders, hands, and feet through the use of a white contrast, which is softened by the fabric of the background and the surface of the shelf.

This interplay of balance is echoed by the composition of the entire scene, with the right-hand third occupied by a shelf holding the woman's hair accessories – jars, hairbrush, hairpins, and, above all, the mahogany-colored hairpiece, one of the elements of female apparel that most attracted the artist, and whose essential femininity is displayed on this shelf.

But it is more than this. By placing the shelf in the foreground, it emphasizes the depth of the main image of the woman washing herself in the tub, since it creates the same impression of looking down from above that the woman has as she bends her head. It is a device used by Degas in many of his paintings of ballerinas, where they are viewed from the opera box. In this respect, the poet and critic Paul Valéry remarked that, by framing the figures from above, the elevated viewpoint was "like seeing a crab on the beach. It allows new perspectives and interesting combinations."

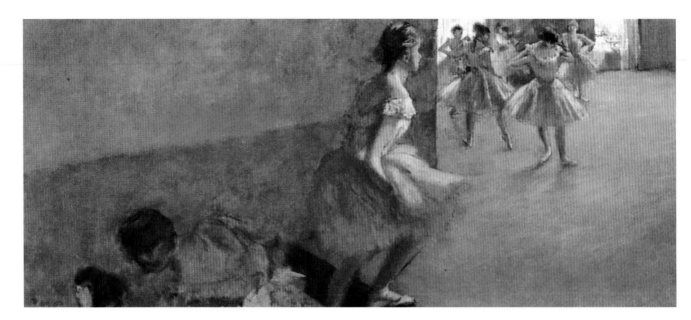

Dancers Climbing the Stairs
1886–1890, oil on canvas, 39 × 90 cm
Musée d'Orsay, Paris

In January 1886, Degas was in Naples resolving matters related to the family inheritance. He wrote to Bertrand co-director (with Colonne) of the Paris Opera House, congratulating him on his appointment: "You and M. Gailhard [artistic director of the Opera] have been so good to me, according me particular attention, that I feel a tiny part of your success, part of the family, so to speak. I have seen so much intelligence and activity in this family, through all the difficulties imaginable that, in wishing you health, wealth, and happiness for the New Year, I am merely doing my duty. Your new title will also suit you admirably, sir, and as soon as I return, I will make haste to the Opera to most respectfully offer you my hand.

"Please remember me to M. Gailhard and ask him to accept my sincere regards."

In another letter written in the same month, to sculptor Paul-Albert Bartholomé, he declared: "With the exception of the heart it seems to me that everything within me is growing old in proportion. And even this heart of mine has something artificial. The dancers have sewn it into a bag of pink satin, pink satin slightly faded, like their dancing shoes."

In 1884, Degas turned fifty and, from then on, began to regard himself as an old man, ill and alone. However, the greater financial security offered by the final liquidation of his inheritance and the fact that his work was beginning to sell extremely well, enabled him to devote himself wholeheartedly to the type of works he wanted to produce, refusing commissions and attempting "the most difficult yet" in each of his compositions.

Thus, from 1886 onward, he ceased to distinguish between preparatory studies and final works, incorporating them into the different stages of his work, and leaving it to the observer to discern his technique. On May 17, a critique appeared in *Le Voltaire,* stating that art lovers were all the keener to buy his paintings since the artist, who was becoming increasingly demanding of himself, was producing decidedly less work.

In this respect, the painter Renoir often said, "If Degas had died when he was fifty, he would have been remembered as an excellent painter, nothing more. It was when he turned fifty that his work developed and that he really became Degas."

Thus, in this canvas, Degas took his work on horizontal depth even further, and developed a vertical space that slanted toward the observer in the lower left-hand section, from where the dancers are emerging. The space of the rehearsal area appears to be the same as that used for other paintings in this format, with a wall delimiting the left-hand two-thirds of the composition and a classroom in the background and to the right, from where the scene is lit.

1890-1894

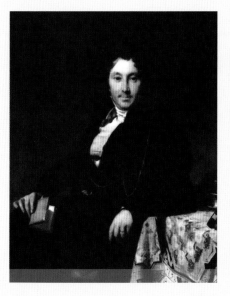 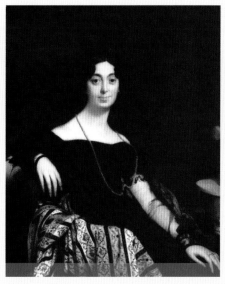

These two paintings hung in the living room of the apartment in the Rue Victor Massé, to which Degas moved in 1890.

Jacques-Louis Leblanc (1774–1846), Jean-Auguste-Dominique Ingres, 1823, oil on canvas, 119 × 93 cm, Metropolitan Museum of Art, New York.

Madame Jacques-Louis Leblanc (Françoise Poncelle, 1788–1839), Jean-Auguste-Dominique Ingres, 1823, oil on canvas, 119 × 93 cm, Metropolitan Museum of Art, New York.

1890

━ Degas takes part in an exhibition of French paintings held at Earl's Court, London.

━ He contributes to the acquisition of Édouard Manet's *Olympia*, which is about to be exhibited in the Louvre Museum. The acquisition is organized by Claude Monet with the participation of the former group of Impressionist painters.

━ Degas moves to a large apartment at 37, rue Victor Massé, where he installs his collection and a studio. In a letter to his landlord, dated April 13, he admits, "Ah, you have done me proud. At last I can enjoy a little peace in your beautiful apartment…. May we end our days here."

━ He attends an exhibition of Japanese art, which opens at the École des Beaux-Arts on April 25.

━ He takes his last cure in Cauterets. Richaud, the first flautist at the Opera House, invites him to a recital of *Orfeo*.

━ In September, he travels with his sculptor friend Bartholomé to visit the Jeanniots, in Burgundy, where he is inspired to produce his first landscapes in monotype.

━ He takes part in the Catalogue of Paintings, 18th Annual Exhibition, within the context of the Inter-State Industrial Exposition, held in Chicago between September 3 and October 18.

1891

━ He takes part in the 7th exhibition organized by the New English Art Club, London.

1892

━ In January, a small collection of paintings by Degas and others artists is presented by the Fine Arts Society in Mr. Collie's Rooms, London.

━ Degas attends performances of Giuseppe Verdi's *Aída*, Jacques Meyerbeer's *Robert le Diable*, and *Lohengrin* by Wagner, even though he is not a fan of the latter.

━ In the summer, some of his works are put up for sale as part of the Cocquelin Collection, in the Barbizon Galleries, Piccadilly, London.

━ In August, he spends time with the Valpinçons at Ménil-Hubert, in Normandy.

━ In fall, he takes part in an exhibition of paintings by French masters, organized by the Continental Gallery, London.

━ From October through December, an exhibition of Degas's landscapes is held at the Durand-Ruel gallery in Paris. This is the first of only two solo exhibitions held during his lifetime. It offers a synthetic view of nature, based on his memories, especially the trip to Burgundy made two years earlier.

━ In winter, he exhibits at the New English Art Club, London.

Degas *at home with his housekeeper Zoé Closier, photograph, 1890–1895. Zoé was the artist's housekeeper up until the last months of his life, when his niece Jeanne Fèvre came from Argentina to take care of him.*

Self-portrait, *photograph, c. 1890.*

1893

■ Degas becomes increasingly isolated and embittered about his approaching old age. He maintains his friendships with the Halévys, the Braquavals, and the Valpinçons at Ménil-Hubert.

■ He takes part in an exhibition of paintings and sculpture by modern British and foreign artists, which opens in the Grafton Galleries, London, on February 18.

■ In spring, he takes part in an exhibition held at the gallery of Boussod, Valadon & Cie., at 5, Regent Street, London.

■ In August, he spends a few days in Switzerland with his sister Thérèse and his brother-in-law, Edmondo Morbilli, who is very sick and dies two years later. He writes to Ludovic Halévy from the Jungfrau Hotel, in Interlaken, on August 31: "I have scarcely left the side of the poor invalid and my heroic sister. Women have something good [about them], when we [men] are worthless."

■ In summer, he exhibits at the New English Art Club, London.

■ His work is included in the collection of foreign works on loan from private galleries in the United States exhibited at the World's Columbian Exhibition, organized by the Department of Fine Arts, Group 146, Chicago.

■ He encourages young artists, including sculptors Paul-Albert Bartholomé and Paul Paulin, and painters Louis Braquaval, Jean-Louis Forain, and Suzanne Valadon (mother of Utrillo), whom he nicknames the "terrible Maria."

1894

■ Degas exhibits *The Absinth Drinker* (see page 69) at the Grafton Gallery, London, which causes great controversy.

■ He takes part in the loan exhibition, organized in Cleveland, Ohio.

■ After leading an eventful life, his brother Achille dies. His friend Paul Valpinçon dies in the same year.

■ He becomes a keen photographer using an Eastman Kodak. Among his favorite themes are gatherings of his friends, who pose for him in elaborate compositions – Stéphane Mallarmé, Renoir, his brother René, the Halévys, and even Degas himself. Daniel Halévy says of Degas's new interest that he throws himself into it "with the same energy that he puts into everything."

■ On December 22, the French army captain, Alfred Dreyfus, is condemned to life imprisonment for treason. Degas is one of the few artists to agree with the verdict, while most artists and academics are strongly opposed to it. To this end, Émile Zola publishes *J'accuse,* an open letter the French president, Félix Faure.

■ A number of Degas's works are exhibited in the Musée du Luxembourg as part of the "Caillebotte Gift."

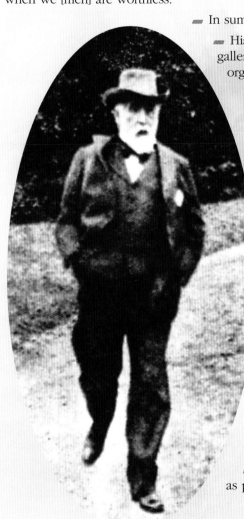

Edgar Degas, *photograph, c. 1900.*

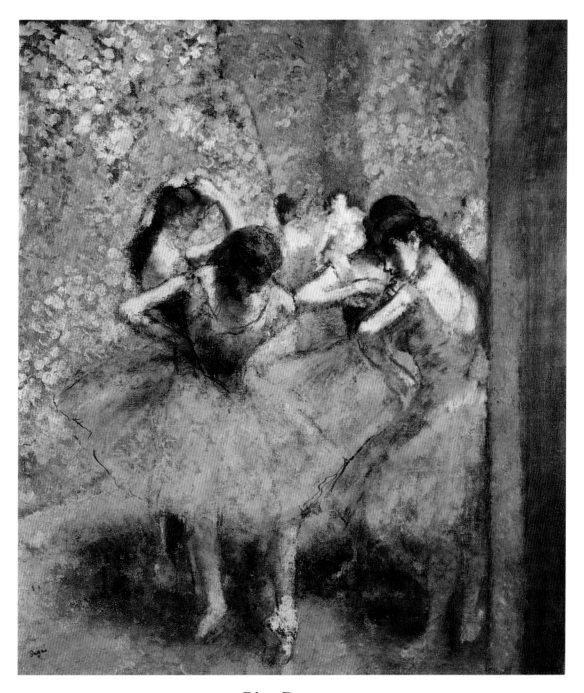

Blue Dancers
c. 1890, oil on canvas, 85 × 76 cm
Musée d'Orsay, Paris

Like other oils in the ballerinas series painted at the time, this painting is treated in the manner of a pastel with rapid applications of predominately whitish paint which give the work a more matte finish.

The figures are defined with strokes that tend to disintegrate into a few sharp lines to highlight the dancers' profiles. At times, these profiles are worked in a more intense blue, like the blue of pastel and, at others, as in the case of the ballerina on the right, with a thick black line that brings out the theatrical aspect of the figure.

The dancers' poses are carefully thought out so that the volume of their tutus is balanced by their arms, although they each have a distinctive gesture – one is fixing her hair, another is adjusting her waistband, another her neckline, and the dancer on the right, her left shoulder strap.

To the right of the composition is a vertical element – part of a wing or a pillar – which gives the scene greater sense of intimacy, since it creates the impression that the painter was hidden when he observed the dancers and that they couldn't see him.

The dancers, who seem to be placed on a series of planes, as if suspended in mid-air, are united by the positions of their heads, forming an almost closed circle that reinforces the sense of intimacy of this captured moment.

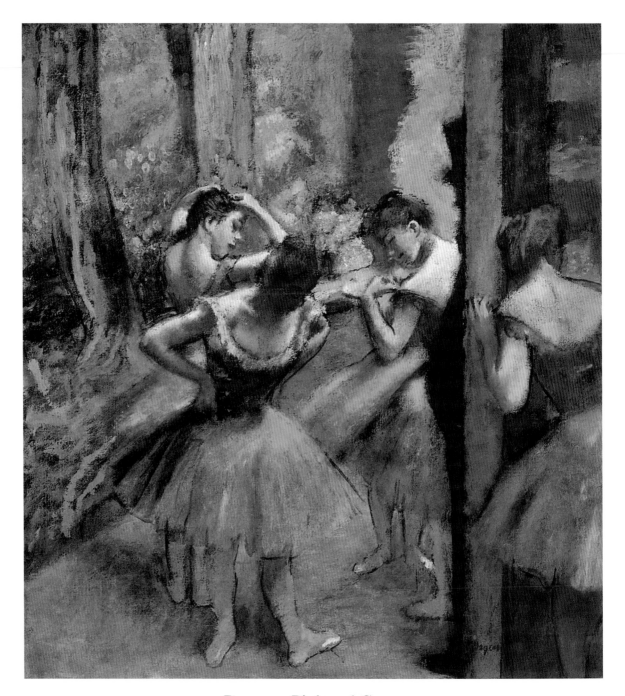

Dancers, Pink and Green
c. 1890, oil on canvas, 83 × 76 cm
Metropolitan Museum of Art, New York

In this painting, (see also *Blue Dancers,* page 107), Degas abandons the diagonal arrangement used for most of the ballerinas painted during this period. Instead, he presents them standing close together in a series of planes and, behind them, the backdrop painted in more luminous tones of red and gold.

The observer's attention is caught by the dynamic arrangement of the dancers' bent arms, which create lines between them, while beyond and beneath them are the strong perpendicular lines of the trees, the pillar, and the legs of the ballerinas who, unusually for this period, have been painted in their entirety.

Although the medium used is oil, the finish is reminiscent of pastel. This is due to the fact that Degas worked the paint in thick, superposed layers, mixing them with white, to suggest the opacity of pastels.

The work was also executed fairly rapidly, as in the case of pastels, and without the artist making extensive changes, which has been verified by the use of x-rays.

To heighten the chromatic contrast of the parts to which he wanted to draw attention – for example, the dancers' necklines and the landscape of the background – Degas applied a second complementary color, such as orange on blue or pink on green, using a dry brush and even his hands (his fingerprints are still visible) instead of the traditional use of a glaze (a transparent layer of paint applied over another layer of a different color to modify it). In this way, the areas of color remain isolated and don't blend with the color over which they have been applied, while glaze has only been added in small flecks to obtain a more saturated color.

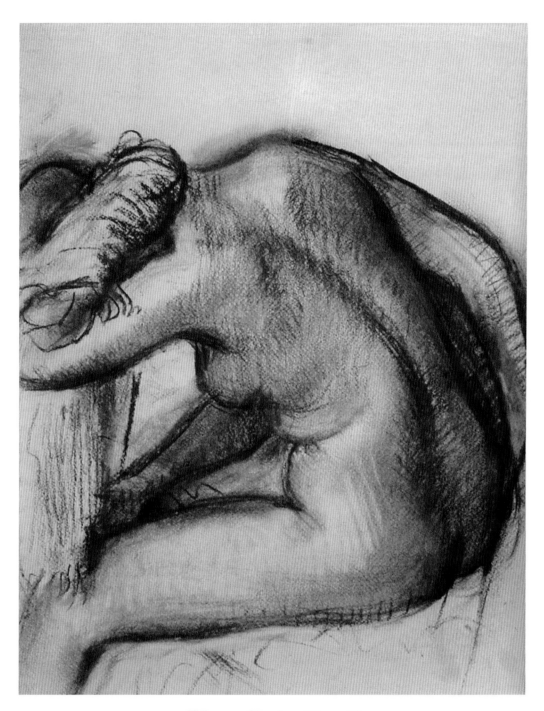

Woman Drying Herself
c. 1890, charcoal on paper, 43 × 34 cm
Narodni Muzej, Belgrade

Dennis Rouart regarded this work as baroque and monumental, since Degas portrayed a full, well-rounded figure. This could be due to the fact that charcoal creates a more substantial appearance than pastel, and gives greater emphasis to the lines that mark the movement of the shoulder. Charcoal also gave the artist an opportunity to create lines reminiscent of Japanese prints.

The theme of a woman drying her hair is also typical of Oriental iconography, and is further emphasized by the fact that it is presented here without any form of background or supporting features that define the room in which the woman is portrayed.

Degas had already worked the theme of a woman drying her hair using a variety of techniques – etching, sculpture, drawing, oil, and even pastel. However, in the early 1890s, he reinterpreted it in a series of seven works, adding strokes of charcoal to the pastel.

On the one hand, he drew on the influence of Ingres, through his own study (1855) of Ingres's *Bather of Valpinçon,* from which he has here retained the anatomical detail and the love of line.

However, this figure also repeats one of Degas's favorite poses, that of the slave in Delacroix's *Entry of the Crusaders into Constantinople,* from which he also copied the sense of volume.

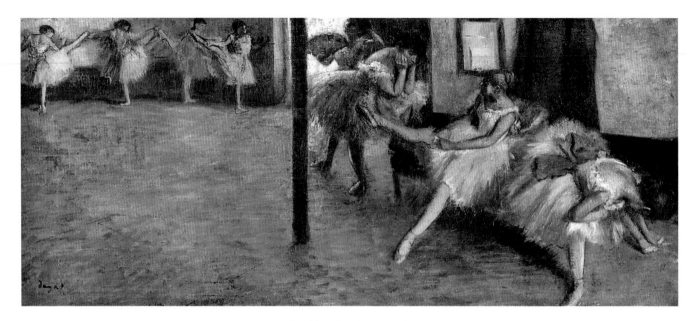

Ballet Rehearsal
c. 1891, oil on canvas, 48 × 88 cm
Yale University Art Gallery, New Haven, Connecticut

Until the end of his life, Degas continued to be a keen observer of the world of women – women ironing, washing and drying themselves, dancing – without there being any evidence to suggest that he ever managed to sustain a lasting emotional relationship. Although he was, in general, always extremely discreet in respect of his private affairs, he was even more so when these involved a woman. He took extreme care not to leave written evidence of anything that happened in this respect, like the note he wrote to his friend Bartholomé in 1891: "Voltaire said that the first man to compare a woman with a flower was a lover, the second was an imbecile... You know whom I compare with a flower and which of the two names I deserve. We will continue this appraisal on Wednesday."

Degas sought refuge from all his problems in painting and after this episode, he continued to paint his ballerinas in oblong formats. In this work, however, compared with the ballet scenes painted in the 1880s, the background appears on the left, while the wall delimiting the rehearsal room in the foreground is placed on the right-hand side. The two areas are unified by the floor, which transmits light and creates an interplay of unreal shadows. The rehearsal room is imaginary since it did not exist either in the old Opera House in the Rue Le Peletier, or the new premises in the Palais Garnier.

The ballerinas are positioned haphazardly within the space, most adopting postures that Degas had used in other paintings. This is something he did frequently in the 1890s, using sketches from his notebooks or figures painted on other canvases, repositioning them and changing their size and orientation, as if he were creating a collage.

Although this scene is painted in oil, Degas used the same technique as for pastel, superposing layers of color in different directions, with tones that do not blend and which have a whitish finish that suggests the opacity of pastel.

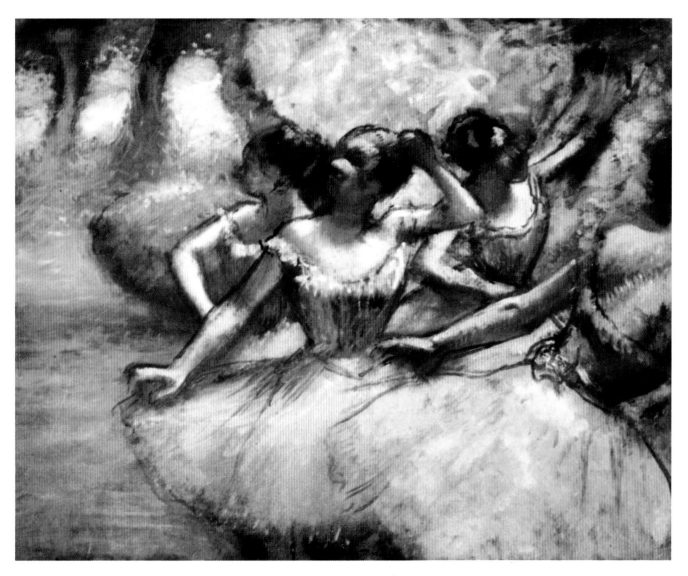

Four Dancers on Stage

c. 1892, pastel, 72 × 92 cm

Museu de Arte de São Paulo, São Paulo, Brazil

This pastel, which belongs to the artist's later period, reflects a greater interest in color than drawing, which is broken up into irregular lines to emphasize the volume of the dancers in the first and second planes and, above all, the different lines of their arms which create a sense of movement.

The color has been equally divided between the dancers and the background, which is delimited by diagonal bands of color. Thus, in the lower right-hand corner a large area of blue represents the tutu of one of the dancers. Across the composition, the other three dancers are painted in orangey tones, while the background echoes the blue of the foreground and contrasts with the yellows and oranges of the second plane.

As in other paintings from this period, in which dancers are grouped together with a strong intensity of color, the arrangement of the dancers and the contrasting lines and colors give them an unreal, almost ethereal quality. At the same time, the anatomical detail disappears to the point that it is not clear how the dancers are supported on the floor, although this can be attributed to the artificial light of the stage.

The positioning of the figures toward the right gives this side of the composition greater energy, whereby it appears that the dancers may exit the canvas at any moment.

On the other hand, the perspective creates a diagonal directionality toward the upper left-hand corner of the composition where there appears to be a scenic background depicting several trees through which the landscape seems to stretch away, becoming more clearly defined and finally leaving the composition at a vanishing point toward the right.

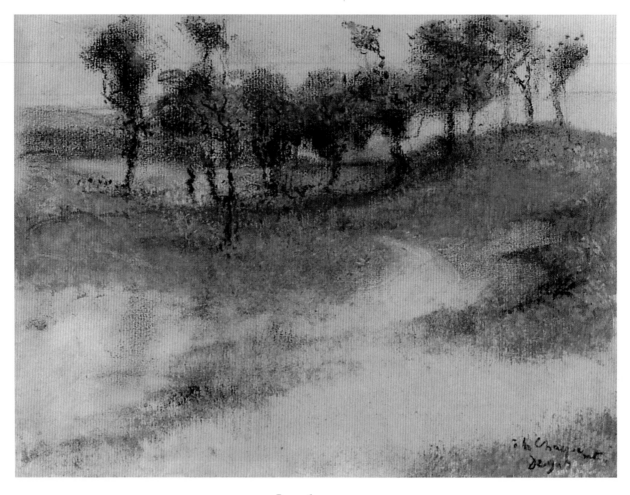

Landscape

c. 1892, monotype with oil and pastel on paper, 27 × 36 cm
Musée d'Art et d'Histoire, Neufchatel, France

Between 1890 and 1892, Degas made several journeys within France, during which he worked on a series of landscapes for monotypes. On a visit to Burgundy, in 1890, he stayed with the painter and etcher Georges Jeanniot and his family. According to Jeanniot's description of Degas's technique, the latter would first of all paint the scene onto sheets of copper or zinc, using his fingers or a palette knife, dabbing off any excess paint with a pad. Then he would use an old printing press to print the painting onto India paper, making more than one copy (sometimes as many as four), each of which was obviously lighter than the last. After leaving them to dry, he would retouch them with pastels. These were not, therefore, works executed *en plein air,* but indoors and, in the light of the Impressionists' passion for painting landscapes from nature, Degas preferred to define them as "imaginary landscapes."

Earlier, in the 1860s, he had produced another series on the same theme, but had never managed to identify with this genre.

In 1892, the first of only two solo exhibitions held in Degas's lifetime was, strangely enough, devoted entirely to landscapes.

In a letter to fellow-artist Telemaco Signorini, the Italian painter Giovanni Boldinin, who went to see the exhibition at the Durand-Ruel gallery, defined Degas's landscapes as "of supreme interest."

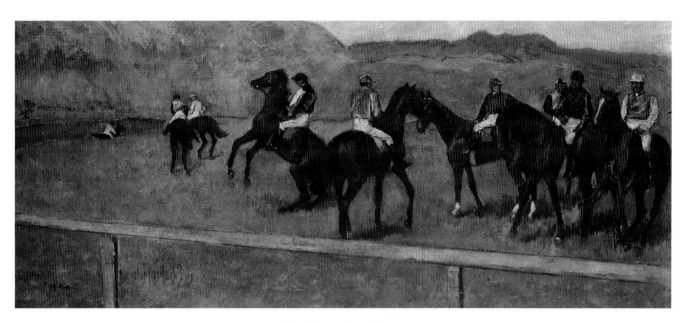

Before the Start

1878–1880, oil on canvas, 40 × 89 cm
Stiftung Sammlung E.G. Bührle Collection, Zurich

For this composition, Degas used an elongated format, as he would begin to do for his paintings of ballerinas. It was a device characteristic of the artist's production during the 1880s.

As in most of his horse-racing scenes, there is no reference to the public in this painting, nor is there a specific landscape that would make it possible to identify the racecourse. He also repeated the time at which the scene takes place – the jockeys getting ready before the start.

However, it is impossible to consider this apparent emptiness as a simplification, since every spatial element in this composition is extremely well thought out.

The foreground is crossed by the diagonal line of the rails which gives the composition an oblique perspective. On the left, a rider is galloping away toward the right, which creates another line of perspective. The oblique and parallel lines are multiplied to the right, where the horses appear to be arranged in a haphazard manner, alternating the spaces between them and the different perspectives. The effect is reinforced by the elongated space in which various sequences can be represented, as in the friezes of classical antiquity.

In this respect, the kinetic artists of the mid-20th century regarded Degas as the forerunner of some of their theories. In his essay on the *Origins and Development of Kinetic Art*, Frank Popper considered that, in certain respects, the kinetic method used by Degas anticipated that of the movies. According to Popper, it didn't matter that, to begin with, some of his works were influenced, to a greater or lesser extent, by the experiments of French physician Jules-Étienne Marey and photographer Eadweard (sic) James Muybridge, or some other photographer. The important thing was that Degas's cinematographic method involved more of a technical process – the mobility of scale and plane, and the spatial mobility in which the pluridimensional perspective of the movies was reflected by oblique and paradoxical angles, and by the division of space. Finally, there was the succession of images in which the same action was repeated from one work to the next, and the effect of a technique of off-center composition, similar to that of certain photographers.

Over the years, color also assumed greater importance in Degas's paintings of horses. In February 1880, French critic Félix Fénéon said that: "His color reflects an artistic and personal skill. He will externalize it in the multicolored confusion of the jockeys."

Degas and his models

It has been impossible to determine with any certainty the nature of Degas's relationship with women. It is not known whether he had a stable relationship, an affair, or even a sexual relationship. There is no record of anything of this kind. Even the poet Paul Valéry, who spent a great deal of time with the artist and was one of his first biographers, was forced to admit that he knew nothing of Degas's emotional life.

Neither did the artist's attitude toward women in public shed any light on the matter, since it was always somewhat ambiguous. To all intents and purposes, he paid tribute and flattered them to excess, but Berthe Morisot gives an account of the ambiguity of his behavior. One spring evening in 1869, after supper, Degas moved his chair closer to hers, stating loudly that he was going to woo her. To the young woman's great surprise and dismay, this courtship degenerated into an increasingly bitter monologue in which he expounded Solomon's view that Woman was the downfall of the righteous man. Morisot, who greatly admired Degas, was amused by this declaration, since she thought he had been disappointed in love. However, it was typical of Degas that he also described women, including Berthe Morisot, Suzanne Valadon, and Madame Halévy, with such epithets as "terrible," while Henri Rouart's wife was the "formidable" and "terrible" Mme Rouart. This attitude, which verged on misogyny, gave rise to gossip and jokes among some of his Impressionist colleagues, who began to inquire as to whether or not the artist conducted clandestine relationships. Édouard Manet, who loved gossip (something that Degas hated), maintained with several of his friends that Degas was having sexual relations with his housekeeper and they questioned her about it. "The master? He's not a man," she replied. "I went into his room while he was changing his shirt and he said: 'Go away, you wretched woman!'" Degas found out about these stories and took his revenge for years. Whenever he went to Manet's studio, he told him he couldn't see anything, leaving the artist worried and anxious. Then Manet learned from mutual friends that Degas had in fact been enthusiastic about his work. Another confrontation was caused by Manet's declaration to his sister-in-law,

Berthe Morisot, that Degas "was incapable of loving a woman, and even less of telling her so or doing anything about it."

Degas never married, but this was not particularly unusual among artists at the time. One of his friends, Pierre Puvis de Chavannes, did not marry until the later years of his life, even though he had been having a secret affair with the Princess Cantacuzene since his youth. Another of Degas's close friends, Gustave Moreau, did not marry either. He lived with his deaf mother, only leaving the house to teach at the École des Beaux-Arts and attend artistic events. He communicated with his mother by writing notes, which have survived as one of the best artistic diaries of the 19th century. Degas described him as "a hermit who knew the times of the trains," but Degas himself was not so very different. In his youth, he had gone to dances and courted a young girl or two, but he was not the typical bohemian artist who attended the gatherings at the Café La Nouvelle Athènes with a young model perched on his knee. As a young man, he had devoted himself to painting historical and mythological themes, which he regarded as the most elevated styles. This type of painting demanded a great many preliminary studies and drawings, and progressed slowly. In 1863, his brother René wrote, "He works furiously and only thinks about one thing, his painting. He doesn't even take time to enjoy himself, he just works." It cost him dearly to execute a composition. Some critics believe he couldn't imagine a scene he hadn't actually seen. Nor did he find it easy to put faces on his figures without making sketches from real life, so that he developed a particular complicity with his models.

During his first stay in Italy, at the end of the 1850s, he wrote in his notebooks: "Pretty girls in the back of the carriage in front of us – one of them was my coachman's girl ... this girl who climbed for a short while between the coachman and myself." But this is the only note he made on the subject.

In his letters from New Orleans, in 1873, he bemoaned the fact that he was not married on several occasions, although he still hoped to have a family and children of his own. As he got older, he began to make excuses as to why he never married: "I was always afraid that my wife might look at one of my paintings and say: 'Mmmm, very nice, dear.'" On other occasions, he explained his feelings more poetically: "There's love and there's painting. And we only have one heart."

Study of a Ballerina, *charcoal.*

What is known for certain is that, on his return from North America, Degas became deeply involved in Realism and, to this end, extended the scope of the people he painted. Until then he had limited himself to painting close friends and relatives, but the new themes of laundresses and ballerinas needed women who did this work for a living, whom he could use as his models.

As far as the laundresses were concerned, this was easy since, except for a few months, Degas always lived in the Montmartre district and, as soon as he left the house, he was able to see the laundresses at work. At the time, clothes

Study of Ballerinas, charcoal.

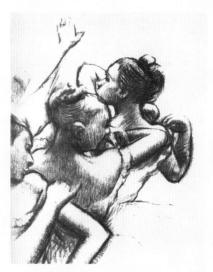

Group of Ballerinas, charcoal.

had to be washed and ironed without the help of any labor-saving devices. Large numbers of women were employed in this type of work, especially in Montmartre, which, because it was not in the center of Paris, could accommodate large premises suitable for hanging out washing. The district has now changed beyond all recognition but, in Degas's day, members of the bourgeoisie rubbed shoulders with artisans, and, in the Rue de la Fontaine, town houses stood alongside laundries.

As he returned from dining out, Degas would find the

Although, unlike Renoir, Degas never sought to perfect or embellish the subjects of his portraits, he took this even further when his models were from the working classes. According to critic Georges Rivière, who was also a friend of Degas's: "You could say that he took a certain pleasure in emphasizing the defects of individuals who didn't belong to the higher echelons of society.... For him, humankind was ugly, at least where art was concerned." In this respect, Henri de Toulouse-Lautrec would follow in Degas's footsteps, and, when asked by a certain lady why he painted such ugly women, he replied emphatically: "Because they are, madam!"

laundresses still working, the gaslight highlighting their features with the contrasting effects of light and shadow. The artist was a keen observer and would make sketches of the gestures involved in the work of these women. The art critic Gustave Coquiot wrote at the time that Degas was drawn by the coarseness of their gestures: "He is deeply inspired by these workshops smelling of bleach, sweat, and the insipid odor of the linen as it is ironed. He even emphasizes – as if this were possible – the lowly nature of their work. He places liters of wine in front of these women

who, incidentally, yawn widely enough to dislocate their jaws." The women always ended up drunk.

It was also common for Degas to leave the district, since he was a keen walker. Each day he would roam the streets of Paris, with no particular goal in mind, even when he was almost blind and, using a cane, he would dice with death as he passed between the motor vehicles. He also often took the omnibus so as to encounter all types of people, as his brother René had once complained. According to Berthe Morisot, this led him to feel "an extraordinary admiration for the intense humanity of the young women of the city." He regarded what went on in the streets of the capital as a performance, and was always sketching gestures and faces in his notebooks so that he could use them later in his paintings.

To paint his ballerinas, Degas attended performances at the Opera House in the Rue Le Peletier. He painstakingly gathered information from masters and pupils, filling his notebook with sketches and notes. It was not until the early 1880s, when he could watch the work in the rehearsal room and from the stalls, that he was able to make a more in-depth study of the strength and energy required of these young dancers. Their aim in all this was to escape the wretchedness of their surroundings, by aspiring to a better professional position or becoming the wife, or even the mistress, of a man of greater economic and social status.

It appears that Degas was sometimes moved by the precarious situation of these young women, the form of upmarket prostitution that awaited so many ballerinas, and he would hire them to go to his studio where he made notes and worked on preliminary sketches and drawings. He left notebooks filled with these notes and drawings, and more than one ballerina complained about the unintentional scratches she received while he measured her body with his compasses. The comings and goings of so many young women aroused suspicion among the artist's neighbors and the police were called to investigate on a number of occasions, although the matter never went any further.

Although there is nothing to suggest Degas was ever on intimate terms with any of the ballerinas, one of them did

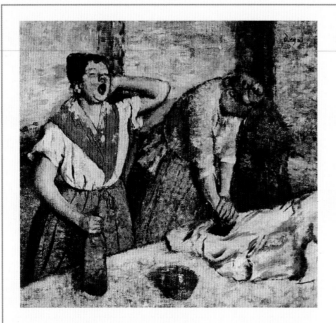

The Ironers, c. 1884, oil on canvas, 76 × 82 cm,
Louvre Museum, Paris.

Cassatt. When the latter asked him what attracted him to this environment, Degas replied: "The reddened hands of the young woman who fixes the hatpins." He spent a great deal of time with Cassatt, giving her advice, and painting her portrait on a number of occasions, but there is nothing to suggest that anything more went on in their studios.

In the mid-1880s, Degas began to devote himself to what would be his great genre until the end of his life – women washing and drying themselves, and combing their hair. According to Gustave Coquiot, the models were astonished by this and spoke of it incredulously when they met on the way to the Moulin Rouge, at the Moulin de la Galette:

"Do you know how they're posing in Degas's studio?"
"No."
"With women in the bathtub and washing their backsides!"

In his paintings of nudes, Degas expressed his feelings toward women. Some critics have identified a disdainful sensitivity in these works. He made his models pose in almost contorted positions that became increasingly dehumanized. Toward the end of his life, he confessed: "I paint women in the tub, when in the past I would have painted Suzanne [presumably Suzanne Valadon] in the bath." *He was not wrong when he told Walter Sickert in front of one of these paintings:* "Perhaps I have regarded woman too much as animal."

Over the years, Degas became increasingly embittered. Following the Dreyfus affair he dismissed a model, "Simply because she was a Protestant, and the Protestants are in league with the Jews in favor of Dreyfus." In general, he treated his models with natural disdain, reproaching them for having pear-shaped buttocks, or for smelling unpleasant. However, there was one exception. In the 1890s, he became a great admirer of one of his models, Suzanne Valadon, who was also the model and mistress of Toulouse-Lautrec. Degas encouraged her to draw and etch. He even bought some of her works and hung one of them in his room. He would often visit her in her studio in the Rue Corot and enjoyed the stories she told him about her young admirers, but nothing in his letters appears to indicate that things went any further. The artist encouraged her to continue painting until the very end of his life. When she was asked, after his death, if she had had a sexual relationship with Degas, she acknowledged that "no man had ever paid her so many compliments on her skin, her hair, or her muscles, but 'that' – never. He was too afraid."

say that the artist liked to stand at the bottom of the staircase they climbed at the end of their class.

Degas represented these dancers as they really were, with their faces, in everyday attitudes, and without the traditional contours of the female body. According to art critic Charles Ephrussi, Degas chose small, slight ballerinas with ambiguous forms, and disagreeable – even repellent – features, and gave them movements devoid of grace. His *Little Fourteen-Year-Old Dancer* was widely criticized not only for the intrinsic quality of the sculpture, but also the aesthetic appearance of the girl. Many of these criticisms, all of a similar nature, were published by Paul Mantz in *Le Temps:* "Dreadful, because it is totally devoid of thought, the face is pushed forward with animalistic insolence, or rather the snout, and the word is appropriate since this poor girl is a novice, one of the *petits rats* of the corps de ballet. Why is she so ugly? ... Degas has dreamt up an ideal of ugliness."

He depicted his café-concert singers in much the same way – performing in public, with common features, devoid of femininity – and only created real depth in their gestures and the strength of their singing. Degas never presented images of these women offstage, since he was not interested in exploring a world that he regarded as far too squalid. Even so, he did investigate the sordid world of the brothel. He had begun to produce a series of monotypes on the theme of prostitution for the illustrations of the 19th-century best seller, *La Famille Cardinal,* which told the story of a family of prostitutes and Toulouse-Lautrec encouraged him to experience the "incomparable atmosphere" of the places where this trade was plied. Renoir made the distinction between the models of the two artists: "Lautrec's models are debauched, Degas's never!" Unfortunately, many of the drawings made in brothels were destroyed after the artist's death by his brother René.

In the early 1880s, Degas was also drawn to the world of millinery and went to milliners' workshops to make notes and sketches, accompanied by Mme Straus or Mary

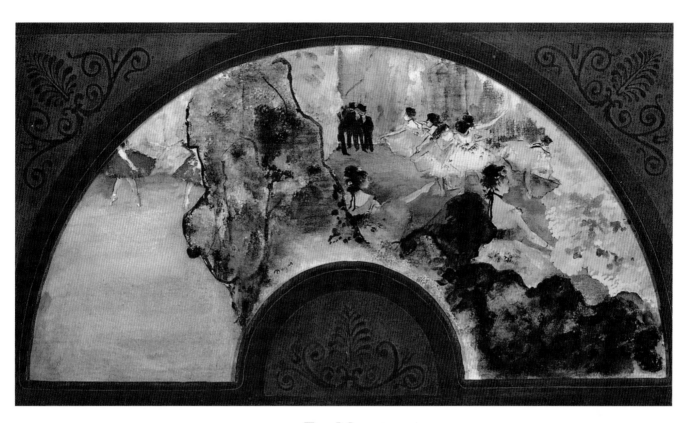

Fan Mount
c. 1879, gouache, oil and pastel on silk, 31 × 60 cm
Tacoma Art Museum, New York

Toward the end of the 1870s, Degas decorated some twenty or so fans with scenes from the ballet. After this series, he did not repeat the technique until 1885, to mark the première of the opera *Sigurd*, by his friend Ernest Reyer, whose preparations he had followed with great interest. It has been suggested that the artist was in love with one of the sopranos, Rose Caron, a suggestion supported by various written references to the artist's collaboration on the opera. Even years later, in 1934, Jacques-Émile Blanche wrote to Daniel Halévy: "Could you possibly find me the score for *Sigurd*, that song, which Degas used to sing with such feeling, imitating the gestures of Rose Caron?"

The fact is that the artist often used fans to experiment with different techniques – watercolor, gouache, pastel, and ink, highlighted with gold on silk or paper. Although, at the start of his career, Degas painted in oils on canvas, he soon began to use cardboard instead of canvas. Gradually the technique of oils began to be replaced by other, combined techniques, since he found himself more at ease with pastel as he was losing his sight. He applied it on oils, etchings, and monotypes – a continuous process of experimentation based on his desire to find the most appropriate technique for each scene. At the Impressionist exhibition of 1879, the critics were already referring to his "incessant quest for new techniques."

In this respect, the Rouarts were first-class witnesses, both as the artist's friends and also because of their technical knowledge. *In Degas à la Recheche de sa Technique* (Degas in Search of his Technique) Denis Rouart wrote: "He was extremely preoccupied by the material aspect of art, and was always searching for the best medium and the best fixative, the best canvas and the best preparation, without ever finding a definitive solution. His entire life was taken up with quests, both in the esthetic and technical fields, insofar as they related to art."

In this instance, the artist has given the scene an Oriental quality. On the other hand, the form of the fan tends to determine the point of view, which in most cases was the main opera box from which the observer appeared to be looking at the width and depth of the stage.

In this scene, the depth is such that the observer is able to see a ballerina who is concealed from the audience. In the foreground, a deep cloud of smoke, illuminated by pink and red rays, simulates the eruption of a volcano.

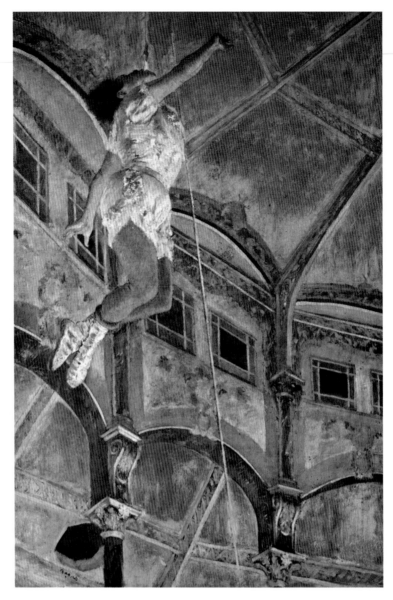

Miss Lala at the Cirque Fernando
1879, oil on canvas, 117 × 78 cm
The National Gallery, London

Miss Lala was a well-known mulatto acrobat and trapeze artist. Degas went to see her perform this trick at least four times between January 19 and 25, 1879. She was also known as *la femme canon* since her most sensational trick was to fire a canon suspended on chains that she gripped with her teeth. However, this painting shows her being hauled up into the circus dome by a rope that she holds onto by means of a device clenched in her teeth.

In the same year that Degas painted this picture, Miss Lala performed in London, where the press reported that her tricks had already amazed Paris and that her act far surpassed anything that had ever been seen before.

In this painting, Miss Lala is suspended in mid-air while the audience watches her from the same viewpoint as the observer. The perspective of the painting surprised Degas's contemporaries, even though the artist drew his inspiration from Giovanni Battista (Giambattista) Tiepolo and other 18th-century Italian artists.

Miss Lala's pale lilac costume not only stands out against the orange background but also adds a delicate touch to it. The color is also contrasted with the green of the steel girders that intersect against a reddish-brown ceiling on the right of the composition.

Ornamental details such as the gilt stuccowork of the capitals, the corbels above them, and the medallions embellishing the arches, are painted in a diffuse manner that makes them stand out but prevents the spectator's gaze being drawn away from the main focal point – Miss Lala's pirouette. For the same reason, Degas has not painted the other elements of the circus or the act (fixings, trapeze, etc.), nor the audience. What does interest him is the substantial architecture of the dome and the apparent weightlessness of the acrobat, who appears to be rising magically since the rope by which she is suspended is barely visible.

1880-1884

1880

▬ Degas concentrates on producing etchings, together with Mary Cassatt and Camille Pissarro.

▬ The fifth Impressionist exhibition – which Degas refers to as the "Salon des Indépendants" – is held at 10, rue des Pyramides from April 1–30. The young artist, Paul Gauguin, takes part for the first time. The works submitted by Degas include the portrait of *Louis-Edmond Duranty* (who dies nine days after the exhibition opens), seven pastels and oils, two groups of drawings and another group of etchings. In spite of being listed in the catalogue, his *Little Fourteen-Year-Old Dancer* is not exhibited until the following year.

▬ Although Degas has refused to participate in the Salon since 1870, other Impressionists continue to apply. Pierre-Auguste Renoir and Claude Monet, the only two to have paintings exhibited, send a letter to the Minister of Fine Arts protesting about the poor positioning of their works and requesting an exhibition devoted exclusively to the Impressionists. In support of this request, Zola publishes a series of four articles, "Le Naturalisme au Salon," in *Le Voltaire* between June 18 and 22.

1881

▬ Degas discusses preparations for the sixth Impressionist exhibition with Gustave Caillebotte, and secures the support of Camille Pissarro. Caillebotte subsequently withdraws from the exhibition, while Claude Monet and Pierre-Auguste Renoir decline to exhibit.

▬ The sixth Impressionist exhibition is held at 35, boulevard des Capucines from April 2 to May 1. Degas exhibits *Physionomies de criminaux* – a series of drawings of criminals implicated in a court case that had been very much in the public eye – and his sculpture of the *Little Fourteen-Year-Old Dancer,* which is the subject of harsh criticism.

▬ In April he exhibits works at the exhibition of the Cercle des Arts Libéraux, in Paris.

▬ Degas throws himself into organizing the benefit auction for the widow of Louis-Edmond Duranty, at the Hôtel Drouot. He contributes four works and appeals to all his colleagues to send something. He also asks some of them "to campaign to get art lovers and people you know to bid up the price of your works."

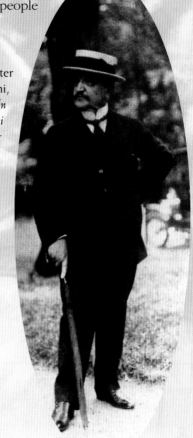

The Italian painter Giovanni Boldini, *photograph, late 1890s. In 1889, Degas and Boldini traveled to Spain together to visit the Museo del Prado, in Madrid.*

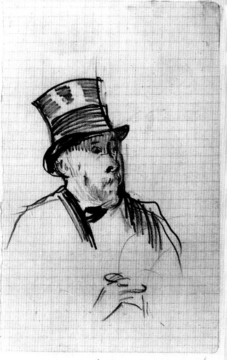

à l'affût d'une étoile

Degas. À l'affût d'une étoile [In search of a star], Jean-Louis Forain, *drawing. Forain (1852–1931) was a Realist-Impressionist painter and illustrator much given to playing with words, and relating them to his drawings, a skill that Degas greatly admired.*

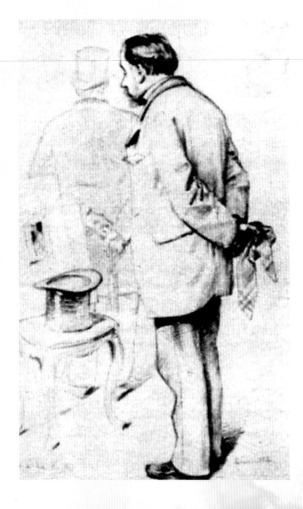

Sketches of Degas, *Paul Gauguin, 1880–1895, Album Briant, Musée du Louvre, Paris. Studying Degas's pastels proved to be a revelation for Gauguin and directly influenced some of his works, for example The Bath (1887).*

— He throws himself increasingly into the techniques of pastel and monotype.

1882

— Degas concentrates on the series devoted to laundresses and milliners.

— He moves to 21, rue Pigalle. His housekeeper Sabine Neyt dies and is replaced by Zoé Closier.

— In July, he spends a week with the Halévys, in Étretat, and the month of September in Switzerland

1883

— Degas becomes a regular at the Café de La Rochefoucauld.

— On April 30, Édouard Manet dies and, in spite of the ups and downs of their relationship, Degas is deeply affected. He becomes increasingly isolated, and the themes of illness and death recur frequently in his conversations and letters.

— In the summer, Paul Durand-Ruel organizes an exhibition of Impressionist paintings, drawings, and pastels at the Dowdeswell & Dowdeswell gallery, 133, New Bond Street, London. Degas's work is exhibited and is hugely successful.

— The artist takes part in the Pedestal Fund Art Loan Exhibition, which opens at the National Academy of Design, New York, on December 3.

1884

— A retrospective exhibition of Édouard Manet's work is held at the École des Beaux-Arts, in Paris. During the liquidation of Manet's estate, his brother Eugène and sister-in-law Berthe Morisot (Eugène's wife) present Degas with *The Departure of the Folkestone Boat.*

— Degas spends the summer with the Valpinçons at Ménil-Hubert, in Normandy. On August 16, depressed by the fact that he has just celebrated his fiftieth birthday, he writes to his sculptor friend, Paul-Albert Bartholomé, "Is it the country, is it the weight of my fifty years that makes me as heavy and disgusted as I am? ... I am reading *Don Quixote.* Ah, happy man and what a beautiful death! ... Ah, where are the times when I thought myself strong. When I was full of logic, full of plans. I am sliding rapidly down the slope and rolling I know not where, wrapped in many bad pastels, as if they were packing paper." This is first of the periodic episodes when he complains about his age, the death of his friends, his loneliness, and his financial problems.

— He takes part in *Le Sport et l'Art (Sport and Art)* an exhibition held in the Galeries Georges Petit in Paris, between December 14, 1884, and January 31, 1885.

Carved wood chest, *Paul Gauguin, 1884, private collection. Gauguin and Degas became great friends and publicly acknowledged their admiration and recognition of each other's work. Here, for example, Gauguin has reproduced Degas's ballerinas on the chest.*

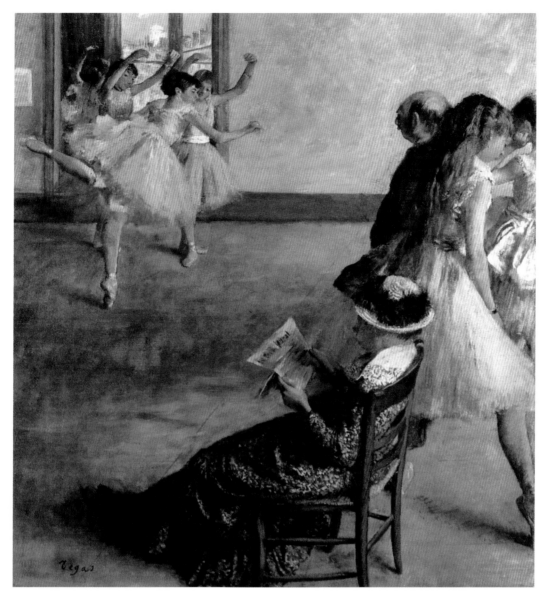

Ballet Class
c. 1880, oil on canvas, 82 × 77 cm
Philadelphia Museum of Art, Philadelphia

Ballet Class includes many of the elements that characterized the ballet scenes set in the rehearsal room of the Opera House. In this instance, however, the spatial distribution is extremely studied, with the empty space in the center as the main protagonist. According to a letter from Mary Cassatt to Louisine Havemeyer, dated April 28, 1920, the ballerina downstage on the left was originally situated in the center of the composition, and the one in the foreground on the right took up more space. Degas made these two changes (which have been verified by the use of x-rays) to enlarge the central space, since it is this empty space that gives the three ballerinas on the left of the composition the capacity for movement. In another letter to Louisine Havemeyer, dated April 18 of the same year, Mary Cassatt described this group as "extremely beautiful" and "classically inspired."

In the foreground on the right, a mother is engrossed in *Le Petit Journal,* a very successful popular daily newspaper. Combined with the simplicity of her clothes, this indicates that she is a person of humble origins who is accompanying her daughter in order to find her a good patron – a recurrent theme in artist production of the time. It is also the theme of the 19th-century best seller, *La Famille Cardinal,* which told the story of a family of prostitutes, and one that Degas portrayed impassively in his works, although he personally decried the fact that families commercialized their daughters in this way.

According to Mary Cassat, the ballerina Marie von Gothem posed as the model for this woman, the same model who posed for the *Little Fourteen-Year-Old Dancer,* recognizable by the set of her mouth. It appears that she also posed for the ballerina presenting he opposite profile near the dancing master.

Behind the mother, the cropped figures of the two ballerinas reflect the influence of Japanese prints on Degas's work. Next to them is the dancing master, Jules Perrot, whose gaze, directed toward the three ballerinas on the left, links them to the ballerinas on the right. It has subsequently been confirmed that this figure did not feature in the original painting.

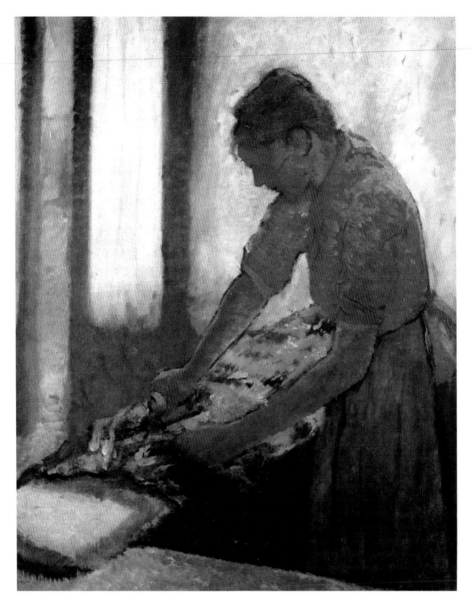

Woman Ironing
c. 1880, oil on canvas, 81 × 66 cm
Walker Art Gallery, Liverpool, England

Degas used the figure in this painting to make drawings that would help him portray other women ironing, silhouetted against the light, up till the end of the 1880s.

In this instance, the woman is depicted almost in profile, in a more oblique composition, and, because there are no clothes hanging up, the light enters more directly, creating a stronger contrast.

To make the silhouette stand out against this direct light, Degas had to emphasize the outline. The colors were applied extremely uniformly, but without becoming flat.

This apparent technical simplicity did not go unnoticed by his contemporaries. Some even thought that the artist had reached his limit and could go no further. For example, Albert Wolff wrote in *Le Figaro,* "Monsieur Degas showed talent, and his sketches are certainly not those of a newcomer. If a young man of twenty put his name to them, his future would be assured. But [the artist] is frozen at this point, at the end of his career, without having advanced a step…. The misfortune of this school is that it doesn't want to learn anything, that it elevates its ignorance to the level of principle, and its studio daubings to that of artistic theory."

However, others considered that this simplification and repetition of themes was certainly going somewhere. In *La Vie Moderne* (April 24, 1879), Armand Silvestre offered a completely different view: "Let's move on to something with meaning. We will find it at its highest level in the rare canvases of Monsieur Degas – always the same process of synthesis expressed with a truly admirable sense of painting. See these laundresses bent over their arduous task. From a distance, you would say it was a Daumier, but from close to it is much more than a Daumier. There is in this work a certain considered mastery whose power is indefinable. It is the most striking protest against the search for colors and over-complicated effects endured by contemporary painting. It is a short, accurate, and precise alphabet, cast into the studio of calligraphers whose arabesques make reading intolerable."

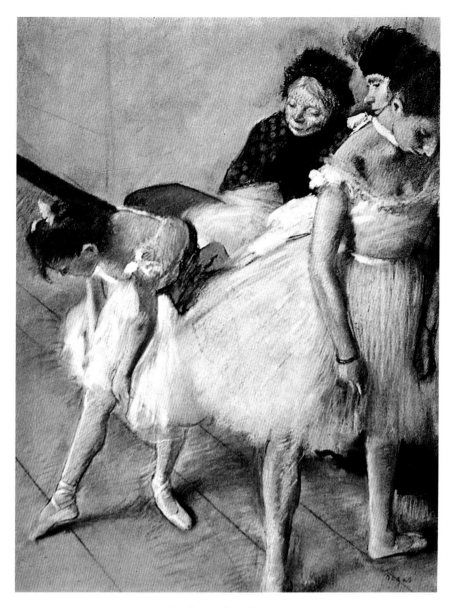

Before the Exam
1880, pastel, 63 × 48 cm
Denver Museum of Art, Denver, Colorado

In the 1880s, Degas was already a famous artist who was particularly well known as the "painter of ballerinas." As such, he had access to the dancers' rehearsals and preparations, which enabled him to make a great many sketches of their gestures and movements at every stage of their work.

The art critic Charles Ephrussi had already defended Degas's ballerinas toward the end of the 1870s in the *Gazette des Beaux-Arts:* "Our modern artists produce huge canvases, with scant regard for whether the value of the theme justifies such ambitious proportions. They portray ignoble themes that are systematically opposed to classical beauty, and everyday themes through their hatred of elegance. They are proscribed painters, if you like, but painters nonetheless.

"This aesthetic often produces singular results. In the work of Monsieur Degas, for example, who chose small, slight ballerinas with ambiguous forms, and disagreeable – even repellent – features. He gave them movements devoid of grace, and bathed this extravagant theme in fine color, a delicate light that covered the floor and décor. Through the value of amazingly accurate tones he placed everything in its plane, in spite of using a [particular] perspective with amazing frequency. The artificial atmosphere of the theater has never been more skillfully expressed, nor have the light, diaphanous skirts of the corps de ballet ever been made to float more convincingly. The painter continues to be acclaimed in spite of the ugliness of his figures.... *In The Dance Class* (1874) (see page 64) and *Two Dancers* (1879 (Monsieur Degas had an evident predilection for choreographic drawings), what ungraceful attitudes, what angular, disjointed limbs which become dislocated in clownish movements that were certainly never inspired by Terpsichore. One ballerina, in particular, is rubbing her legs in the manner of a masseur in a *hammam.* In spite of these deliberate banalities, [the artist] must be congratulated for his bold synthesis, the amazing strength of drawing in these outstretched arms and even these ill-defined hands, and a spiritual observation focused objectively on the inner destitution of these priestesses of the graceful art of dance."

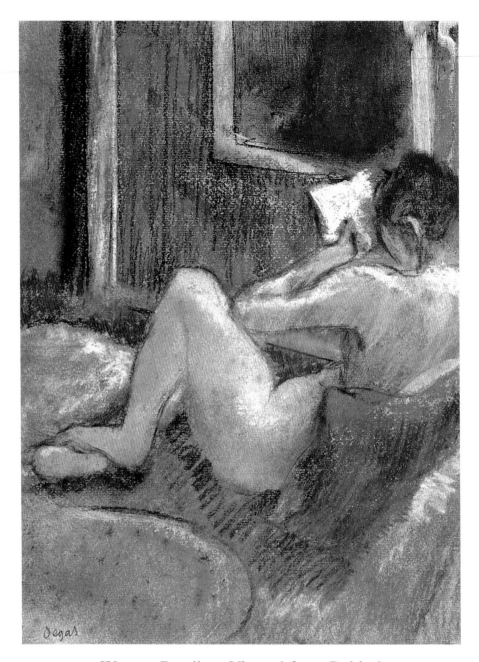

Woman Reading, Viewed from Behind
1880–1885, pastel on monotype, 38 × 27 cm
Private collection

This work is a second impression of *Woman Reading (Liseuse)* painted between 1880 and 1885. This is borne out by the fact that the brushstrokes are virtually identical and the dedication to the Vicomte Lepic on the earlier version is still legible. During the 1880s, Degas's nudes gradually reduced the depth of his space which, taken overall, gave his work a synthetic classical style, in which the most important element was the vigor of the line.

As the term suggests, monotypes are plates that are only used once. When they are used for a second time, as in this instance, the color is very light and creates a base of tentative shading.

Over this, Degas has skillfully applied a significant amount of pastel, with which he was even able to modify certain forms. The colors – ochers and blues – are extremely harmonious and typical of the first half of the 1880s.

This enrichment did not go unnoticed by the best art critics of the day. At the Impressionist exhibition of 1880, Joris-Karl Huysmans said: "No painter, since Delacroix, whom [Degas] has studied extensively and who is his true master, has understood how Monsieur Degas [achieves] this marriage and adultery of colors, none has so far [produced] such a precise and detailed drawing, a flower of such delicate color"

On the other hand, most of Degas's nudes are viewed from behind, which could be symptomatic of his relationship with women toward the end of the 1870s. At the time, he began to regard himself as a bachelor and to refer to himself as such in public, an attitude that exempted him from having to "return" the invitations of his many hostesses.

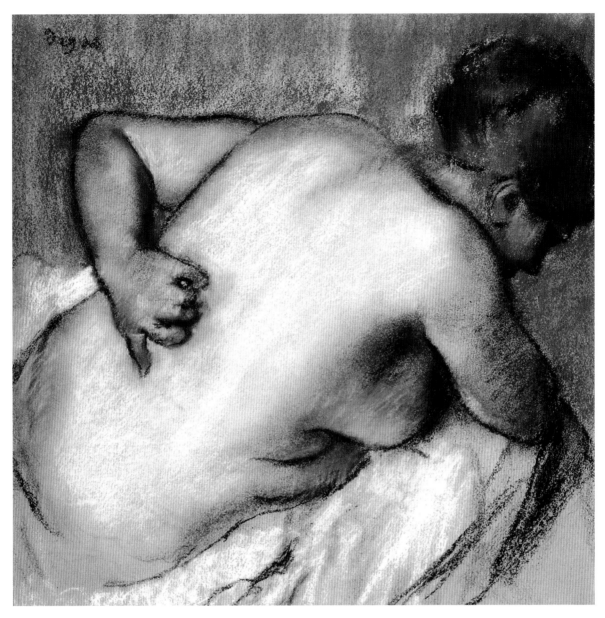

Woman Scratching her Back
1881, pastel on paper, 61 × 61 cm
Denver Museum of Art, Denver, Colorado

In Degas's Realistic world, women are portrayed without any ideal of beauty. He therefore depicts this *Woman Scratching her Back* exactly as she is, with her coarse body and reddened hands. The gesture contributes to the overall impression – in this contorted position, the woman is performing the basic act of scratching her back.

The poet, essayist and critic, Paul Valéry, Degas's friend and biographer, was asked about the artist's relationship with women on a number of occasions. He tried to avoid the issue in his writings. In *Degas Dance Drawing* he said that the artist "portrayed the femaleness of his usual models realistically ... he took no pleasure in embellishing them. I know nothing of his emotional life – our views on women are sometimes the result of our experiences. It is wise not to refer to one's own experience, when matters of this nature cause nothing but disappointment, bitterness, and even something worse. But Degas's character makes me think that his early life had little to do with his way of diminishing women as he does in his paintings. His gloomy gaze never saw anything through rose-tinted glasses."

In *Woman Scratching her Back*, the subject appears to have been enlarged, to the point of being disproportionately large in relation to the size of the paper. As a result, she was placed diagonally across the sheet, and even twisted to the left, to create a sense of visual continuity.

The scene is strengthened by the use of the color black for the shading and outline, which is unusually thick, and even creates a sense of volume in certain areas.

Beneath the dark lines, the model's skin is painted in a whitish, wax-like tone, compared with the brighter white of the linen beneath her body. The pale tone of her shoulder contrasts with the redness of her face, arms, and hands, the result of her work, or of being exposed to the sun, which attests to her humble origins.

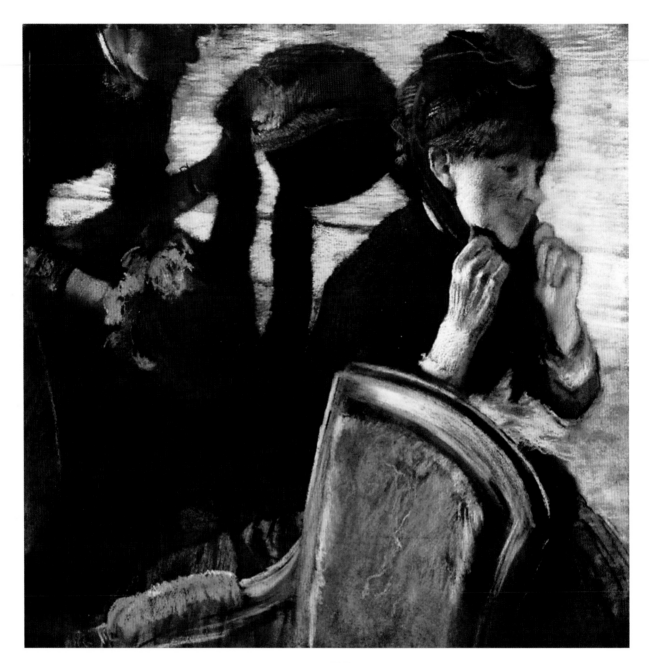

At the Milliner's
c. 1882, pastel, 67 × 67 cm
Museum of Modern Art, New York

Degas shared many confidences with fellow-painter Mary Cassatt and also gave her a great deal of professional advice. While he considered her to be the best sketch artist of the time, she, for her part, regarded him as her master.

Cassatt also posed as Degas's model in several series of portraits, such as those devoted to the milliner's and visits to the Louvre Museum.

This work, in which Cassatt is trying on a hat, captures a casual act and a spontaneous moment. Seated behind the empty armchair in the foreground, she is tying the ribbons of the hat, a gesture for which Degas highlights the joints of her hands, perhaps to convey the idea that she earns her living by them.

On the left, in a much darker light, almost in shadow, the shop assistant offers two other styles of hat to Mary Cassatt. The only parts of the woman visible in the scene are her lower profile and her arms – her body is out of the picture, as if only her gesture is important.

Although this is an apparently banal and spontaneous scene, the work is the result of a great deal of thought and reflection, which Degas's close friend Ernest Rouart explained as follows: "Degas attributed great value to the composition, to the arabesque formed by the lines, then to the definition of form and shape, the accent of the drawing, as he called it. He never felt he had gone far enough in the vigorous expression of form."

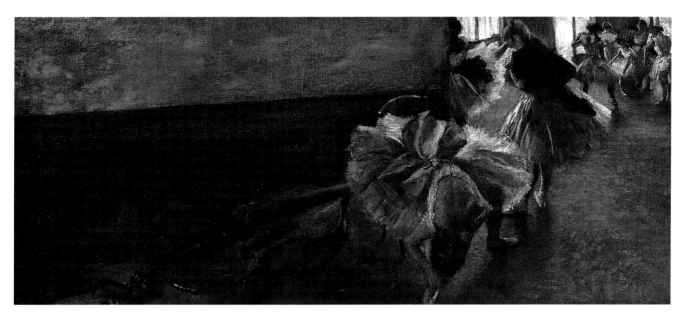

Dancers in the Rehearsal Room with a Double Bass
1882–1885, oil on canvas, 39 × 90 cm
Metropolitan Museum of Art, New York

To gain access to what went on during rehearsals at the Paris Opera House, in 1882 Degas wrote a letter to Albert Hecht, the figure looking through binoculars from the orchestra stalls in *Ballet Scene from Robert Le Diable* (1876):

"My dear Hecht:

"Have you the power to get the Opera to give me a pass for the day of the dance examination, which, so I have been told, is to be on Thursday?

"I have done so many of these dance examinations without having seen them that I am a little ashamed of it.

"Warmest greetings, Degas."

Hecht's reply must have been satisfactory, since Degas sent him another letter in which he said: "I thought I could slide into the Opera amongst the others with a slip of paper and you want to lead me in person to the feet of M. Vaucorbeil." The latter was the director of the Opera between 1879 and 1884, and these letters show the great support that the artist received from the establishment.

The composition has an oblong format, which Degas particularly liked, and to which he returned on a number of occasions over the course of twenty years, from the second half of the 1870s. In most of them, the artist portrayed groups of ballerinas in a series of different postures before the start of a rehearsal.

The dimensions of this format enabled the artist to present the dancers' different postures in the manner of a classical frieze, without being obliged to create a unified scene.

However, the many gestures of the ballerinas, whose faces are not shown, give the impression that this is in fact the same dancer who, before starting a class, had to perform a series of repetitive and monotonous exercises, which run from left to right, as if in a film strip.

As happens in other paintings in this series, the décor of *Dancers in the Rehearsal Room with a Double Bass* is clearly delimited by a wall that runs at a slight diagonal across the left-hand two-thirds of the composition. On the right, the classroom opens out and balconies not only vary the sense of depth but also of light.

The brownish-yellow tone against which the artist has highlighted bright notes of color is typical of the oils of this period. In this instance, these highlights are provided by the bow of the dancer in the foreground and the fans of the group in the background.

Although Degas found the shape of the double bass esthetically pleasing, he usually represented it by highlighting its neck. Here, however, he shows the body of the instrument, which occupies the horizontal half of the composition, and serves to guide the observer's gaze toward the group of dancers.

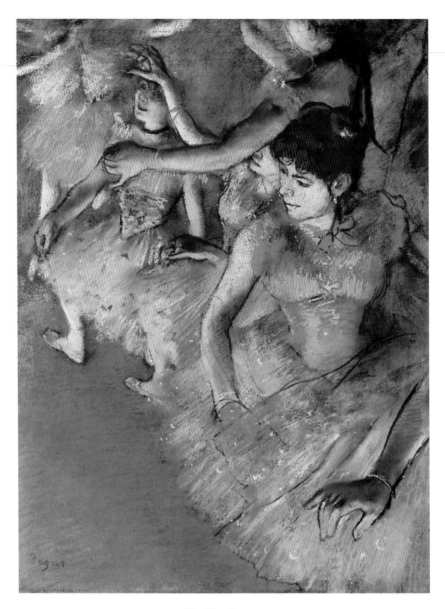

Ballerinas
1883, pastel, 65 × 51 cm
Dallas Art Museum, Dallas, Texas

In 1883, Degas wrote a number of letters to his friend, Ludovic Halévy, in which he interceded in respect of the wages of several ballerinas at the Opera House, including the young dancers Chabot, Salle, and Sacré. It might seem somewhat surprising that he would seek to use his position in this way, given his attempts to deny his aristocratic origins and changing his name from De Gas to Degas because he considered that it was not fitting for someone with an aristocratic name to make his living by painting. However, he occasionally made much of being the son of a banker and concerned himself with more mundane matters, such as the well-being of the ballerinas at the Opera House. Furthermore, it has been proven that he did this disinterestedly, his only concern being that the young women were able to work as they wished, without being forced into an unwanted relationship.

This greater sensitivity toward ballerinas developed from the early 1880s, when Degas was allowed to attend ballet rehearsals and exams at the Opera House, and produced an increasing number of drawings on their lives behind the scenes. At the same time, he gradually replaced oil with pastel, as this enabled him to capture these moments more rapidly and with greater freedom of movement.

Degas's mastery of pastel was much greater than that of his contemporaries, since he had developed techniques to improve the fixing of this medium. Denis Rouart published a study on the techniques used by Degas, whose concerns he had shared with his family. He used the example of *Dancers Backstage* (National Gallery of Art, Washington), pointing out that "at first glance, it is easy to see that, whereas the dancers' flesh, hair, and dresses are depicted in pastel in the standard manner, the décor of vegetation, in the background on the right, the flowers decorating their hair, the back of the wings, the parquet, and the leg of the ballerina in the foreground are all painted with a brush, using another – superficial but fluid – process. It could be gouache, tempera, turpentine, or dissolved pastel. But on closer examination, you realize that the parquet has not been treated in the same manner, for example, as the décor of the background."

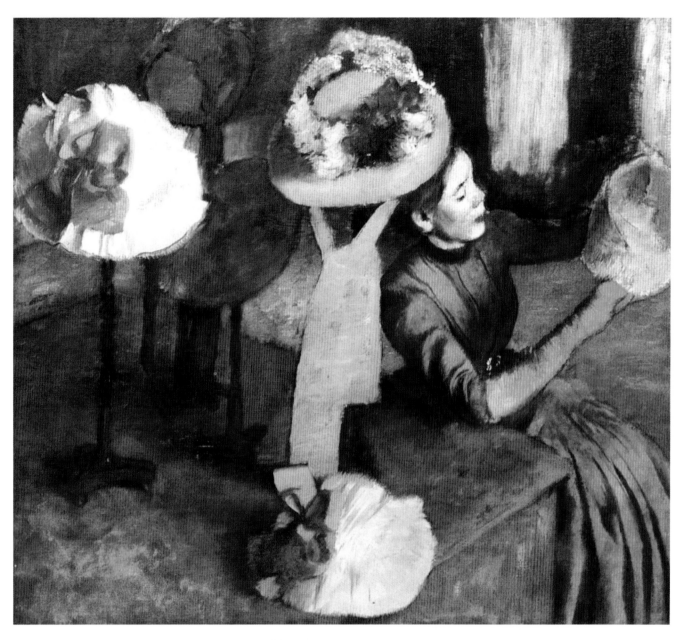

The Millinery Shop
c. 1884, pastel, 100 × 111 cm
Art Institute of Chicago

It has been said of Degas that, although he had never painted still lifes, he organized the composition of his milliners' series as if they in fact belonged to this genre, investing each hat with an individual character in relation to the whole. By way of example, Degas recorded in his notebooks that he was trying a "series on bakers' boys, seen in the cellar itself, or through the basement windows from the street. The pink color of the flour, curves of dough, still lifes of different breads, large, oval, long, round, etc... Studies in color of the yellows, pinks, grays, and whites of breads. The perspective of bread in rows..."

Thus, in this painting the hats occupy the left-hand two-thirds of the composition, with one suspended so that the elevated viewpoint makes it appear as if the milliner is actually wearing it. The positioning of the woman is similar to that of *Woman with Chrysanthemums* (1865) (see page 36) in which the figure appears to have been relegated to the right of the composition, in this instance even cropping part of her skirt and the hat she is holding. Once again, Degas makes the composition appear casual, when it was in fact the result of careful reflection.

The movement of the hands as the subject looks at the hat, is marked by the brushstrokes to the left of it, which create an indistinct background, and by other strokes perpendicular to the outline of the woman's arms

The woman is gathering the ribbons of the hat, isolated from the observer, as if the artist has adopted an elevated viewpoint. She is one of the few women whom Degas painted with feminine grace, an attribute that he did however acknowledge in real life.

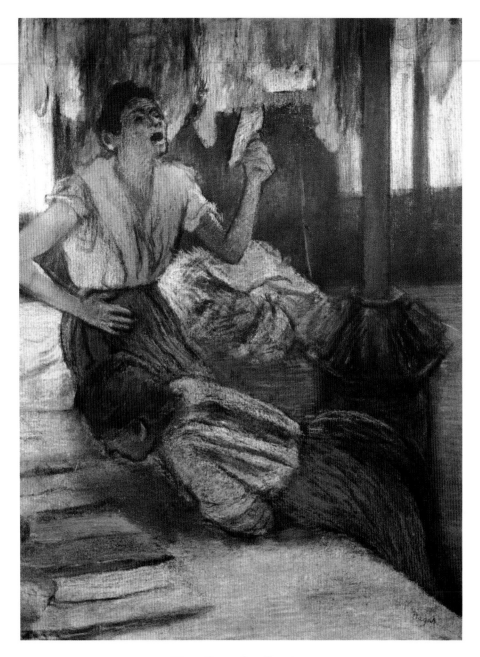

Reading the Letter
c. 1884, pastel, 63 × 45 cm
The Burrell Collection, Glasgow

In his individual studies of women ironing, Degas's treatment of the actual task made him the first painter to analyze the movement of the body that accompanied the action of ironing.

The theme of laundresses and women ironing had already been reinterpreted more realistically by Jean-François Millet in 1850, and a decade later by Honoré-Victorin Daumier. Daumier's paintings of the women who worked on the banks of the Seine were already far removed from the 18th-century French paintings that depicted these women singing on their way to work.

In 1884, as well as being upset by the fact that he had recently turned fifty, Degas was also preoccupied by his progressive loss of sight. In a letter written to Henri Rouart in that year, he remarked: "How can one listen seriously to the misfortunes of others when one considers oneself so much above them in that respect? Really it is too much, so many necessary things are lacking at the same time. In the first place my sight (health is the first of the worldly goods) is not behaving properly ... my sight no longer connects, or it is so difficult that one is often tempted to give it up and to go to sleep for ever. It is also true that the weather is so variable; the moment it is dry I see better, considerably better, even though it takes some time to get accustomed to the strong light which hurts me in spite of my smoked glasses; but as soon as the dampness returns I am like I am today, my sight burnt from yesterday and bruised today. Will this ever end and in what way?"

Meanwhile, Degas had already begun to produce copies (monotypes and etchings) of many of the drawings he was making on the days when the reduced humidity enabled him to see better. He worked on these later, when his sight had deteriorated further.

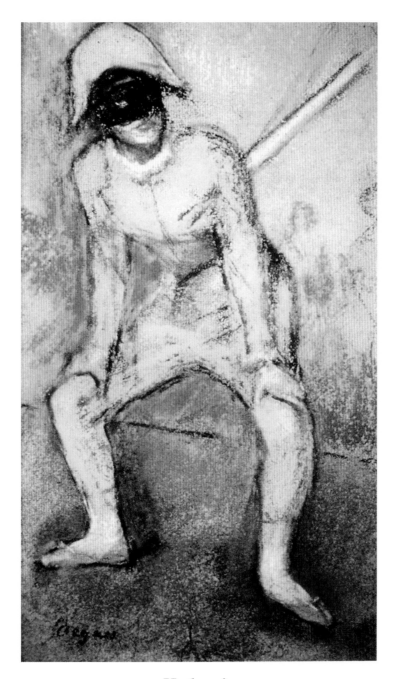

Harlequin
1884, pastel, 32 × 18 cm
Fondation Bemberg, Toulouse, France

Reaching the age of fifty was a milestone that greatly affected Degas, since it coincided with a further deterioration of his sight and a greater sense of solitude, in spite of the fact that he led an active social life. At the time, however, he produced eight pastels and drawings of *Les Deux Jumeaux de Bergame* (The Twins from Bergamo).

This operetta, composed by Jean-Pierre Claris de Florian, in 1782, tells the story of two harlequin brothers who come to Paris and fall in love with the same young woman. After many quarrels and fights, it all ends happily with a double wedding following the appearance of a second young woman.

The work was first performed in the Paris Opera House in January 1886, but Degas had already seen it two years earlier in Brittany. Several studies have even suggested that the artist may have started the first preparatory drawings for this theme immediately after the adaptation in one act, with music by Charles Lecocq, which had been performed in the Paris Opera House in 1875.

In the original version, the role of the elder brother was played by Marie Salanville, Vicomte Lepic's mistress, whom Degas described in a poem as the "indefatigable masked harlequin." The younger brother was played by Alice Biot, whose character is represented in this painting.

In this pastel, Degas stresses the importance of movement, which is highlighted by the vigorous sweep of the outline. To emphasize the light-hearted tone of the work, he has used light colors and an unreal light, typical of theater spotlights.

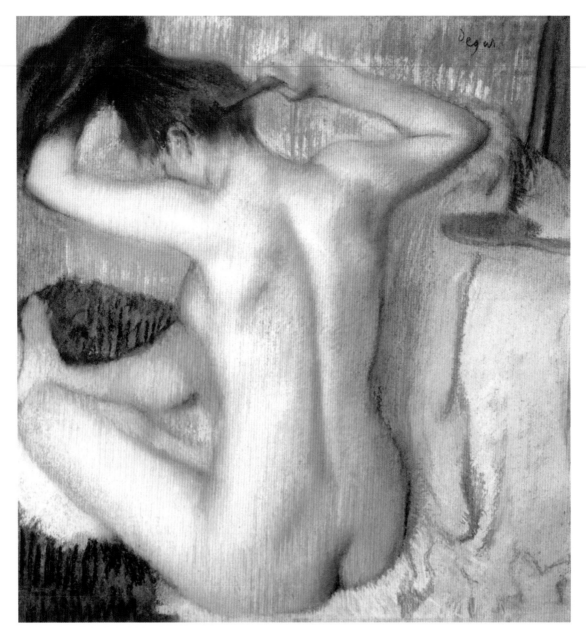

Woman Combing her Hair
1885, pastel, 50 × 50 cm
State Hermitage Museum, St. Petersburg

It is thought that this may have been the pastel sent to the last Impressionist exhibition, in 1886, although this cannot be proved with any certainty since there was no exhibition catalogue. The comments on the series were valid for each and every one of the compositions, so that, although they cannot be linked to individual works, they can be applied in general to most of Degas's nudes from the 1880s.

In this respect, Joris-Karl Huysmans, one of the greatest critics of the day and until then an admirer of Degas's work, drew attention to this new genre: "Degas, who in his amazing paintings of ballerinas had already implacably portrayed the decadence of the mercenary stupidity of despicable amusements and monotonous leaps, nourished ... with his studies of nudes, a watchful cruelty, and a patient hatred."

But as well as reinterpreting scenes of nudes, the artist continued to demonstrate his mastery over the technique of pastel, creating smooth lines to shape the body of the subject, and applying other darker lines to indicate the deeper areas of shading. The poet, critic, and essayist Paul Valéry said of this genre, "in the nude, observed in its every aspect, in an incredible number of poses, and even in action, [Degas] was seeking a unique system of lines capable of defining a particular moment of the body, with the greatest precision, but also in the most general terms possible. Obvious grace and poetry are not his objectives ... he never abandons himself to natural desire. I like this rigor. These are figures that don't give the impression of performing an action, of having finished something, but of having done it to themselves."

The colors are soft, from the sky blue in the foreground to the light-ocher wallpaper of the background, which highlight's the model's mahogany-colored hair.

1885-1889

1885

▬ Degas takes part in a tribute to Édouard Manet, attending the banquet organized at Père Lathuille's bistro in the Batignolles district of Paris to commemorate the first anniversary of the retrospective exhibition of the artist's work at the École des Beaux-Arts.

▬ At the auction of the Comte de la Béraudière's collection at the Hôtel Drouot, Degas acquires a painting by Ingres.

▬ Degas's eyesight continues to deteriorate.

1886

▬ Degas moves to 2, rue Pigalle, in Paris.

▬ He takes part in *Works in Oil by the Impressionists of Paris*, which opens at the American Art Association, in New York, on April 10.

▬ He takes part in the special exhibition, *Works in Oil and Pastel by the Impressionists of Paris*, organized by the American Art Association at the National Academy of Design, New York, from May 25.

▬ The eighth and last Impressionist exhibition is held from May 15 to June 15, at the corner of the Rue Laffitte and Boulevard des Italiens. The highlight of the show turns out to be *La Grande Jatte* by Georges Seurat who, along with Paul Signac, is exhibiting for the first time. Gustave Caillebotte, Claude Monet, Berthe Morisot, Pierre-Auguste Renoir, and Alfred Sisley do not take part. Degas sends various pastels of milliners and a series of ten female nudes who are described in the catalogue as women "bathing, washing, and drying themselves, rubbing themselves down, combing their hair, or having their hair combed."

▬ In view of how the Impressionist exhibitions have developed, Degas decides not to exhibit in public again and to sell his work selectively, via his dealers.

▬ He distances himself from the early Impressionists, but maintains his friendship with Camille Pissarro until his death. Paul Gauguin, who has publicly expressed his differences with Degas in this same year, breaks off relations with Georges Seurat and Paul Signac and once again turns to Degas to ask for his support.

▬ Émile Zola publishes *L'Oeuvre (The Masterpiece)* in the Rougon-Macquart cycle, a novel that outrages Impressionists such as Claude Monet and Paul Cézanne. Cézanne is particularly upset and the incident destroys his longstanding friendship with Zola. In spite of being in close contact with the Zola family, Degas always maintained that he never read it.

▬ Vincent van Gogh praises a painting by Degas exhibited in the gallery of Boussod, Valadon & Cie., run by his brother Theo.

1887

▬ Degas moves to the Rue Flochot.

▬ He takes part in the Durand-Ruel collection of French painting, held at Moore's Art Galleries, New York, on May 5 and 6.

▬ He exhibits at the Ad. Beugniet Gallery, at 10, rue Laffitte, Paris.

▬ Theo van Gogh buys *A Woman Seated beside a Vase of Flowers (Madame Paul Valpinçon)* (see page 36) for Boussod, Valadon & Cie. In the next few years, he continues to buy others, in spite of the fact that Degas is increasingly selective about his buyers since he has been acclaimed by the critics.

Edgar Degas, Ludovic Halévy, and Albert Carré in Dieppe, *photograph, 1885.*

The Apotheosis of Degas, *photograph, 1885, a parody of Ingres' painting* The Apotheosis of Homer. *According to the poet and critic, Paul Valéry, Henri Rouart had the temerity to criticize the coldness of Ingres's Apotheosis, and to observe that all those frozen figures in their noble vestments exuded an air of glacial frigidity. Degas was outraged, stating that the painting was magnificent and the canvas filled with an atmosphere of empiricism. He had forgotten, Valéry added ironically, that empiricism is a doctrine that inflames. This photograph reproduces the neoclassicism of the composition with great irony. Toward the end of summer, Degas went to Dieppe to visit the Halévys. He placed himself in the center of this composition in a parody of the great blind poet, surrounded by the three muses (the daughters of journalist John Lemoine) and, at his feet, in attitudes of adoration, Elie and Daniel Halévy. They are all trying not to laugh.*
Always dissatisfied, Degas criticized the resulting photograph in a letter to Ludovic Halévy, in September 1885: "It would have been better if I had placed my three muses and my two choirboys in front of a white or light-colored background. The detail of the ladies' dresses is lost. It would have been better if the figures had been moved more closely together."

1888

— In January, Degas exhibits at the gallery of Boussod, Valadon & Cie., 18, boulevard Montparnasse, Paris.

— In May, he takes part in the Foreign Loan Section of the Glasgow International Exhibition.

— He also exhibits work at the New English Art Club, in London.

— Paul Durand-Ruel opens a gallery in New York, which gives European artists access to the stable American art market. The support of the American painter, Mary Cassatt, enables Degas to make a name for himself in the United States and, through the agency of her friend Louisine Havemeyer (née Elder), official US museums buy his works.

1889

— Degas takes part in the exhibition of paintings and etchings held at the Durand-Ruel gallery, in Paris, from January 23 to February 14.

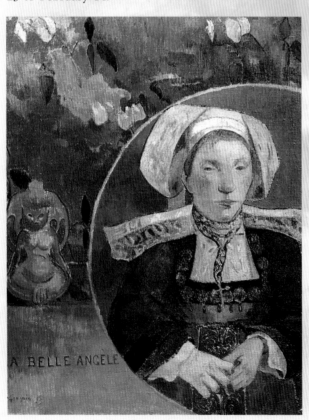

— He travels to Spain and Morocco with the Italian painter Giovanni Boldini to study the works of Velázquez and Delacroix in more depth. He prepares for the journey enthusiastically, in spite of his sight problems: "I am filling my head with Spanish ideas by reading Edmondo de Amicis' *Spain and the Spaniards* and a guide to bullfighting." He also looks forward to the warmer climate: "The weather is fine and hot in the mountains. No doubt we will bake on the plains of Castile, but the museums are always cool."

— He takes part in the Retrospective Exhibition of Fine Arts (1789–1889) held during the World's Fair.

— Odilon Redon publishes an article in praise of Degas: "His name, even more than his work, is synonymous with character … he will always be central to debate on the principle of independence. Degas will have the right to have his name inscribed on the top of the temple."

— He travels to Naples for the last time to settle matters relating to his family inheritance.

— He takes another cure in Cauterets.

La belle Angèle (Portrait of Madame Satre), *Paul Gauguin, 1889, oil on canvas, 92 × 73 cm, Musée d'Orsay, Paris. Degas bought this painting at an auction in 1891.*

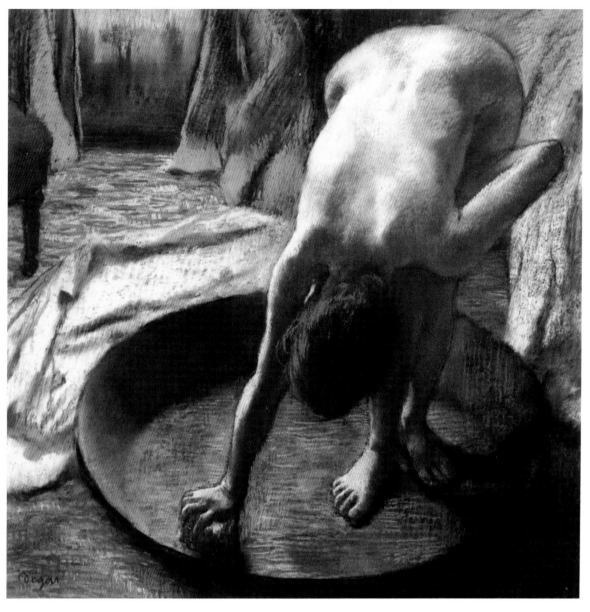

The Tub
1885, pastel on paper, 70 × 70 cm
Hill-Stead Museum, Farmington, Connecticut

Degas's series of works depicting women washing and drying themselves are the finest examples of 19th-century nudes. The artist was well aware of his ability to innovate.

In this pastel, he has reproduced the exact moment at which the woman is stooping, arching her shoulder, to wet the sponge. In 1888, art critic Félix Fénéon described these women in the following terms: "Hair falling onto a shoulder, a torso above the hips, a belly above the thighs, hands and feet attached to their joints. This other wench, seen from above, standing on her bed, with her hands on her hips, is a series of slightly swollen, interconnected cylinders. Opposite, kneeling down, with her thighs open, her head bent over the soft flesh of her chest, a young woman is drying herself. And in dark, poky little rooms in local boarding houses, in cramped bedrooms, these richly colored bodies, racked by debauchery, childbirth, and disease, scrub their skin or stretch out on their beds."

The reaction to this series of women washing and drying themselves, presented at the last Impressionist exhibition, in 1886, will therefore come as no surprise. According to critic Joris-Karl Huysmans: "When they saw the front view of the woman squatting, her belly depicted without the usual dishonesty, some of the visitors to the exhibition cried out in indignation at such frankness, undoubtedly struck by the sense of life that emanated from these pastels. They exchanged tentative feelings of disgust and, as they left, uttered the sacred epithet: 'It's obscene!'"

Similar comments began to circulate among the models of Paris, since Degas used to let them walk freely around his studio, between tubs and baths, with accessories for doing their hair, until they were tired and began to adopt the attitudes that seemed most natural to them. That was when the artist began to make his sketches.

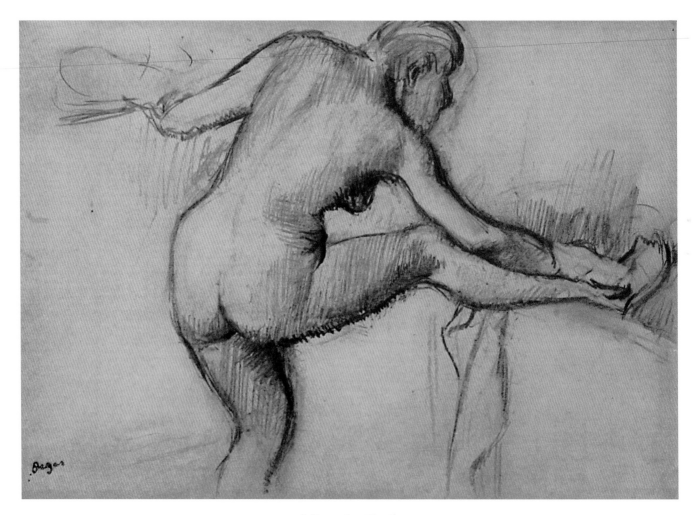

After the Bath
c. 1886, charcoal on cardboard, 27 × 39 cm
Narodni Muzej, Belgrade

In this charcoal drawing, Degas analyzed the flexibility of a woman trying to dry the end of her right foot. He repeated the same scene in a variety of different postures, for example *Woman Drying her Foot* (1885–1886, Metropolitan Museum of Art, New York), in which the seated model is seen in profile from the left, although her face is concealed. In this instance, however, the face is characterized by a few lines reminiscent of the simian features copied by the artist from the science journal *Nature*, and later applied to sculptures such as the *Little Fourteen-Year-Old Dancer,* whose face had so upset visitors to the Impressionist exhibition of 1881, and the primitive faces of the *Physionomies de criminaux,* a series of drawings of criminals made in the early 1880s.

Nor were his nudes unanimously accepted at the time. With regard to the series of women washing and drying themselves, exhibited at the last Inpressionist exhibition in 1886, even the prestigious critic Joris-Karl Huysmans experienced conflicting emotions. Thus, he said of Degas: "Such a painter, the most personal, the most perceptive of all those on whom, without even suspecting it, this wretched country relies," but went on to say that, after portraying the ballerinas' world so implacably the artist had ended by accumulating "in his studies of nudes, a watchful cruelty, and a patient hatred."

Huysmans considered that Degas seemed "to have wanted to retaliate and throw the most exaggerated insult in the face of his century, by reducing its most revered idol, woman, to the woman that he debases." Thus, in the end, he "summarizes his repugnance by making her fat, paunchy, and short-legged."

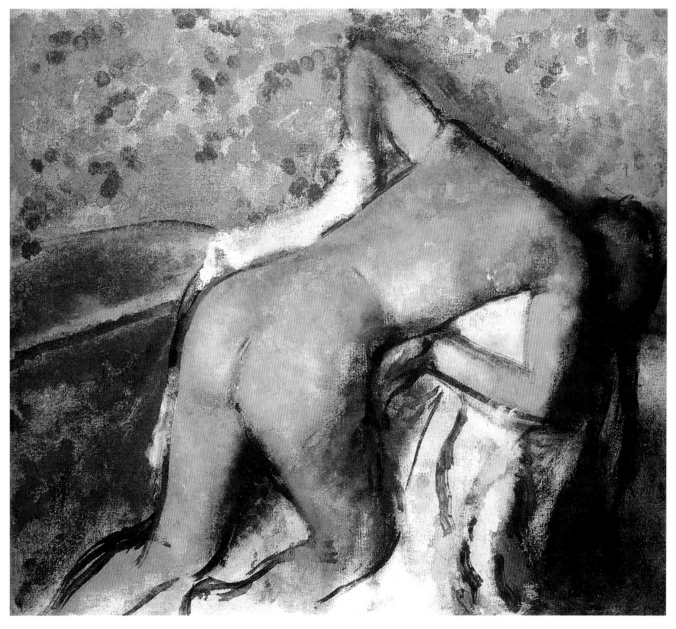

After the Bath (Woman Drying Herself)
1892, oil on canvas, 76 × 86 cm
The Henry and Rose Pearlman Foundation

Degas had always been interested in poetry – he was a great admirer of Charles Baudelaire and had an in-depth knowledge of his work. In the 1890s, he was in much closer contact with his poet friends, especially Stéphane Mallarmé, with whom he was particularly close. He also had a high regard for Paul Valéry, who dedicated two monographs to the artist after having spent a great deal of time with him both socially and in the confines of his studio. He was also one of the few people who occasionally ate at the painter's house.

This is why Degas wrote more poetry during this period, some of which has survived, as in the case of the eight sonnets published jointly with a composition or two preserved in letters, and other writings by the painter.

It may have been this poetic influence that led the artist to produce more sensual works during the same period, like this one for example. The theme of a woman drying herself as she rests her head on the back of an armchair was repeated throughout the 1890s, with extremely sensual overtones.

However, as well as this erotic quality, the body is portrayed in an almost contorted position, with a noticeable twist to the left shoulder and an unnatural positioning of the head, which is lowered, with the long hair falling forward.

Unlike the other oils from this period, *After the Bath (Woman Drying Herself)* has a much more fluid application in which the layer of paint barely covers the canvas, whose texture is visible beneath the woman's body. The weave of the canvas is even more noticeable on the surface of the towel, where unpainted areas leave the white priming exposed.

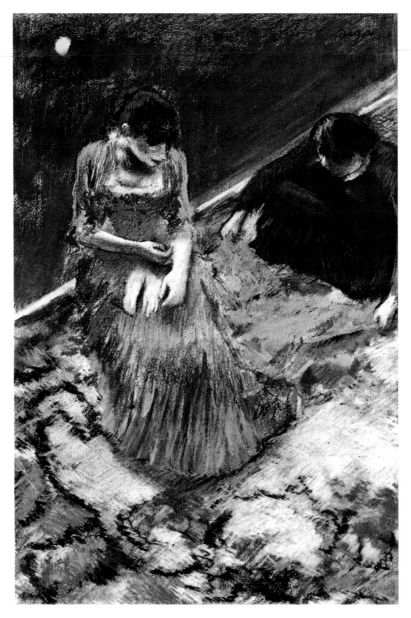

Before the Curtain Call
1892, pastel, 51 × 34 cm
Wadsworth Atheneum, Hartford, Connecticut

During the first half of the 1890s, Degas was still leading the same social and cultural life he had led as a young man: dining out three times a week, attending musical soirées organized by his friends, and going to cafés-concerts, the opera, and the theater.

Occasionally, he would even take part in the performance as an actor since, each year, toward the end of June, he would leave Paris – not without a certain amount of grumbling – to spend the summer visiting friends, staying with the Valpinçons, the Rouarts, and the Halévys in turn. During this time, he was extremely good company and took part in social gatherings and improvised theatrical performances.

However, he was also drawn to the world of singers and actresses as a spectator, rarely going behind the scenes or exploring the world of these artists as he did that of his ballerinas.

In this instance, Degas produced an exercise in framing, obtaining the best results by adopting an elevated viewpoint. The poet, critic, and essayist, Paul Valéry, remarked that framing the subjects from above was "like seeing a crab on the beach. It allows new perspectives and interesting combinations." However, Degas spent years trying to change this viewpoint which he considered technically more difficult but which he seemed to choose instinctively: "After having done portraits seen from above, I will do others seen from below. Seated near a woman, and looking at her from below, I will see her head in the lamplight surrounded by crystals."

Another characteristic of Degas's work is that the figures are usually placed off-center. It was a characteristic greatly admired by his friend Camille Pissarro who, in a letter to his son Lucien, advised him that, before starting a work, he should draw a grid, a technique used by Degas to great effect.

1895-1899

1895

— Degas's sister Marguerite dies in Buenos Aires. Berthe Morisot dies in the same year. She was a great admirer of Degas and her notebooks were filled with notes on his work and ideas.

— The Lumière brothers present the first public cinema show.

— The so-called Dreyfus Affair divides public opinion in France.

— The first one-man show of Paul Cézanne's work is held in December. Organized by his dealer Ambroise Vollard at the latter's gallery in the Rue Laffitte, it comprises 150 of the artist's works. Among the many other collectors and artists who attend, Camille Pissarro, Pierre-Auguste Renoir, Claude Monet, and Edgar Degas buy paintings. The general public still does not appreciate Cézanne's work and Vollard is even forced to remove it from the window of his gallery. Degas is aware of the major importance of this painter and begins to collect his works. In so doing, he influences other collectors and investors in art, who follow his lead.

1896

— Cézanne's paintings begin to increase in price. At Vollard's gallery, Degas pays 400 francs for *Still Life with Glass, Cloth, and Apples* almost double the maximum price reached two years earlier when the paintings in "Père" Tanguy's store were auctioned off and *Village Corner* was sold for 215 francs.

— Degas takes part in an exhibition at the Durand-Ruel gallery, in Paris.

— He takes part in the first Annual Exhibition held at the Carnegie Art Gallery (now the Carnegie Library's Music and Art rooms), Pittsburg, from November 5, 1896 to January 1, 1897.

— He exhibits at the Christmas exhibition organized by Louis Bock & Sohn at the Kunst-Salon, Hamburg, December 1–31.

— Also in December, he takes part in the exhibition of new acquisitions held at the National-Galerie, Berlin.

— He travels to Carpentras for the funeral of his friend Evariste de Valernes.

— He becomes even more isolated and has virtually no social life, apart from his visits to the Rouarts and Halévys.

1897

— The annex of the Musée du Luxembourg is inaugurated on February 9. Among the exhibits, the "Caillebotte Gift" includes seven works by Degas. Impressionist painting continues to be the butt of public ridicule.

— Degas takes part in the International Exhibition of Art, which opens in Dresden on May 4.

— In August, he takes a cure in Mont-Doré.

— At the end of August, he travels to Montauban with his sculptor friend Paul-Albert Batholomé, to visit the Musée Ingres. It is an idea he has had for some time but he needs someone to go with him to help him *see* Ingres's drawings.

— He copies Andrea Mantegna's *Diana the Huntress* and *Minerva Chases the Vices from the Garden of Virtue* in charcoal and pastel.

— He takes part in the second Annual Exhibition held at the Carnegie Art Gallery, Pittsburg, from November 4, 1897 to January 1, 1898.

— With French public opinion divided by the so-called Dreyfus Affair, Degas's increasingly pronounced anti-Semitism means that he becomes more and more withdrawn and isolated. He distances himself from such close friends as the Halévys whose Jewish origins disturbed him, in spite of their belonging to the liberal middle classes.

Renoir and Mallarmé, *photograph, c. 1895, 39 × 29 cm, Museum of Modern Art, New York.* For this photograph, painter and poet had to pose motionless for fifteen minutes.

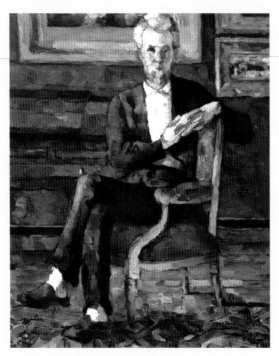

Victor Choquet, *Paul Cézanne, 1877, oil on canvas, 46 x 38 cm, Columbus Museum of Art, Museum Purchase, Howald Fund, Columbus, Ohio. Degas ended up with seven of Cézanne's works in his collection, including this painting which, according to him, was "a portrait of a madman, painted by a madman."*

1898

— Degas takes part in the exhibition of selected works by old and modern masters, organized by the Annual Exhibition of the Antiquarians of the Art Institute, Chicago, January 1–23.

— He takes part in an exhibition of modern painters held in Boston, March 7–27.

— He takes part in the exhibition organized by the New English Art Club in the Dudley Gallery, London, in April.

— In May, he pays 200 francs for a fragment of a painting by Paul Cézanne representing green pears.

— He takes part in the International Exhibition of Art, organized by the International Society of Sculptors, Painters and Gravers, at the Prince's Skating Rink, London, which opens on May 16.

— In summer he stays with his painter friend Louis Braquaval in Saint-Valéry-sur-Somme, where he paints landscapes. In September, he writes to Alexis Rouart: "If it weren't for the landscapes I intended to try, I would have left already. My brother was due to return to his newspaper on the first of the month and the landscape(!) has kept me a few days longer. Will your brother believe it?"

— In winter, an exhibition of works by Max Lieberman, Edgar Degas, and Constantin Meunier is held in the gallery of Bruno and Paul Cassirer, in Berlin.

— Degas takes part in an exhibition of paintings by the French school, organized by the Corporation of London Art Gallery, in the Guildhall, London.

— The Carnegie Art Gallery in Pittsburg organizes its third Annual Exhibition.

— The painter's sight deteriorates daily and he devotes himself increasingly to sculpture.

— Émile Zola sends an open letter *(J'accuse)* to the President of the Republic, Félix Faure, denouncing the army for having deliberately manipulated the evidence at the trial of Captain Alfred Dreyfus.

1899

— Degas's work is presented at the spring exhibition held at the Ernest Arnold gallery in Dresden.

— On September 19, Alfred Dreyfus is acquitted and reinstated in the army, but Degas refuses to accept the verdict

— He takes part in an exhibition of painting organized in St. Petersburg by the journal *Iskusstvo* [Art and Applied Art], between November 2, 1899, and January 1, 1900.

Cinématographe Lumières, *photograph of a poster.*

Le Petit Journal, *photograph, 1895. The so-called* Dreyfus Affair *dominated the French press of the day.*

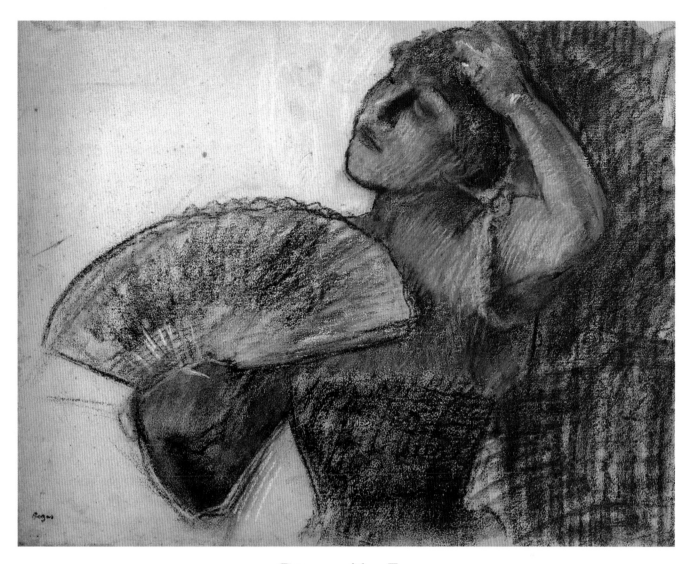

Dancer with a Fan
c. 1895, pastel on paper, 48 × 61 cm
Libby Howie Collection

In the 1890s, Degas abandoned his choreographic representations of dancers in favor of studies of ballerinas preparing to dance or, as in this instance, taking a break.

From 1893 onward, he also attended the theater of the Paris Opera House less frequently and concentrated on painting dancers in his studio, where he kept a few tools of their trade – a low bench, a fan, and a tutu, all worn with use.

This was where he produced this *Dancer with a Fan*, which, in spite of being done in his studio, has the contrasts of light and shadow, and the dark colors created by artificial stage lighting. It is possible that the work is based on a photograph taken in his studio between 1895 and 1896, in which the dancer raises her arm to adjust the shoulder strap of her bodice.

This pose was characteristic of Degas's work for a number of years, and is found in other compositions of individual ballerinas and groups of dancers, since it was typical of this period that the artist reworked gestures copied some time before.

In the last years of his artistic production, however, Degas began to depict his dancers from a closer viewpoint and with more vigorous lines, which in this instance create the movement of the right hand holding the fan. The image is given greater strength by the colors, arranged in large areas of complementary red and green.

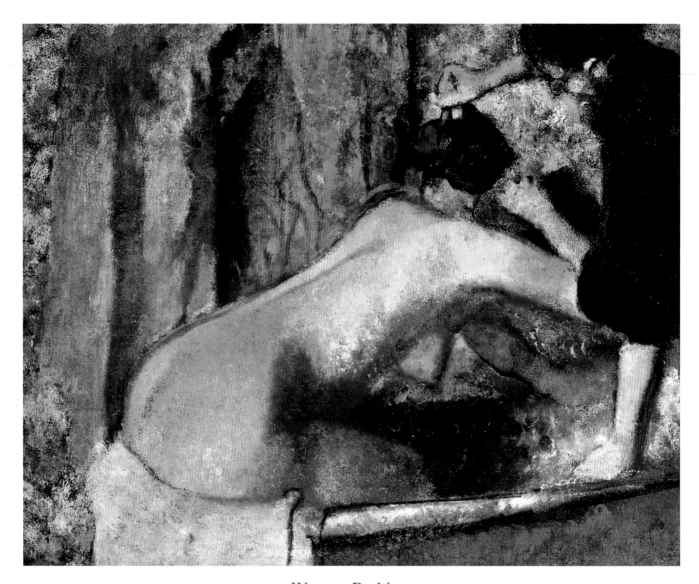

Woman Bathing
c. 1895, oil on canvas, 71 × 89 cm
Art Gallery of Ontario, Toronto

This painting has all the characteristics of Degas's later oils, in which he worked the medium as if it were pastel. The colors are much brighter and more strongly contrasted, but have the whitish reflection reminiscent of the opacity of pastel. They are combined in violently contrasting forms that illuminate the model's skin, like the intense red that appears to come from the bath tub and draws the observer's attention to the bather's chest.

The application of layers of color, using a dry brush, gives the work a matte finish. As a result, the surfaces assume an unreal appearance that makes them difficult to identify, for example the draped fabric on the left of the painting, and the whitish surface of the inside of the bath, which seems to blend with the steam.

The relatively sketchy figure of the maid is represented by her arms performing the action of rinsing, and part of her head. She is basically painted in black as if she were a shadow, in the same way that Degas painted the voyeur in *Dancers, Pink and Green* (1890) (see page 108). In this painting, he is not trying to create an attractive image of the nude, but to give visible form to reality as he sees it.

It appears that, in preparation for this work, Degas made a series of drawings of a woman seated on the edge of a bath, rinsing her neck with water.

This later series of oils is pervaded by a sense of uneasiness, a feeling that the artist is being forced to confront himself against his will. It was because of his – apparently congenital – retinopathy that, from 1890, he was tormented by the thought of going blind. In spite of having taken great care of his sight, when he died, he was blind in the right eye and virtually blind in the left.

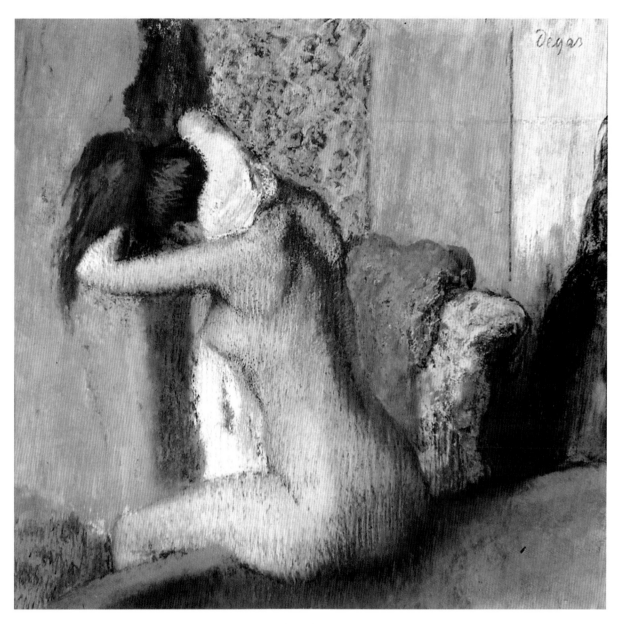

Woman Drying her Neck
1895–1898, pastel, 63 × 65 cm
Musée d'Orsay, Paris

In the late 1890s, Degas began to adopt a viewpoint that was closer to his models – whether they were dancers or women washing and drying themselves – in order better to capture the image.

He explored the anatomy of the female body in even more depth, if that were possible. Pauline, one of his models at the time, said that the painter, who was already nearly blind, used to run his hand over their body in order to draw them.

Although his works were increasingly colorful, due to the use of pastel, whose tones were more intense and which enabled him to apply drawing and color at a stroke, the artist continued to be obsessed by drawing.

In this instance, to offset the inharmonious posture of the model, Degas included a strip of wallpaper in the upper part of the composition, to give a greater sense of verticality to the figure. Similarly, to offset the strong perpendicular strokes of the body, he used a patterned background (part of the papered wall and the armchair) whose sweeping strokes invest the model's skin with greater delicacy.

The visibly rough areas were created by the use of pastel, which Degas began to introduce in the 1870s. The critics realized that he was gradually replacing oil with pastel, as recorded by Philippe Burty who wrote that the artist now preferred "painting with tempera and pastel."

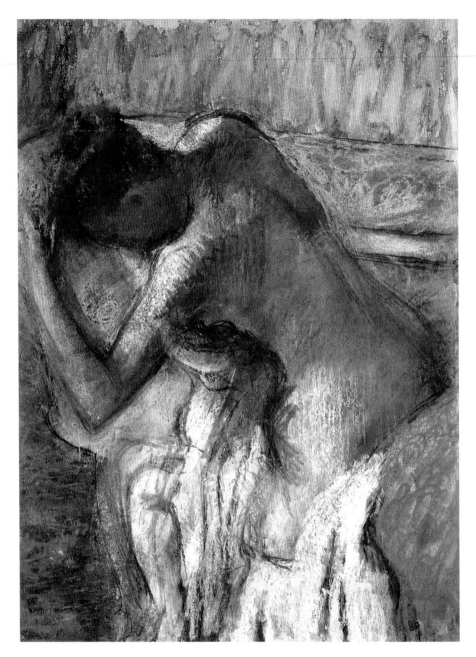

After the Bath

1899, pastel and charcoal on tracing paper, 80 × 54 cm
Columbus Museum of Art, Columbus, Ohio

Here, as always in Degas's nudes, the model has her face concealed. Another feature of this period was the increasing number of views from behind, emphasizing the different curves of the female body.

The effect of light is created by the use of white pastel on the model's skin that seems to enter into a dialog with the fabric she is seated on. The individual textures of the surfaces have been created by different strokes – finer for the model's body and much freer, almost gestural, for the background, which represents wallpaper, and the surface of the floor, probably some kind of carpet.

In reproducing this scene, the artist appears to have been inspired by the prints of Utamaro, in which women are depicted arranging their hair. In terms of the color, he has reinterpreted the green and gold tones of Delacroix.

It is hardly surprising that Degas's work is full of references to other artists, since he had an extensive artistic experience. The years spent copying works in the Louvre Museum, and the incessant – almost obsessive – passion for collecting, which he had always had but which was particularly pronounced in the 1890s, meant that he was constantly surrounded by works of art and reflected this in his own paintings.

Gratified that Degas bought some of his works for his collection, Paul Gauguin wrote in 1898: "Degas, for his talent and conduct, is a rare example of what an artist should be. A man who had colleagues and admirers among those in positions of power – Léon Bonnat, Pierre Puvis de Chavannes, Antonin Prust, etc. – and never wanted to have anything. Never has he been heard or seen [to commit] a vile deed, an indelicacy, or any kind of baseness. Art and dignity!"

1900-1917

1900

— Two of Degas's paintings and five of his pastels are exhibited at the Century Exhibition of French art (1800–1889), held during the World Fair in Paris.

— In June, he takes part in the Secession exhibition, an international art exhibition organized by the Kgl. Kunstaustellungsgebäude, Munich.

— His work is exhibited at the fifth Annual Exhibition held at the Carnegie Art Gallery, Pittsburg, from November 1, 1900 to January 1, 1901.

1901

— Paul Durand-Ruel organizes an exhibition entitled *Degas*, in New York

— The artist takes part in the sixth Annual Exhibition held at the Carnegie Art Gallery, Pittsburg, from November 7, 1901 to January 1, 1902.

1902

— Degas takes part in the ninth exhibition of the Société des Beaux-Arts, Salon 1902, which opens in Brussels on April 1.

— Between August 30 and November 2, he exhibits at the Moderní Francouzské Umění, in Prague.

— He takes part in the loan exhibition (seventh Annual Exhibition), organized by the Carnegie Art Gallery, Pittsburgh, from November 6, 1902 to January 1, 1903.

1903

— The artist takes part in the fourth Vienna Secession exhibition, held in January.

— In February, his work is exhibited at the Kunst und Künstler exhibition, in Vienna.

— In April, he takes part in an exhibition of works by the Impressionist school at the Galerie Bernheim-Jeune et fils, in Paris.

— He also exhibits at the Goupil Gallery, in London.

1904

— Degas's health deteriorates. In August 1904, he writes to lawyer Paul Poujaud to ask his advice about taking a cure. He finally goes to Pontarlier for a fortnight: "After seven attacks of intestinal grippe [gastric flu], my doctor is prescribing a cure in the mountains to get rid of the poison in my system.... I need pure air. My tongue is always coated, my head hot and heavy, and I feel depressed. Gastralgia is a mental illness."

— He takes part in the "Libre Esthétique" exhibition of Impressionist painters, held in Brussels from February 25 to March 29.

— He exhibits at the International Exhibition of Art organized at the Städtischer Kunstpalast, Düsseldorf, from May 1 to October 23.

— He takes part in a comparative exhibition of art from the US and other countries, organized by the American Fine Arts Society and held in New York from November 15 to December 11.

1905

— Degas's eyesight is extremely poor, and he is able to work less and less. Even so, he continues to paint.

— His work is included in an exhibition of 100 Impressionist paintings, held in the Museum of Art, Toledo.

Degas parodying a ballet with the Fourchys, *photograph, c. 1900. Santiago Fourchy was the husband of Hortense Valpinçon.*

Degas with his niece, photograph, 1900, Bibliothèque Nationale, Paris. Degas's nieces and nephews were always extremely fond of their uncle. His niece, Jeanne Fèvre, cared for him during the last months of his life.

1906

▬ Degas exhibits works at the sixth exhibition of the International Society of Sculptors, Painters, and Gravers held in January at the New Gallery, London.

▬ He takes part in an exhibition of paintings, drawings, sculptures, etchings, and objets d'art by the contemporary French school, organized by the Fine Arts Society of the Kunsthalle, Basel, from March 14 to April 22.

▬ He exhibits at an exhibition of modern painting organized by the Municipal Art Gallery, Belfast, in April and May.

1907

▬ Degas takes part in an exhibition of contemporary French art, held in the Château des Rohan, Strasbourg, from March 2 to April 2.

▬ He exhibits at an international exhibition of art and gardening, organized by the Jubiläums-Ausstellung, Mannheim, from May 1 to October 20.

▬ His work is exhibited at an exhibition of French art, held in the Kaiser Wilhelm Museum, in Krefeld, from May 28 to October 20.

▬ He takes part in the Francouzští Impressionisté (XXIII Výstava), organized by the Manés Society, Prague, in October and November.

▬ In winter, he exhibits at the Modern French Painters exhibition, held in the City Art Gallery, Manchester, England.

1908

▬ In January and February, the International Society presents an exhibition of paintings, drawings, etchings, and sculptures (including works by Degas) at the New Gallery, London.

▬ He takes part in the Exhibition of Painting by the French Impressionists, held at the Carnegie Institute, Pittsburgh, from February 11 to March 10.

▬ He exhibits at the Vie et Lumière exhibition, held at the Musée Moderne, Brussels, from April 12 to May 4.

▬ His works are exhibited at the Zolotoe pyro, Moscow, from April 18 to May 24.

1909

▬ In January and February, Degas takes part in a retrospective exhibition of fans, organized by the Société des Arts de la Femme, Brussels.

▬ His work is featured in the Exhibition of Beautiful Women, held in the New Gallery, London, in February and March.

▬ In December, he has works exhibited at an exhibition of 19th-century pictorial works held at the Kunsthalle, Mannheim.

1910

▬ He takes part in an exhibition of modern French painting, held at the Pratt Institute, New York, January 17–29.

▬ He exhibits at the first Italian exhibition held at the Lyceum Club, Florence, between March 15 and April 20.

▬ In April and May, his work is exhibited in the Memzetközi Impresionista Kiallitas, of the Müveszhaz, Budapest.

▬ He takes part in the twenty-first Berlin Secession exhibition (Drawing), held between November 1910 and January 1911.

▬ An exhibition featuring the work of Manet and other Impressionists, held at the Grafton Galleries, London, includes works by Degas.

▬ Degas's work is represented in an exhibition of paintings from the collection of Mrs. Potter Palmer, organized by the Art Institute of Chicago.

1911

— Virtually blind, Degas attends the exhibition of Ingres's work held at the Galerie Georges Petit, in Paris, and confides to a friend, "The paintings I know I can find as the case may be, [but] those I don't know mean nothing to me." He stands in front of the canvases and feels them.

— He takes part in the 79th artistic exhibition of the Kunstverein für Hannover, held from February 24 to April 30.

— In March, Jahr XIII, the eighth exhibition held in the Berlin gallery of Paul Cassirer, includes works by Degas.

— The artist takes part in the eleventh Annual Exhibition of the Grafton Galleries, London, from April 8 to May 27.

— In April, the Loan Exhibition of Paintings and Pastels by E. Degas is held at the Fogg Art Museum, Cambridge, Massachusetts.

— In October, he takes part in an exhibition of contemporary art from Cologne collections, held at the Wallraf-Richarz Museum, Cologne.

1912

— Degas is forced to leave his apartment and studio in the Rue Victor Massé, where has lived for almost twenty years, because the building is due to be demolished. This causes a serious deterioration in his health. Although his model Suzanne Valadon finds him a new apartment on the Boulevard de Clichy, the artist never really gets used to it.

— He is now virtually blind and finally has to stop painting.

— He exhibits at a modern art exhibition – sculpture, painting, and etching – which opens on July 2 at the Museum Folkwang, in The Hague.

— He takes part in an exhibition of 19th-century classical French painting at the Kunstverein, Frankfurt, from July 18 to September 30.

— Works by Degas are exhibited as part of the Marcell von Nemes collection, in Düsseldorf, from July to December.

— He takes part in an exhibition of 19th-Century portraits at the Salon d'Automne (10th Exhibition), held in the Grand Palais, Paris, between October 1 and November 8.

— In October and November, works by Degas are featured in Jahr IX, the ninth exhibition organized by the Berlin gallery of Paul Cassirer.

— Works by Degas are included in an exhibition of French art held in St. Petersburg.

1913

— An exhibition of Impressionist paintings – lent by Durand-Ruel gallery and including works by Degas – is held at the Saint Botolph Club, Boston, January 20–31.

— Between February 15 and March 15, the artist's work is featured in the Armory Show, an international exhibition of modern art organized by the Armory of the Sixty-ninth Regiment, New York.

— In April, Degas's work is exhibited at the Heinemann gallery, Munich, in an exhibition of 20th-century French art.

— His work is included in an exhibition of modern art from 1913, held in the Galerie Manzi-Joyant, in Paris, from June 23 to July 10.

— Between November 25 and December 17, an art exhibition held under the aegis of the Cleveland Art School and organized by Kinney & Levan Building, Cleveland, features works by Degas.

— The twenty-sixth Berlin Secession exhibition, organized by the Sezession Ausstellunghaus, includes works by Degas.

— He takes part in an exhibition of French art in São Paulo.

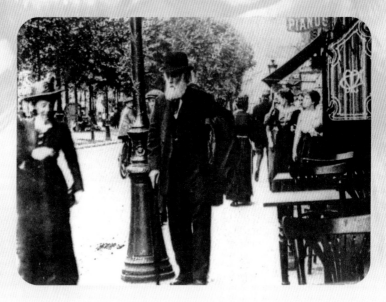

Edgar Degas in Paris, Boulevard de Clichy, photograph, Sacha Guitry, 1910. In his last years, Degas, who was almost blind, used a stick when walking along the Boulevard de Clichy.

Degas, *Maurice Denis, 1906, Musée d'Art Moderne, Troyes.*

1914

— The first free Berlin Secession exhibition is held from April 12 until the end of September, in the Sezession Ausstellunghaus, and includes works by Degas.

— In April and May, Degas's works are featured in an exhibition of 19th-century French painters held in the Ernst Arnold Gallery, Dresden.

— Degas takes part in an exhibition of 19th-century French art held in the Royal Museum, Copenhagen, from May 15 to June 30.

— An exhibition of contemporary decorative French art (1800–85) held in Grosvenor House, London, includes works by Degas.

1915

— Works by Degas are exhibited at the third international Secession exhibition, in Rome, between February and June.

— He takes part in the Loan Exhibition of Masterpieces by Old and Modern Painters, held in the gallery of Knoedler and Co., New York, April 6–24.

— In summer, he presents works at the Panama-Pacific International Exposition of San Francisco (in the French section of the Fine Arts department).

1916

— The Durand-Ruel gallery in New York organizes an exhibition of paintings and pastels by Édouard Manet (1832–83) and Edgar Degas (1834), April 5–29.

— Degas exhibits in the retrospective collection of French art (1870–1910), loaned by the Musée du Luxembourg, Paris, and opened by the Fine Arts Academy in the Allbright Art Gallery, Buffalo, on October 29.

1917

— In March and April, works by Degas are included in an exhibition of 19th-century French art at the National Museum of Estocolmo.

— His works are included in the experimental exhibition held in the gallery of Bernheim-Jeune & Cie., Paris, June 14–28.

— He takes part in an exhibition of 19th-century French art organized at the Galerie P. Rosenberg, Paris, from June 25 to July 13.

— His work is featured in the exhibition of modern art organized by the executors of Sir William Eden in the Grosvenor Galleries, London.

— Degas dies on September 27, at the age of 83, and is buried in the family vault in the cemetery of Montmartre. At his own request, the funeral is limited to close friends such as Claude Monet and Jean-Louis Forain. To Forain fell the task of replacing the standard funeral oration with the words dictated by Degas before he died: "He greatly loved drawing!"

Edgar Degas, *photograph, c. 1908. This photograph in Bartholomé's garden was the last taken of the artist. "I look like a dog," he used to say to Paul Valéry in his last years.*

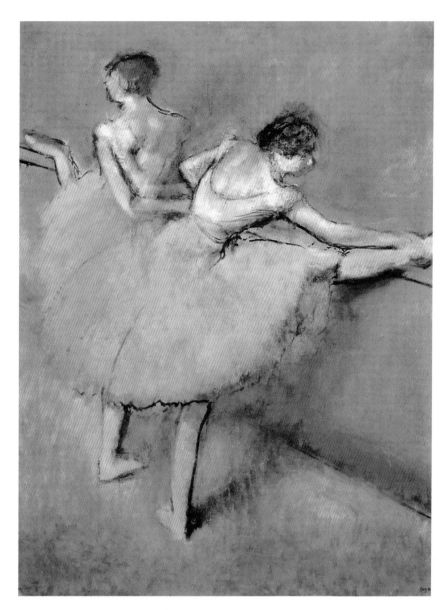

Dancers at the Bar
c. 1900, oil on canvas, 130 × 97 cm
The Phillips Collection, Washington

In 1901, Degas wrote to Hector Brame: "I haven't known how to do anything but accumulate beautiful paintings and no money." In fact, as soon as his financial situation improved in the mid-1880s, he was able to indulge his passion for collecting, acquiring historical works by Tiepolo and El Greco, although specializing mainly in 19th-century French paintings.

At times he bought paintings by artists he liked – for example he acquired 20 paintings and 88 drawings by Ingres, 13 paintings and 129 drawings by Delacroix, 1,800 lithographs by Honoré-Victorin Daumier, 2,000 prints by Paul Gavarni, and seven landscapes by Camille Corot. At others, he would buy to exchange works with his contemporaries or to help fellow artists, as in the case of ten paintings by Gaugin. He managed to acquire most of Manet's etchings, seven of Cézanne's paintings, and works by most of the Impressionists. The only exception was Monet, whom he condemned for his lack of drawing.

Like may artists of the day, he also collected Japanese prints, and owned a hundred or so by Hokusai, Kiyonaga, Sukenobu, and Utamaro.

He had confided to Daniel Halévy: "I buy and buy, I can't stop." In the Rue Victor Massé, where he lived until 1912, his collection was hung on every wall in the apartment, but, when he moved, the works were never rehung and lay piled up on the floor or stacked against the wall.

His artistic development followed a similar pattern. Degas became obsessive about painting very similar works, reinterpreting them until his death, which is why the dating of *Dancers at the Bar* is so controversial. Some sources situate it in the 1880s, since, from the time he first started painting ballerinas, Degas included the motif of two dancers exercising at the bar in various compositions, for example *The Dancing Class* (1871) (see page 50) and *The Foyer of the Opera House* (1872) (see page 59). However, the smooth brushstrokes of this work suggest that it was painted much later.

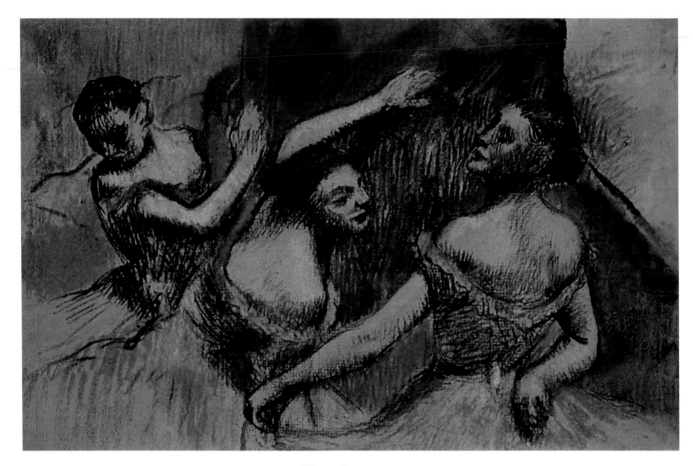

Blue Dancers
1900–1905, pastel on art paper mounted on cardboard, 41 × 63 cm
Narodni Muzej, Belgrade

Within a relatively short space of time, Degas produced eight charcoal drawings and ten pastels on this same theme of three dancers on stage, each with slight variations – the extent to which the dancers' bodies are represented, the format, and so on. In this instance, the upper half of the dancers' bodies are portrayed and, to give them a more majestic air, the artist added a strip of paper in the upper part of the painting.

In the latter years of his life, Degas was barely able to see to paint, and repeated the same themes to the point of obsession – female nudes and ballerinas, which occupied twenty-five and seventy-five percent of his work respectively.

Paul Valéry referred to this period by comparing Degas to a writer determined to achieve the maximum precision of form, writing draft after draft, making corrections, feeling his way, and never having the illusion that he had reached the "definitive" stage of his work. In the same way, the artist reworked his drawings time and time again, giving them more depth, making them "tighter," developing them on sheet after sheet, copy after copy.

As he developed his technique, Degas synthesized his painting to the point of neglecting the appearance of things.

In this work, form is superseded by color, which is applied in flat areas. This explosion of color is accompanied by much more vigorous, much darker lines that reinforce the outline of the figures or enhance their volume through the use of hatching.

The women look more like mannequins than dancers, an effect that would be reworked later by the artists of the Dada movement and Bauhaus school. In this respect Pierre Francastel (1900–1970) described Degas as: "A sensitive being who doesn't want to be deceived by anything and who has succeeded [as he had dreamed of doing at the age of thirty] in fixing on paper, with pencil and pastels, a personal vision of the world.

Very close to the style of the Second Empire in the first part of his work, he comes much closer to us in the latter part. His modernity is not open to dispute, the problem is knowing whether this development is strictly personal or whether it constitutes an aspect of Impressionism."

Thus, while Cézanne developed toward geometrical synthesis, and Monet toward an almost abstract use of color, Degas followed a more conceptual path in his painting, in which he offers the very essence of that painting. Perhaps this was due to the fact that he was not so much concerned with producing a work that pleased his clients and critics as exploring his own style. Degas liked to say that, "A picture is something that requires as much trickery, malice, and vice as the perpetration of a crime, so create falsity and add a touch from nature..."

Nude Dancer Seated
1902, charcoal, 73 × 43 cm
Yoshii Gallery, Tokyo

The poet, essayist, and critic, Paul Valéry, found it difficult to speak to Degas about painting, since the latter only discussed art with fellow artists or, at most, the Rouarts. He was even less inclined to speak about it to writers but Valéry persisted nonetheless. When he asked Degas what he understood by drawing, the painter replied with his famous aphorism: "Drawing is not form, it is the sensation one has of it." According to Valéry, the question "unleashed the artist's torment" but he guessed what he was trying to say. He compared what he called "disposition," that is to say the representation in accordance with the subject matter, with what he called "drawing," the particular way in which an artist's way of seeing and working modifies the exact representation.

Works such as *Nude Dancer Seated,* which represented Degas's perception of reality in his latter years, are in fact quite disturbing.

The artist produced works in this format when, at the end of the day's work, he felt that his sight would allow him to make sketches and drawings for subsequent works.

In his compositions, he did not seek to convey formal beauty but to achieve maximum expressiveness through sinuous lines, which heralded later works by such artists as the Norwegian painter Edvard Munch (1863–1944).

Well aware that these works did not possess the quality of drawing with which he would have invested them several years earlier, Degas kept them hidden and asked that they be burned when he died. However, this *Nude Dancer Seated* managed to survive and was sold in the second auction of the contents of Degas's studio, in 1918.

As in other drawings from this period, the extremities are transformed into something imaginary – the right hand is virtually a stump, while the left is disproportionately large and turned back to front. In 1889, the critic Joris-Karl Huysmans described this natural development of Degas's nudes: "These pastels are reminiscent of a cripple's stump, a withered breast, the balance of a body without legs and muscles, an entire series of attitudes inherent in woman, even a graceful young woman, [who is] delightful when she is lying down or standing, but [assumes] the aspect of a frog or a simian if she has to stoop in order to conceal her deformities with such care."

And Denis Rouart wrote the following about Degas: "His entire life was taken up with quests, both in the aesthetic and technical fields, insofar as they related to art. He did not allow himself to be discouraged by the difficulties or problems that might arise. On the contrary, he liked to confront them and, perhaps, had they not existed, he would have invented them: 'Luckily for me, I did not find my style, I would have become brutalized!'"

Mme Alexis Rouart and her Children
c. 1905, pastel, 160 × 141 cm
Musée du Petit Palais, Paris

During the later years of his life, Degas had very little contact with anyone. Following the Dreyfus Affair, he had distanced himself from the Halévys and Strausses, and most of his other friends were dead. However, he was still in regular contact with the Rouart family.

He continued to go out walking every day, without a particular goal in mind, but hardly ever spoke to anyone, partly because he didn't see them and partly because he didn't want to engage in conversation. Some of the younger generation of painters, such as Pablo Picasso, who met him in the street, held him in such high regard that they did not dare speak to him, just as years before, Degas had not dared to speak to his idol, Delacroix.

Virtually blind, the artist lived within the confines of his apartment, where he was visited by very few people. He ate and lived in the tiny room next to the kitchen, so as not to have to heat the entire apartment or turn on more lights. The rest of the rooms remained in darkness.

Paul Valéry was one of the few people who not only visited the artist but was also brave enough to stay and eat with him – Degas's housekeeper, Zoé Closier, cooked very little and not very well. Each day, the painter gave her just enough to buy a frugal meal, which nearly always consisted of two boiled eggs and apple purée. According to Valéry, if he happened to sample that purée full of little pumpkin-colored fibers, he would find himself seated opposite an incredibly lonely old man, the victim of dismal thoughts, withdrawn, due to the state of his sight and the work that was his whole life.

It was under such circumstances that these last works were produced, including *Mme Alexis Rouart and her Children*, disturbing in its arbitrary use of color and strength of line, but, above all, in the treatment of the little girl kneeling on the chair, with her simian face, reminiscent of the sculpture of the *Little Fourteen-Year-Old Dancer* (1881).

It was years since Degas had devoted himself to the theme of portraits and yet he managed to paint one of the few friends he had left, in an everyday and apparently spontaneous situation. It was with good reason that Degas liked to assert: "To get the best results, you have to stretch out in a chair, and remain there all your life with your arms outstretched, and your mouth open, in order to assimilate what happens, what is around us, and live from this."